LIBRARY OF ART

PUBLISHER - DIRECTOR: GEORGE RAYAS

BYZANTINE ART IN GREECE

MOSAICS~ WALL PAINTINGS

General Editor

MANOLIS CHATZIDAKIS
Member of the Academy of Athens

"MELISSA" Publishing House

English translation revised by HELEN ZIGADA

Editorial Supervisors: LAMBRINI VAYENA-PAPAIOANNOU,
DORA KOMINI-DIALETI, philologists

Design: RACHEL MISDRACHI-CAPON

Photographs: MAKIS SKIADARESIS, VELIS VOUTSAS

Plans: YOTA ZACHOPOULOU, architect

Photo typesetting: FRANGOUDIS Bros

NAXOS

MANOLIS CHATZIDAKIS
Member of the Academy of Athens

NICOS DRANDAKIS
*Professor Emeritus of Byzantine Archaeology
in the University of Athens*

NICOS ZIAS
Byzantinologist

MYRTALI ACHEIMASTOU-POTAMIANOU
Byzantinologist, Director of the Byzantine Museum

AGAPI VASILAKI-KARAKATSANI
Byzantinologist

CONTENTS

INTRODUCTORY NOTES

"This is the metropolis of all the Cyclades"
J. Bryennios

This book in the series of publications on monumental painting in Greece is, I believe, a positive contribution — at the present stage of research on the subject — to the study of Byzantine painting in general rather than of just that found in Naxos and the surrounding area. First, because it presents some of the most important and best preserved monuments of the island — either totally unknown or only partially known so far — and second, because the texts are written by experienced colleagues who were at times in charge of works on these monuments.

These introductory notes contain some general supplementary remarks which, it is hoped, will be of some use to the study of relevant problems and to the definition of the entire monumental physiognomy of the island. The writer's only privilege is that he has had the opportunity of participating substantially, from a position of responsibility, mainly at the inception of the organized programmes mentioned below.

Written sources provide scant information on the history of the Cyclades during the Byzantine era, particularly on that of Naxos, which is the largest of the Cyclades and occupies geographically a central position within this group of islands. During the last decades we have gained gradually knowledge of a different but well-grounded historical evidence supplied by a series of monuments of the ecclesiastical arts, chiefly wall paintings, dating from the 7th to the 14th century without chronological interruption. One of the first facts established by a review of the material available to this day is that the number of monuments decorated with wall paintings on Naxos is far greater than that found on all the other Cycladic islands. This fact requires special historical examination. What is of interest here is that this monumental ensemble, by itself and in association with the information derived from painted and engraved inscriptions, constitutes the most valid historical testimony that Naxos did not cease to occupy a prominent position in the administrative, ecclesiastical, economic and artistic level among the other islands of the South Aegean, except Crete. The discovery and partial uncovering of this vast and valuable material is due, after individual sporadic investigations of a preliminary nature, to long and systematic work on the monuments, from various directions.

At first, the Team for the Photography of Byzantine Wall Paintings (A.K. Orlandos, M. Sotiriou, A. Xyngopoulos and M. Chatzidakis), financed by the National Research Institute (1958-1961), discovered and photographed (with the collaboration of Mrs. A. Vasilaki-Karakatsani) more than 40 wall-painted churches on the island of Naxos. The works carried out subsequently by various departments of the Archaeological Service (Direction of Restorations, Central Atelier for the Conservation of Wall Paintings, Ephorates of Byzantine Antiquities) have been more continuous and productive. These works have often led not only to the consolidation and cleaning of the wall paintings, but also to the separation and removal from the walls of successive layers of painting. This procedure, analogous to the excavation of archaeological strata, has revealed that in many instances, as in the outstanding examples of the Panagia Drosiani and the Panagia Protothrone, certain localities of Naxos have remained constant places of worship throughout successive historical periods from the Early Christian times to our days, and that the same buildings had been repeatedly decorated, at least partly, with new layers of wall paintings. Thus far, a very small part of this material has been published in the form of systematic studies. A larger part has been presented only in numerous but brief reports on conservation works or, occasionally, in reviews of a more general nature. The greater part, however, remains unexamined and unpublished. It would be worth noting at this point that neither conservation works nor research for the listing of all the monumental wealth of the island have been completed as yet.

The material already known from Naxos poses a series of general problems related to the local conditions as well as the historical setting of the times. One of these problems is the distribution of the monuments in different localities and different epochs. More specific problems refer to the prevalent architectural types, the iconographic particularities, the painting style and other similar points.

With respect to the first problem it should be noted that almost all the surviving churches had been built for reasons of safety in the inland, in the densely planted plains and fertile plateaus or in the mountainous region where emery is quarried. Regarding the problem of distribution of the preserved wall paintings to the various epochs of a long historical period, it has been noted that out of a total of 180 layers of wall paintings — or partial paintings — in the approximately 130 churches located so far, not more than two or three layers belong to the age preceding the Iconomachy, while at least 14 monuments show a more complete or just remains of a pure aniconic decoration. The number of wall paintings dating from the 10th century to about 1200 does not appear to be greater, while the number of wall paintings dated or assigned to the 13th century and the first decades of the 14th century, that is to say to the period when the island was under Venetian rule (after 1204), is remarkably greater. After these general remarks on the number of monuments belonging to each period, which must reflect fluctuations related to historical events, we continue with more specific though brief observations on the iconography and style of each period.

The churches of Naxos, like those of the other Cycladic islands, are characterized by relatively small dimensions, common building materials which do not require an advanced technology, and a predilection for the simple single-aisled church with a dome resting on a low drum slightly tapering upwards, a type often encountered on other Aegean islands and in Western Asia Minor. Only a few older churches are of the larger three-aisled basilical type with vaulted roof. The convenient, small vaulted church, single or double, is that most commonly found. The small church of the free-standing cross type with a dome is not very rare. The narthex is absent, but there is often a lateral compartment without a sanctuary, a sort of side narthex. The more composite transitional type with dome of the Greek mainland occurs here rarely, in larger churches, and only during the Middle Byzantine period, as a retarded novelty — something that occurs on other islands too, for example on Kythera.

Masonry of undressed stones is undecorated and in older churches remains to this day poorly cemented and without plastering. Sculptural elements are rather scarce and are found only in a few churches of the Middle Byzantine period, even though marble is available on Naxos.

Painting displays, in general, traits corresponding to a traditional and rather provincial art of sound technique. A closer examination of the monuments known so far, however, has shown that in the field of iconography some remarkable singularities are noted in the arrangement of the representations, while the painting style presents an interesting range and a notable variety from period to period. Within this framework the average artistic quality is fairly high.

The few monuments of the pre-Iconoclast period found in the Greek lands are given a special place because of the problems posed by the unique (single in kind) character of certain representations and arrangements of the iconographic programme. For example, the dome of the church of Panagia Drosiani is painted in a manner unique so far with two facing busts of Christ, of the then known type — as a slightly bearded youth and as a full-bearded mature man — in roundels (Fig. 4). This arrangement must represent a hitherto unknown notion on the iconography of the dome in the pre-Iconoclast period. The paintings of this period in the sanctuary of the same church have also revealed quite a few peculiarities, which came to light after three painted layers of later date had been removed. For instance, in the representation of the Ascension there are six angels supporting Christ in glory. The style of these paintings is of a relatively high standard and the church of Panagia Drosiani discloses some special affinities of style and form with certain Byzantine monuments of Rome (Sta Maria Antiqua et al.). The presence of Pope Martin I, exiled to Naxos in about A.D. 653, is perhaps not irrelevant to these Roman associations.

In the church of Panagia Protothrone at Chalki, which is of foremost importance, the removal of two later layers from the curved walls of the apse has revealed that the oldest layer from the decoration of the original Early Christian basilica depicted a number of Apostles standing in array, full-length and larger than life-size. The Apostles are in a poor state of preservation, with blackened faces (Fig. 7, 8) like the contemporaneous figures of the Sts. Cosmas and Damian in the Drosiani (Fig. 8). In terms of iconography, the closest representations are again found on Naxos: in the sanctuary of the Panagia Drosiani which has the painting of the Ascension (Fig. 7), and in the cave of the Panagia Kaloritsa where the Virgin portrayed in bust at the centre of the sanctuary apse (Intr. Fig. 1) lends specific meaning to the presence of the Apostles — similar to that

conveyed by the representation, at the same place and with the same proportions, of the Virgin in the Drosiani. We may therefore conclude that in the Kaloritsa, too, the Apostles were figures of an Ascension, the upper part of which had been painted over with a representation of the Virgin and angels. The paintings of the Protothrone and the Kaloritsa are related also stylistically. In both churches the monumental figures of the Apostles are pictured in ancient poses with a slight movement. The wide folds of their garments are rendered easily with large, broad, steady lines matching the free modelling and colouring of the faces (Intr. Fig. 2). To this group of pre-Iconoclastic paintings we may add the head of a saint, remnant of a lost layer that has been detected in the church of St. John the Theologian at Apeiranthos.

The particular importance of the Apostles in the church of the Protothrone lies in the fact that the chronological limits of this representation are defined by the overpainted layer of aniconic decoration showing an arcade with large crosses (Fig. 28). A dating in the 7th century would be more likely for the Apostles, when they are compared with similar figures in St. Demetrios at Thessaloniki. This dating also affects, I believe, the corresponding representation of full-length Apostles in the sanctuary of the Panagia Kaloritsa, which is better preserved and has been assigned to the 9th-10th century.

The known pre-Iconoclastic works of monumental painting in Greece are so few that even scant fragmentary decorations of a high quality are of the utmost importance for the art of that period, an importance exceeding the limits of this particular area.

The extent and variety of the aniconic decoration in churches of this area in the following period (9th-10th century) are indeed unique to this day. Since this kind of decoration is associated directly or indirectly with the iconoclast movement, it constitutes valuable evidence on the degree to which the iconomachal policies of the central administration were accepted by certain Greek regions and in particular the island district. With respect to its type it could be noted that in Naxos every aniconic decoration has a certain independence in the choice of ornamental designs. In most instances the motifs selected are Early Christian, in some places the decoration is influenced by contemporary Islamic art. At any rate, the correlation between the decorative subjects of the various monuments is rather loose, while lesser decorative motifs often belong to the same repertory with that encountered in the few aniconic decorations of Crete, the Peloponnese and Eurytania.

The aniconic monuments of Naxos display a rich repertoire of both geometric patterns and animal figures, often unknown elsewhere, which permits further associations and correlations. The dating of this decoration does not present particular problems. The association with the metropolitan iconomachal system is quite obvious. The duration of aniconic paintings, however, must have extended well after the end of the Iconomachy (A.D. 843), since neither the formation of a new iconic programme nor its expansion could have been immediate. The fact that in the Protothrone the crosses were covered only in the 13th century and that to this day three churches of Naxos — St. Artemios (Fig. 10-14), St. Kyriake (Fig. 3-6) and St. John the Theologian at Adisarou (Fig. 3-9) — have retained their aniconic decoration with or without partial overpainting is indicative of the tolerance for aniconic painting in later times.

The view that the aniconic decoration is unrelated to the Iconomachy and its age and that it merely represents the survival of an Early Christian art unacquainted with the painting of figures and scenes (D. Pallas) is not valid. The aniconic layer showing the arcade with the four crosses in the church of the Protothrone lies between an iconic layer of the Early Christian period and another one of the Middle Byzantine period, which makes its dating compulsory. (This is also the case with the aniconic layer in the Drosiani, as I am informed by Mr. Drandakis). The fact that the crosses cover a specific representation betrays an iconoclastic intention. Besides, the close relation with an Islamic decoration, as in St. Artemios, excludes the assumption of a simple survival.

During the next, mainly Byzantine, period (10th - 12th century), the relatively few monuments known so far display the richest iconographic programmes and the highest quality of painting on the island, particularly in the larger churches (Protothrone, St. George Diasoritis, etc.). From the surviving inscriptions we learn that the founders of some of the churches were eponymous notables of the leity and dignitaries of the church. This fact permits an association of this peak period with the establishment of the Aegean Theme and the presence of a *strategos* on the island.

The monuments of this period provide new elements which seem like peculiarities. For instance, in the

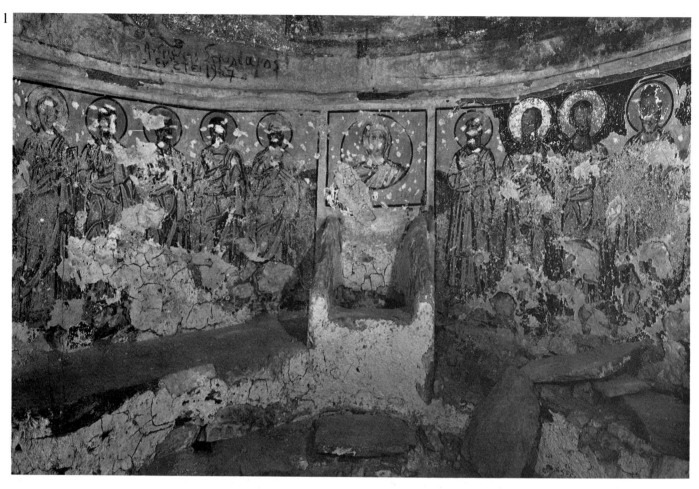

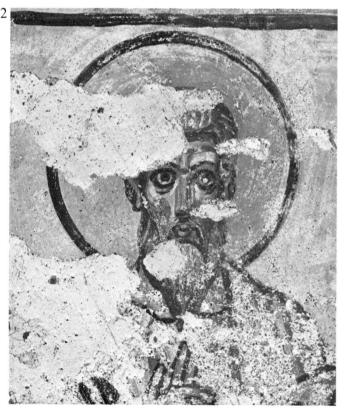

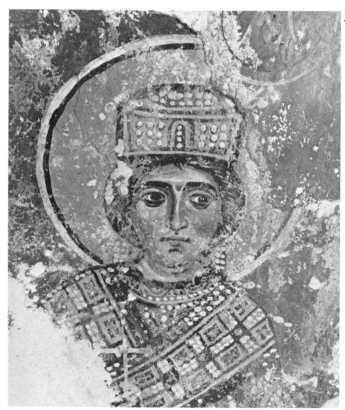

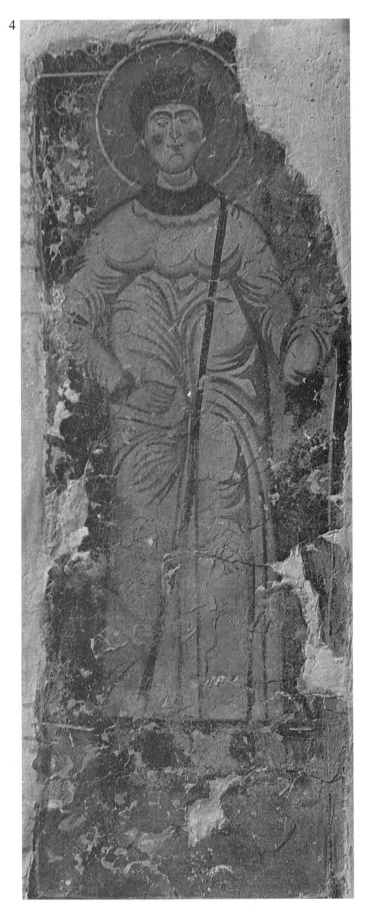

4

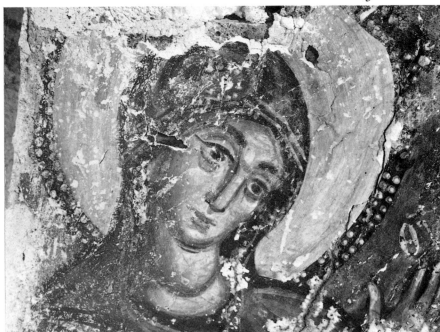

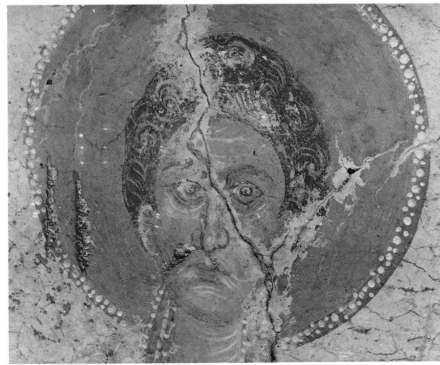

6

1. *Panagia Kaloritsa, sanctuary apse. The Apostles.*
2. *Panagia Kaloritsa, sanctuary apse. Head of an Apostle.*
3. *Panagia at Archatos. Head of a saint wearing a crown (older layer).*
4. *Panagia Arliotissa, sanctuary apse. St. Stephanos.*
5. *Hagios Georgios at Lathrinos (N. church), apse. The Virgin (now in the Byzantine Museum).*
6. *Panagia Fasoulou (ruined church). Saint.*

church of the Protothrone the scene of the Annunciation is placed within the sanctuary in a low position—something that, as far as I know, recurs only in Cappadocia at Bali Kilisse and later in Laconia at Epidauros Limera (13th century). The same church offers valuable evidence on the process leading to the crystalization of new iconographic programmes. The separation of the two successive layers of painting on the dome (Fig. 9, 10) has disclosed: first, that the two layers are not many years apart and, second, that the iconography of the later layer (after 1056) is of a more archaic type than that of the earlier one (about 1052). In the old layer the bust of the Pantocrator on the dome was surrounded by prophets, archangels and cherubim (Fig. 9, 16, 21-24), whereas in the new layer the cherubim and two prophets were replaced by the thaumaturge saints George, Nicholas, Demetrios and Theodore (Fig. 10-13). This regression, which is also present in monuments of later date on Naxos and elsewhere, should be attributed to the particular intention of the new anonymous donor to honour some specific saints. This must have been also the reason for the covering of the relatively recent initial painting on the dome. Because of stylistic affinities the wall paintings of the NW parecclesion (Fig. 17-20), where the painted funerary inscription of 1056 provides a *terminus post quem,* are attributed to the same donor. The two layers of the dome paintings display a marked difference of style. We would add that the painting style of the older layer (1052), with its fine delicate drawing, the softer palette, the more intense spirituality of the figures of the prophets, is related to works of high standard in Asia Minor. It excels in quality the more linear and generally unrefined art of the second layer (after 1056). The short interval of time between the two paintings suggests that their essential dissimilarities may be due to the different origin and background of the donors. Unusual representations have been noted also in other churches of the 11th century. In the church of St. George Diasoritis, for example, we have in the sanctuary three saints depicted in bust (Fig. 4) below the typical hierarchs, and in the nave the rare Biblical scene of the Archangel Michael and Joshua in which the presence of Joshua's escort (Fig. 10) is a literally unique instance. The singularities mentioned here indicatively should be explained in our opinion as random survivals of past phases in the evolution of a specific central system of iconographic programme. Similar peculiarities have been noted to this day in other provincial monuments which are, in effect, of later date. In other words, such instances are not local Naxian phenomena.

The style of the paintings in the church of St. George is not related to the two distinct painting styles of the same century in the church of the Protothrone, though all three are of an anticlassical character. We do have, however, fragments from other churches of the same period, revealing echoes from the classicizing trends of the metropolitan region, like the head of the Virgin in St. Nicholas at Sangri (Fig. 6) and the head of the saint wearing a crown from the older layer in the Panagia at Archatos (Intr. Fig. 3), of the 12th century. The variety is remarkable.

As already mentioned earlier, the 13th century is distinguished for the great number of new churches and new painting layers noted in Naxos, as in most of the regions under Venetian rule. A characteristic of the new churches is the much smaller size in comparison with that of earlier churches. The new founders are no longer dignitaries but private individuals, more often than not peasants, who raised small plain structures of common materials, adorning them only with inexpensive wall paintings by the hand of local craftsmen. The donors often mentioned in the inscriptions are family men, priests, sometimes even painters. Not rarely more than one donor contributed to the painting of the church (Yallou and elsewhere). References to painter-donors are found in the third layer in the apse of the Drosiani (Fig. 13). An inscription records that "the venerable Sanctuary of the Most Holy Mother of God has been storied and painted... at the expense and by the hand of George the sinner painter...". In the Theologos at Apeiranthos (1309) we read that Nicephoros the painter is one of the donors and in the Panagia at Archatos (1285) we find the name of Michael priest and painter — evidence that the painters were local people.

The conservative character of 13th century art is reflected in the survival of iconographic elements typical of older programmes, such as the tetramorphic cherubim on the pendentives of domed churches in St. Nicholas at Sangri (1270) (Fig. 10) and in the Panagia Damiotissa, the caryatid-angels around the Pantocrator in St. John at Kerami (Fig. 6) and in St. Pachomios. Particularities are also observed in the iconography of the sanctuaries. For example, in the Panagia Arliotissa we find a riding saint (only the head of the horse has

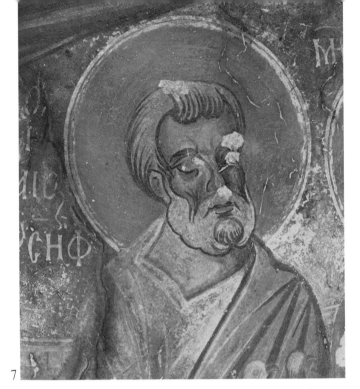

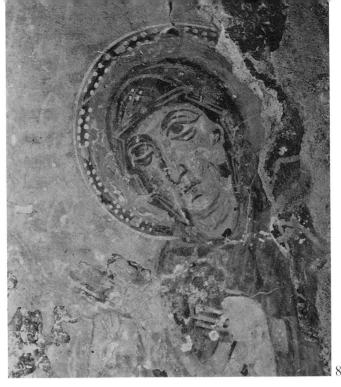

7. *Panagia at Archatos (1285). Joseph from the scene of the Presentation in the Temple (later layer).*

8. *Panagia Damiotissa. Detail from the representation of St. Nicholas.*

survived) and St. Stephanos the deacon (Intr. Fig. 4), in St. Constantine at Vourvouria (1311) the frontal representations of the Sts. Constantine and Helen with the Forerunner and St. Basil, and in the Panagia at Yallou (1289) St. Mamas. An initiative in the choice of not so widely accepted hierarchs is also noticeable. To the above examples we would add the unique instance of the painting of the Dormition of the Virgin (Fig. 21, 22) in the sanctuary apse of the Panagia Drosiani (13th century).

When considering these particularities we should bear in mind that they occur in the decoration of small churches of a private character. Therefore, the owner, donor and user, feels at greater liberty to paint the saints of his preference and place them where he wishes. This comment does not refer only to Naxos.

It has been noted that the greater number of either new or renovated churches with paintings of a higher artistic quality occurs after the mid-13th and in the early 14th century. An indication of the educational level for the whole period is provided by the calligraphy and correct spelling of the inscriptions. At that time the Venetian Marco Sanudi II (1262-1303) was Duke of Naxos, and Naxos was capital of the Duchy. Sanudi's reputation is not that of a philhellene. Therefore, in addition to the tolerance and indifference shown by the Venetian administration towards ecclesiastical matters, some other not well defined circumstances must have favoured this kind of activity by the Orthodox subjects.

We are referring to a series of dated wall paintings which attest to the flourishing of this period in churches of the second half of the 13th century — like St. George at Apeiranthos (1253-54), the Panagia Fasoulou (1281) (Intr. Fig. 6), St. Nicholas at Sangri (1270) (Fig. 4-13), the Panagia at Archatos (1285), St. George at Noskelo (1286-87), St. George at Distomon near Filoti (1287-88), the Panagia at Yallou (1288-89) (Fig. 4-7) — and in churches of the early 14th century — like St. Polycarpos at Distomon near Filoti (1306-7), the Theologos at Afikli near Apeiranthos (the prothesis) (1309), St. John at Filoti (Kaminos 1315), St. Sozon at Yallou (1314-15). The list could be completed with a series of undated and often excellent wall paintings that may well be assigned to this period. At this point we would like to draw attention to the fact that wall paintings of the quality found in St. John at Kerami (Fig. 5-8) and in the Panagia at Yallou (Fig. 4-6), also in St. George at Lathrinos (N. church, now housed in the Byzantine Museum) (Intr. Fig. 5), in the Panagia at Archatos (1285) by the painter-priest Michael (Intr. Fig. 7), as well as in the Panagia Damiotissa (Intr. Fig. 8), represent the average artistic level of that period for Naxos. They also disclose a remarkable variety, which is not surprising since we know of at least three local painters.

It should be noted that the best of these paintings reveal, at times, echoes from the currents prevailing in

the metropolitan art, which was free and of high quality, without ever reaching its standard, for all art here is of a conservative character. Nevertheless, only paintings of a certain category, poor in composition and clumsy in design (St. Constantine at Vourvouria, Panagia Arliotissa (Intr. Fig. 4) can be characterised as works of a popular art.

The fact that Frankish influences are hard to discern in Naxos — by contrast with other Venetian-ruled regions — may be associated with the extreme conservatism of the island and signify an awakened Orthodox, if not national, awareness.

The absence, or at least the scarcity, of wall paintings after the first decades of the 14th century, as well as in the following centuries — contrary to what took place in Crete and elsewhere — is a purely local occurrence, which constitutes another subject for research.

Athens, July 1988 Manolis Chatzidakis

Bibliography

In addition to the bibliographical references given at the end of each chapter, the following are cited here indicatively:

GENERAL

K.D. Kalokyris, Ἔρευναι Χριστιανικῶν Μνημείων εἰς τάς νήσους Νάξον, Ἀμοργόν καί Λέσβον, Athens 1960, p. 1-40, pl. Α΄-ΙΣΤ΄ (reprinted from the Ἐπετηρίς Θεολογικῆς Σχολῆς τοῦ Πανεπιστημίου Ἀθηνῶν, 1958-59 and 1959-60).

N.B. Drandakis, «Μεσαιωνικά Κυκλάδων — Νάξος», Ἀρχαιολογικόν Δελτίον, Vol. 20 (1965), B₃: Χρονικά, Athens 1968, p. 541-548, Pl. 680-692.

G. Demetrokallis, Συμβολαί εἰς τήν μελέτην τῶν βυζαντινῶν μνημείων τῆς Νάξου, Vol. Α΄, Athens 1972.

T. Velmans, *La peinture murale byzantine à la fin du Moyen Âge*, Paris 1977, p. 147-149, 205-206, 251 (= *Bibliothèque des Cahiers Archéologiques*, XI).

M. Chatzidakis, "L' art dans le Naxos byzantin et le contexte historique"(summary), *XVe Congrès Internationale des Sciences Historiques, Bucarest 10-17 Août 1980, Rapports Vol. III*, Bucharest 1980, p. 13-15.

M. Chatzidakis, «Ἡ Μνημειακή Ζωγραφική στήν Ἑλλάδα — Ποσοτικές προσεγγίσεις», Πρακτικά Ἀκαδημίας Ἀθηνῶν, Vol. 56 (1981), Athens 1981, p. 375-390, especially 382-383.

ANICONIC

H. Ahrweiler, "The Geography of the Iconoclast World", *Iconoclasm,* ed. A. Bryer and J. Herrin (Ninth Spring Symposium of Byzantine Studies, University of Birmingham, March 1975), Chapt. IV, Birmingham 1977, p. 21-27.

D. I. Pallas, "Les décorations aniconiques des églises dans les îles de l' Archipel", *Studien zur Spätantiken und Byzantinischen Kunst,* Fr. W. Deichmann gewidmet, Vol. 10 (1986), Part II, p. 171-179, Pl. 37-42.

M. Chatzidakis, «Ἡ Μεσοβυζαντινή Τέχνη», Ἱστορία τοῦ Ἑλληνικοῦ Ἔθνους, Vol. H΄, p. 279, 285-286, 291.

10th - 12th CENTURY

M. Panayotidi, "L' église rupestre de la Nativité dans l' île de Naxos. Ses peintures primitives", *Cahiers Archéologiques,* Vol. XXIII, Paris 1974, p. 107-120, Fig. 1-14.

Id., "La peinture monumentale en Grèce de la fin de l' Iconoclasme jusqu' à l' avénement des Comnènes (843-1081)", *Cahiers Archéologiques,* Vol. XXXIV, Paris 1986, p. 75-108, Fig. 1-36.

13th CENTURY

M. Chatzidakis, "Aspects de la peinture murale du XIIIe siècle en Grèce", *L' art byzantin du XIII siècle, Symposium de Sopocani 1965,* Belgrade 1965 and reprint *Studies in Byzantine Art and Archaeology,* Ed. Variorum Reprints, London 1972, Chapt. XIII, p. 59-73, Fig. 1-27.

G.S. Mastoropoulos, «Ἄγνωστες χρονολογημένες βυζαντινές ἐπιγραφές 13ου καί 14ου αἰώνα ἀπό τή Νάξο καί τή Σίκινον», Ἀρχαιολογικά Ἀνάλεκτα Ἀθηνῶν, Vol. XVI (1983), 1-2, Athens 1985, p. 121-132, Fig. 1-6.

PARALLEL

S. Kalopissi-Verti, "Osservazioni iconografiche sulla pittura monumentale della Grecia durante il XIII secolo", *XXXI Corso di Cultura sull' arte Ravennate e Bizantina, Ravenna 7-14 Aprile 1984,* p. 191-220, Fig. 1-10.

Id., "Tendenze stilistiche della pittura monumentale in Grecia durante il XIII secolo", *XXXI Corso di Cultura sull' arte Ravennate e Bizantina, Ravenna 7-14 Aprile 1984,* p. 221-253, Fig. 1-11.

N.B. Drandakis, «Παρατηρήσεις στίς τοιχογραφίες τοῦ 13ου αἰώνα πού σώζονται στή Μάνη», *The 17th International Byzantine Congress, Washington D.C., August 3-8 1986,* New York 1986, p. 683-721.

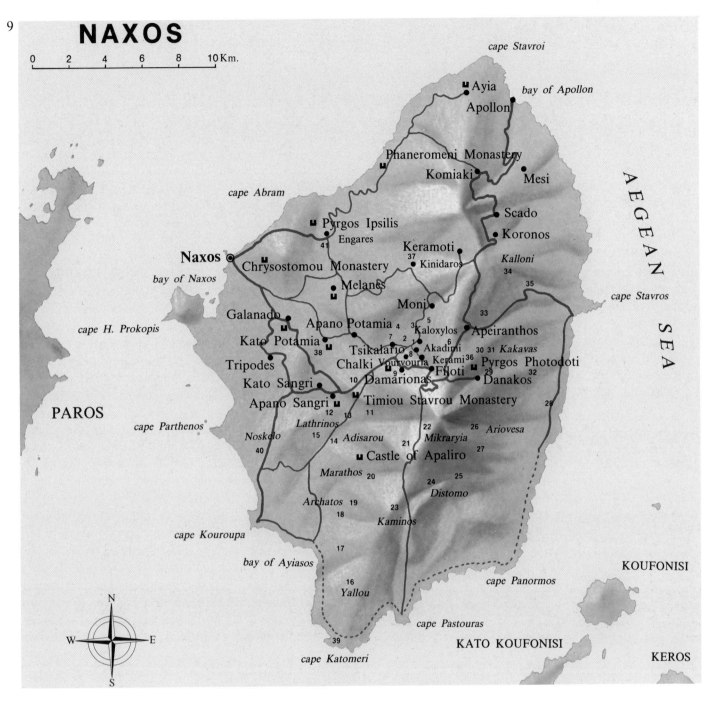

9. Map of Naxos showing the sites of the most important Byzantine churches marked with numbers (after N. Kephalleniadis).

Byzantine churches. 1. *Protothrone*. 2. *Hagios Georgios Diasoritis*. 3. *Panagia Dam(n)iotissa*. 4. *Panagia Rachidiotissa*. 5. *Panagia Drosiani*. 6. *Hagios Ioannis Theologos*. 7. *Hagios Stephanos*. 8. *Hagios Ioannis*. 9. *Hagios Constantinos*. 10. *Hagios Artemios*. 11. *Panagia Kaloritsa*. 12. *Hagios Nikolaos*. 13. *Panagia Arkoulou*. 14. *Hagios Ioannis*. 15. *Hagios Georgios*. 16. *Panagia*. 17. *Panagia*. 18. *Hagios Stephanos*. 19. *Panagia*. 20. *Hagios Georgios*. 21. *Hagios Stathis*. 22. *Panagia Argiotissa (Arliotissa)*. 23. *Hagios Ioannis Theologos*. 24. *Hagios Polycarpos*. 25. *Hagios Georgios*. 26. *Hagios Georgios*. 27. *Panagia*. 28. *Prophetis Elias*. 29. *Hagios Ioannis Theologos*. 30. *Hagios Pachomios*. 31. *Hagios Georgios*. 32. *Hagios Panteleimon*. 33. *Hagios Ioannis Theologos*. 34. *Hagia Kyriaki*. 35. *Panagia Fasoulou (Hagioi Menas, Vincentios and Victor)*. 36. *Hagios Georgios*. 37. *Hagios Demetrios* 38. *Hagios Mamas*. 39. *Hagios Sozon*. 40. *Hagios Georgios*. 41. *Panagia Monasteriotissa*. ◪ **Towers — Tower - Monasteries.**

PANAGIA DROSIANI*

The walker who sets off from Chalki in the olive-growing plain of Tragaia for the neighbouring village of Moni will meet shortly before reaching his destination, to the right, a little off the way and higher than the main road, the cemetery of the community. The cemeterial church, dedicated to the Birth of the Holy Virgin, is the only surviving part of the Monastery of Panagia Drosiani. The Monastery (in Greek Moni) has given the nearby village its name. Information on the Monastery was supplied at a later date by John IV Crispi, Duke of the Archipelago (1555), and others, among whom the Ecumenical Patriarch Johannicius II from Herakleia (1652). As we shall see later on, however, the original part of the church is of much earlier date.

Wall paintings in the interior of the church have preserved a number of undated dedicatory inscriptions in capital letters. An inscription within a roundel on the dome reads (in transcription):

Ὑπέρ σο / τηρίας Ἄνδ / ρέα κ(αί) τῆς συμβ(ίου) / αὐτοῦ καί τῶν τέ / κνον αὐτῶν / ἀμήν [;].

"For the salvation of Andreas and his wife and their children. Amen".

Another inscription on the east wall records:

Ἐγένετο τό ἔρ / γων τοῦτο ἐπί / --------/ καί ἐπή Σισιννίου / τοῦ ἁγιοτάτου --------

"This work was executed under... and under Sisinnios the most holy...".

On the eastern section of the arch before the north conch we read:

ὑπέρ / εὐχῆς / Στεφά / νου κ(αί) τὸν / γω / νέον / αὐτοῦ / † ἀμήν.

"For the blessing of Stephanos and his parents. Amen".

And on the narrow front of the north conch:

† ὑπέρ εὐχῆς κ(αί) σοτηρίας κ(αί) ἀφέσεως ἁμαρτιὸν τῶν δούλων σου οὐ ὑδες----------

"For the blessing and salvation and forgiveness of sins of your servants...".

The single-aisled church is triconchial with a dome (Fig. 2). It was built in the Aegean fashion with undressed flat stones and was probably roofed with slabs. The total length of the interior, including the apse and the westward extension, is 19.40 m. and the width, from the middle of the north conch to the middle of the south conch, approximately 8 m. The original west section is about 3.50 m. wide. The large semicircular apse is pierced by a double-arched window, the lower part of which was blocked with masonry when the church was decorated with wall paintings for the first time. Most probably the west section, which is today 11 m. long, originally did not exceed 1.50 m. in length. A triple-arched belfry was added to the later section of the south side. During the Byzantine period three single-naved parecclesia were built adjoining the north wall of the monument with their entrances through this wall. Except for the middle parecclesion, the other two are triconchial and domed.

The architectural features of the original building are archaic and crude. The unpretentious pointed arches supporting the dome are not of the ordinary type. Pendentives are virtually non-existent: shapeless and forming curved angles, they are indistinct lower terminals of the continuous base-line of the dome. The dome has no drum and its base is a quadrilateral with rounded corners. Inside and out parabolic, almost conical, the dome rises in the exterior from a quadrilateral base pierced to the E. and W. by a single-arched window.

The triconchial plan of the original church has been known since Early Christian times (cella trichora). Used for martyria and mausolea, it was frequently employed in the 4th century, while triconch structures were erected also in the 6th century. Later, the triconchial plan was used for churches, like that at Castelseprio. The probability that the triconch of the Drosiani was initially built as a mausoleum cannot be excluded (the subjects of the painted decoration are indicative, e.g. the Deesis which has an eschatological content and the Ascension which is related to the Last Judgement).

A dating of the original core of the Drosiani to Early Christian times is further suggested by the double arched window of the apse which calls to mind the corresponding, though larger, window of another neighbouring, originally Early Christian monument, the church of the Protothrone at Chalki (see next chapter) and the windows of basilicas in W. Cilicia.

The traces of an episcopal throne in the apse of the main church do not imply that it was a cathedral. Quite a few small churches, particularly in Naxos,

* Paper read at the X International Congress of Christian Archaeology held in Thessaloniki from 28/9 to 4/10/1980.

have a built bench with an episcopal throne in the apse.

The panels of the marble templon, as it has been restored, show a decoration frequently encountered in the 6th century: Greek crosses within roundels and wavy tendrils terminating into Latin crosses. The tendrils are similar in technique with those on panels in Ravenna (second half of 6th century). The templon of the Drosiani was perhaps carved at that time.

The monument was consolidated first by the local inhabitants, who covered the roof of the original church with cement, and later by the Archaeological Service. The view of assigning the church to the years before the Iconomachy is supported by the surviving original wall paintings. These early paintings which had been covered by a thick lime coating or by later layers of painted decoration — three successive layers on the half-dome of the apse — were exposed by the Greek Archaeological Service under the careful supervision of Stavros Baltoyiannis, Inspector of the Conservation Department of the Ministry of Culture and Science. Their cleaning lasted many years.

Originally, of the interior surfaces of the church only the dome, the sanctuary apse and the north conch were decorated with wall paintings.

The unusual painting on the dome shows two busts of Christ within roundels, like *imagines clipeatae*, in a N-S arrangement (Fig. 4). That to the N. depicts Christ with a very short adolescent beard, holding the Book of Gospels, and that to the S. portrays Christ with a pointed beard, holding a scroll. The two windows of the dome are framed by the winged symbols of the Evangelists, in bust. St. Matthew's symbol, the angel, is better preserved. The representation of the Ascension occupied the entire apse while the intrados of the triumphal arch in front of the apse was painted with two frontal archangels (Fig. 5). The northward side of the east wall has retained a half-obliterated inscription in many lines. Ornamental motifs (Fig. 6) completed the painted decoration of the sanctuary walls.

The eastern section of the arch in front of the north conch shows, below, St. Julian (?) with the dedicatory inscription mentioned earlier, and, above, a female saint, probably a healing one. Facing her (on the western section of the arch) is an unidentified saint. The semi-dome of the north conch was painted with a half-length representation of the Virgin Nikopoios (Fig. 8, 9), flanked by the Sts. Cosmas and Damian portrayed in bust within roundels. Below, on the curved wall of the conch, a Deesis (Fig. 8) shows Christ standing full-length, flanked by St. Mary and the frontal King Solomon to the left (Fig. 10), and by a praying female saint and the Forerunner to the right (Fig. 11).

We have no other example from the pre-Iconoclast period of a dome painting with a double portrayal of Christ. Indeed, this is a unique instance. As in other Early Christian works, Christ is cross-nimbed. In one of the busts of the dome (and in the Deesis of the north conch) Christ is portrayed with adolescent down on the cheeks, in the other with a beard, just as He is pictured in the Rabula Gospels. The difference between the two representations of Christ in the Rabula Gospels (and also in S. Apollinare Nuovo at Ravenna) has been interpreted as intending to emphasize the double nature of Jesus — human and divine. Could this apply also to the double portrayal of Christ in the dome painting of the Drosiani?

On the curved wall of the sanctuary apse the twelve Apostles of the Ascension (Fig. 7) are shown in almost rythmically alternating poses: frontal, three-quarter, and profile. Between the figures are small trees rendered in a very concise manner, reminding of trees depicted in catacombs. Simon, the first Apostle on the right, and the beardless John — whose names are legible — call to mind figures painted in catacombs. In accordance with the Constantinopolitan iconography, Andrew as well as Peter and the ninth Apostle hold a cross-staff. In the middle of the representation of the Disciples, above the episcopal throne, is a medallion with the head of the Virgin between two small full-length angels turned towards the Apostles. The Virgin was represented in the scene of the Ascension in earlier times and in the Rabula Gospels. The half-obliterated Ascending Christ is shown seated on the arc of heaven holding an open book. Six angels support the glory of Christ, whereas usually there are no more than four. The disposition of the feet of the lower left angel is reminiscent of the angels supporting a crossed medallion in the mosaics of S. Vitale in Ravenna. The figures of the lower angels occupy the entire available area, as in the scenes stamped on the flagons of Monza.

St. Cosmas and St. Damian are portrayed full-length in the apse of the church honouring their name in Rome (526-530) and in the apse of the Euphrasian basilica at Parenzo (Poreč, 6th century). The Deesis is one of the earliest representations of this subject.

As already mentioned, the dedicatory inscriptions of the Drosiani begin with phrases like: "for the salvation" or "for the blessing" or again "for the blessing and salvation". Such phrases are found at the beginning of Early Christian inscriptions (e.g. the inscrip-

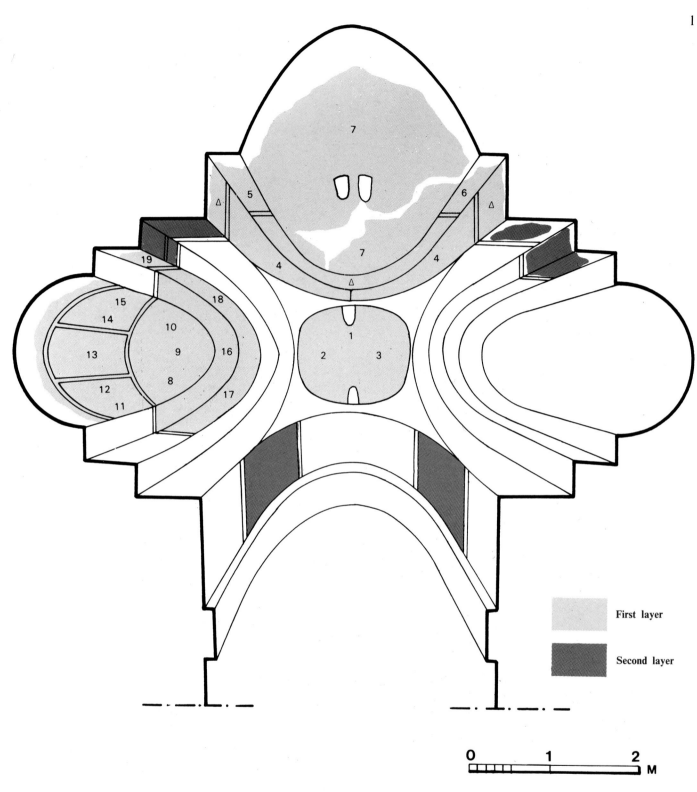

1. Panagia Drosiani. Perspective plan.

PANAGIA DROSIANI

1. Inscription. 2. Bust of Christ with adolescent beard. 3. Bust of Christ with long beard. 4. Full-length archangels. 5. Founder inscription. 6. Remains of inscription. 7. Ascension. 8. Bust of St. Damian. 9. The Virgin Nikopoios. 10. Bust of St. Cosmas. 11. King Solomon. 12-15. The Deesis (12. St. Mary. 13. Christ. 14. Female saint. 15. St. John the Baptist). 16. Remains of inscription. 17. Full-length saint. 18. Full-length female saint. 19. St. Julian (?). Δ. Decorative motifs.

First layer

Second layer

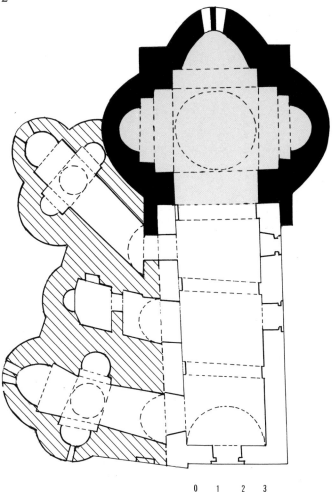

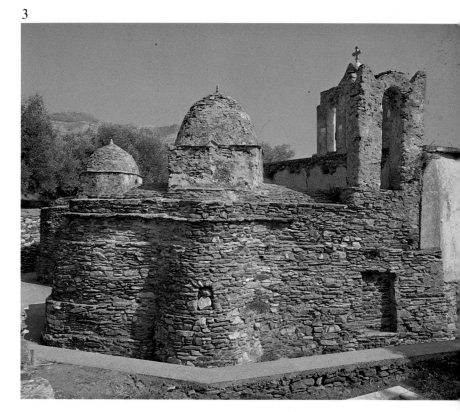

2. *Panagia Drosiani. Ground-plan of the original building and its extensions.*

3. *Panagia Drosiani, West parecclesion.*

tion on the Stuma Paten, 565-578). Similarly, the style of the lettering with the oblique terminations of the straight down-strokes is encountered in 6th century inscriptions. The dating of wall paintings, however, cannot be based exclusively on the style of the lettering.

Of the angels on the triumphal arch, the one painted on the southern section is better preserved. His attire is similar to that of the archangels at S. Apollinare in Classe, and his wings form a semicircular curve very close to his halo, like those of the angels in the apse of S. Vitale. The female saint in front of the north conch is dressed in a long white tunic with several broad folds rendered by dark-red lines, comparable with those in the painting of the donors of St. Demetrios at Thessaloniki (not much later than the mid-7th century). The density of the folds there suggests absolute immobility, whereas here the fewer folds denote movement. This may justify the dating of the Drosiani paintings to a slightly earlier date. From the saint's hand hangs what seems like a doctor's bag,

similar to that of St. Luke in the catacomb of Commodilla. Her cap calls to mind the hair-dressing of the marble head of the Empress Ariadne in the Louvre and of the so-called Theodora at the Castello Sforzesco in Florence.

The type of the Virgin Nikopoios, painted here with a beautiful oval face, is found on Imperial seals of the 6th and 7th centuries. According to this type, the Virgin holds with both hands a medallion containing the portrait of Christ. The eyes of the Virgin, of King Solomon, of St. Damian, and of Christ on the dome, are rendered in the same manner and resemble the eyes of the Saviour in the apse of S. Vitale. The painting of St. Cosmas, portrayed here with a furrowed cheek, displays a realism familiar from Roman portraits.

The Virgin of the Deesis is titled Hagia Maria, as was the practice in the years before the Iconoclasm. A light red spot spreads over the right cheek and, lower, an oblique line in darker red adds with effective simplicity and great intensity an expression of pain har-

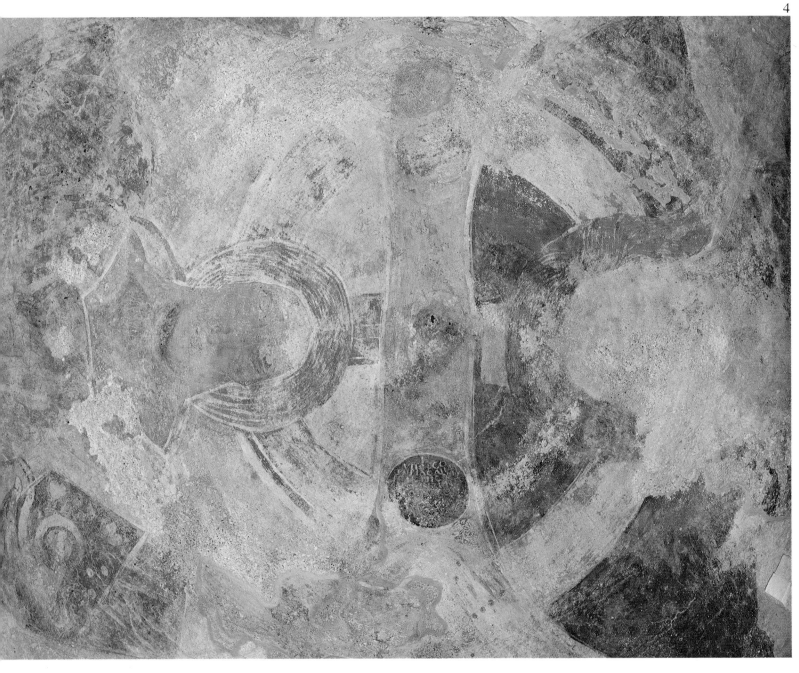

monizing it with the bitter lines of the mouth. The unidentified female saint with the rich garments in the Deesis wears an ornate mantle resembling that of the Empress Theodora and the ladies of her retinue in S. Vitale.

St. John the Prodrome is of dark complexion. His face, tanned by the scorching desert sun, is of a type between the broader face of St. Zacharias at Parenzo and the narrower face of Christ on the cross of the allegorical representation of the Transfiguration at S. Apollinare in Classe.

King Solomon is unusually depicted holding a cross. Apparently not participating in the Deesis, he is

4. Panagia Drosiani. Dome painting showing two busts of Christ.

5. Panagia Drosiani. Archangel on the triumphal arch.

6. Panagia Drosiani, sanctuary. Decorative motif.

7. Panagia Drosiani, sanctuary. An Apostle from the representation of the Ascension.

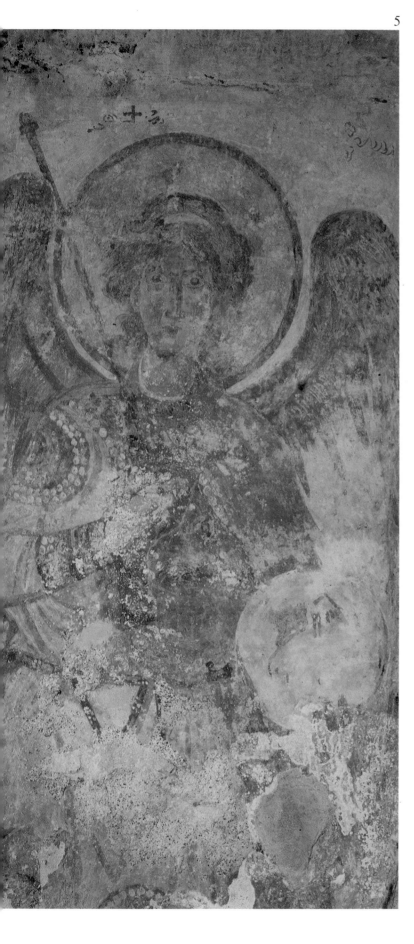

5

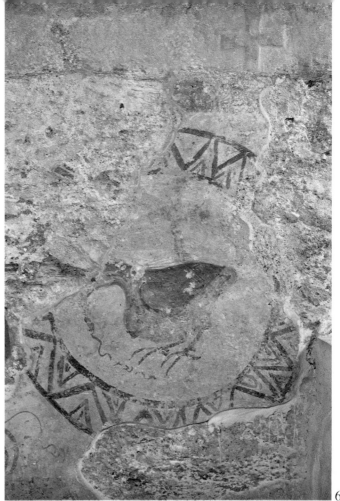

6

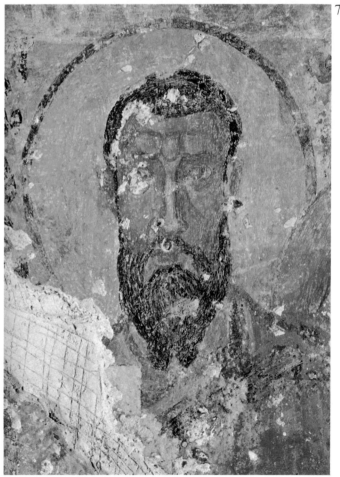

7

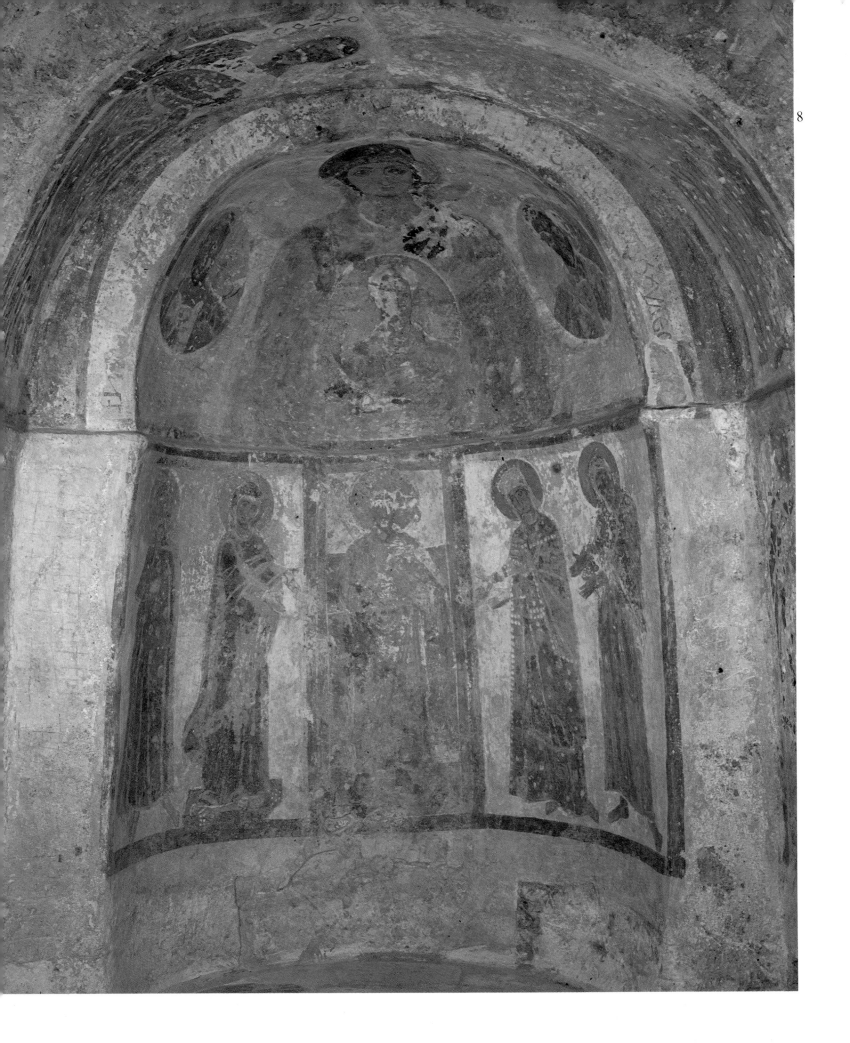

9

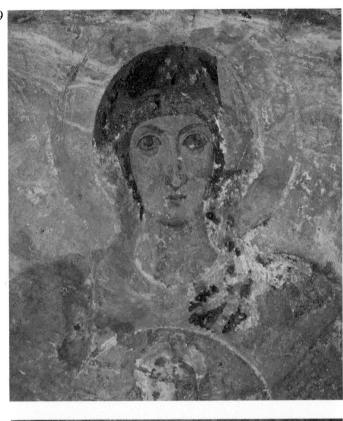

8. *Panagia Drosiani, N. conch. The Virgin Nikopoios with the Sts. Anargyroi (above) and the Deesis (below).*

9. *Panagia Drosiani, N. conch. The Virgin Nikopoios (detail of Fig. 8).*

10. *Panagia Drosiani. The Virgin (St. Mary) and King Solomon (detail of Fig. 8).*

11. *Panagia Drosiani. Female saint and St. John the Prodrome (detail of Fig. 8).*

12. *Panagia Drosiani, parecclesion, sanctuary conch. The Platytera (first layer).*

10

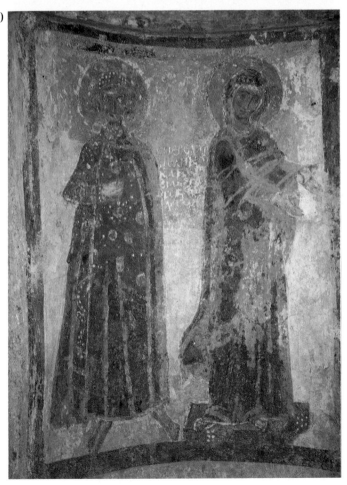

11

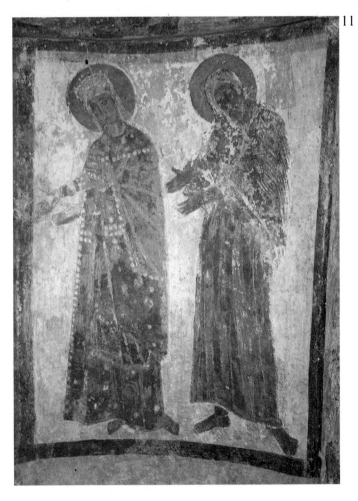

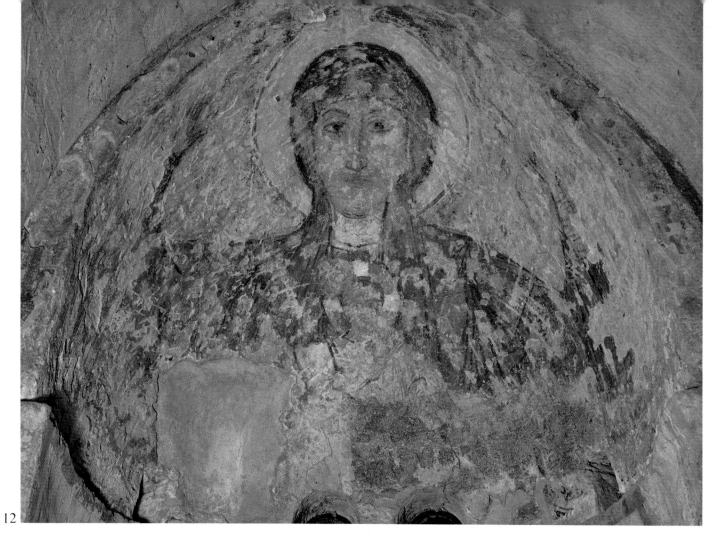

12

perhaps represented as an expounder of the Wisdom of the Father which is expressed by Christ. His attire is reminiscent of that of St. Theodore in the icon of the Virgin and Child at Sinai. His crown is surmounted by a cross like the crown worn by Tiberius (578-582) on the coins bearing his effigy.

The colouring of the faces in the wall paintings of the Drosiani calls to mind the wall painting of the Maccabees and of S. Solomone at S. Maria Antiqua in Rome (630-640).

Some portrayals, like that of the Virgin Nikopoios and of the ethereal angel on the triumphal arch, display a delicate idealized beauty. A number of holy figures are light-complexioned, whereas almost all male saints are painted with a dark reddish hue. The cheeks in some faces show a faint redness. On the contrary, in the harsh most powerful and realistic face of the lower left angel of the Ascension, the flaming red colour of the right cheek forms a sharp impressionistic contrast to the whitish tint of the skin.

The wall paintings of the first layer in the Drosiani present dissimilarities which may be attributed to the use of different models or to varied contemporary trends. A number of comparisons point to a dating in the late 6th and the first half of the 7th century. Furthermore, the depiction of single saints in the low-

er part of the walls of the church conforms with the development of icon worship from the second half of the 6th century onwards. The combination of hellenistic with abstract features in the painting style constitutes a dualism noticeable in the 7th century.

The faces in some of the Drosiani paintings are distinguished for their remarkable beauty. This provincial classicizing monument, which does not lack in realistic tendencies, most probably echoes the art of the Capital and provides valuable evidence on 7th century painting in Greece.

Nicos B. Drandakis

Bibliography

N.B. Drandakis, «Βυζαντινά καί μεσαιωνικά μνημεῖα Κυκλά-δων», ’Αρχαιολογικόν Δελτίον, Vol. 21 (1966), Β΄ 2: Χρονι-κά, p. 401-403.

Id., «Προεικονοκλαστικαί τοιχογραφίαι τῆς Νάξου», ’Αρχαιο-λογικά ’Ανάλεκτα ’Αθηνῶν, Vol. III(1970), p. 414-421.

Id., Οἱ παλαιοχριστιανικές τοιχογραφίες στή Δροσιανή τῆς Νά-ξου, Athens 1988.

PANAGIA DROSIANI

Supplementary note

When studied, the successive layers that had covered the original Ascension depicted in the sanctuary apse of the church of Panagia Drosiani and the overpainted crosses, as well as the wall paintings in the other conchs, will contribute to the verification of a series of phases in the art of painting at Naxos. For example, we note that in the sanctuary apse all subsequent layers represent the Deesis. The older layer, which is badly preserved, is of rather poor artistry. The next layer is of higher artistic quality with a noble Forerunner (Fig. 15, 16) of the 12th century. Another layer, by the painter Georgios, of the late 13th century shows well designed linear figures without depth (Fig. 13). To this painter are also attributed the saints in the parecclesion (Fig. 20) and perhaps some of the figures in the church of the Damiotissa (Intr. Fig. 8). The large composition of the Dormition of the Virgin — now detached from the wall of the sanctuary apse — with echoes of the voluminous style of the late 13th century may be associated with the paintings in the apse of St. George at Lathrinos (Fig. 21, 22 and Intr. Fig. 5). On the walls of the sanctuary and on the arches partial overpainting is sporadic. In the N. conch of the triconchial church, a 13th century angel covered the unidentified female saint of the Early Christian Deesis with King Solomon (Fig. 19). Again, some 13th century figures — now removed from the wall — had been preserved in a layer painted in a more popular style with full-length female saints of a certain facial type with a lively expression (Fig. 17. 18).

M.Ch.

13. Panagia Drosiani, sanctuary apse. The Virgin from the Deesis painted by George the sinner (detached).

14. Panagia Drosiani, sanctuary apse. The Virgin from the Deesis (detached).

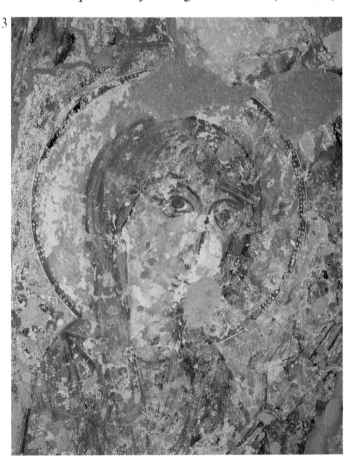

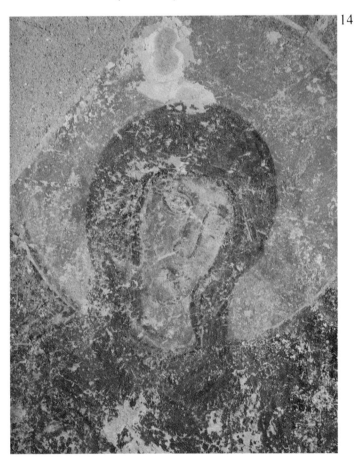

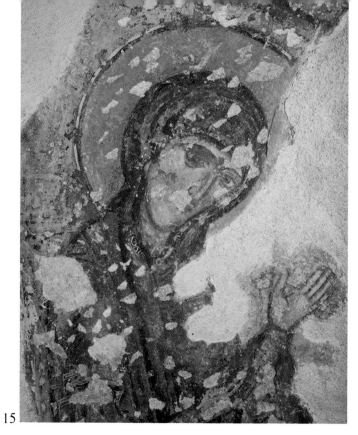

15

16

15. *Panagia Drosiani, sanctuary apse. The Virgin (detached).*

16. *Panagia Drosiani, sanctuary apse. St. John the Prodrome (detached).*

17. *Panagia Drosiani, sanctuary. Female saint (detached).*

18. *Panagia Drosiani, sanctuary, S. side. St. Irene (detached).*

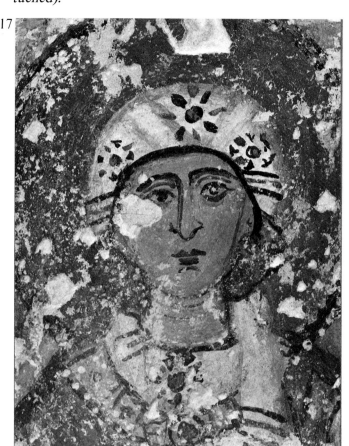

17

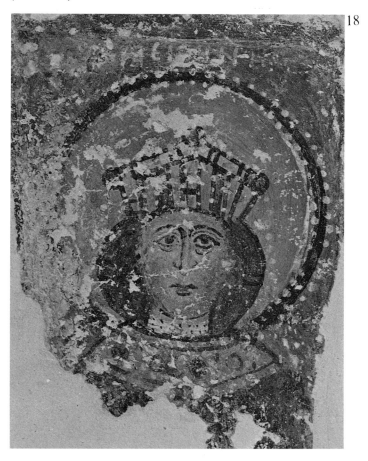

18

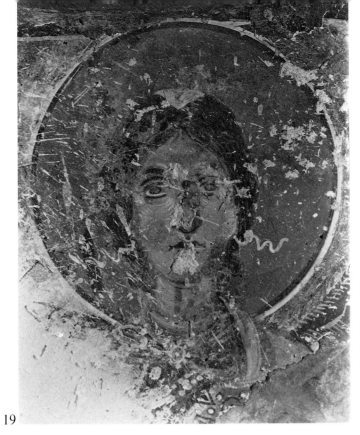

19

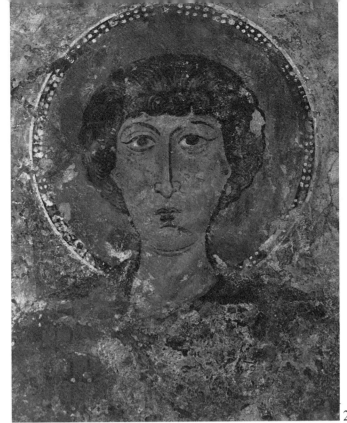

20

19. *Panagia Drosiani, N. conch. Angel (second layer, detached).*

20. *Panagia Drosiani, parecclesion, sanctuary. Military saint.*

21. *Panagia Drosiani, sanctuary apse. Hierarch (detached).*

22. *Panagia Drosiani, sanctuary apse. Apostle from the scene of the Dormition of the Virgin (detached).*

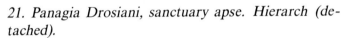

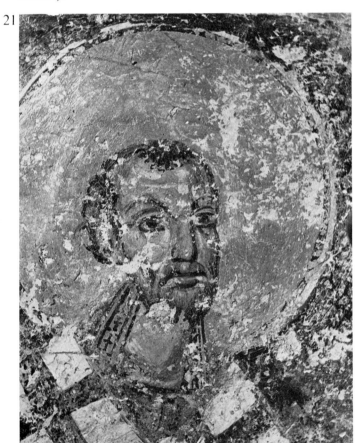

21

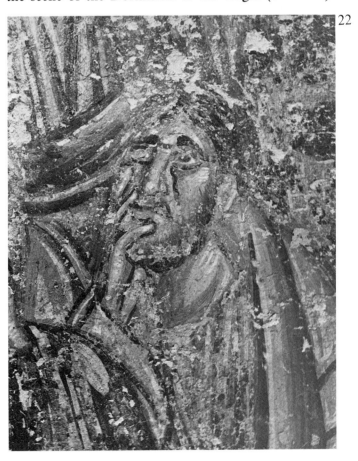

22

PANAGIA PROTOTHRONE AT CHALKI

The Protothrone (Fig. 4), the large parochial church honouring the Annunciation, dominates the village of Chalki, near the main road of the island in the district of Tragaia, in central Naxos.

The surviving Middle Byzantine inscriptions provide important information and Patriarchal sigils mention "the church of the Protothronos". Nevertheless, the history of the monument has gaps, either because the inscriptions are no longer in their original position or because they have not been fully read and interpreted as yet.

The most important inscription (Fig. 5), incised on a marble *kosmetes* (of the templon?) with relief knobs and looped circles, is now incorporated in the façade, at the base of the large triple-arched belfry of later date. Except for one or two words that are still undeciphered, the inscription reads as follows in the sequence in which it has been incorporated in the wall:

ΛΕΟΝΤΑ ΘΕΟΦΗΛΕΣΤΑΤΟΝ ΕΠΙΣΚΟΠΟΝ ΚΕ
ΝΙΚΗΤ(ΑΝ) ΠΡΩΤΟΣΠΑΘΑΡΗΟΝ ΚΕ ΤΟΥΡΜΑΡ-
ΧΗΝ
ΝΑΞΗΑΣ ΚΕ ΣΤΕΦΑΝΟΝ Κ[Ο]Μ[ΗΤΑ] Τ[ΟΝ] ΚΑ-
ΜΗΛΑΡΗΝ ΚΕ
ΤΟΥΣ ΕΝ ΠΙΣΤΗ ΕΝ ΦΟΒΟ ΗΣΗΟ[Ν]ΤΑΣ Α[ΓΗΑ]ΣΟ
Ν ΑΥ ΤΟΙΣ R ΤΟΣ ΜΥΡΝΕΟΝ ΙΝΔ Ẽ´ ΕΤΟΥΣ ϛφξ̃´
Θ(ΕΟΤΟ)ΚΕ ΔΕΣΠΥΝΑ ΚΕ ΜΗ(ΤΗ)Ρ ΤΟΥ ΚΥ(ΡΙΟΥ)
ΣΚΕΠΕ ΦΡΟΥΡΗ ΦΥΛΑΤ[Ε] ΤΟΥ (Σ) ΣΟΥ(Σ) ΟΙ
ΚΕΤΑΣ ΤΟΥΣ ΑΝΑΚΕΝΗΣΑ[Ν]Τ(ΑΣ) Τ(ΟΝ) ΕΝΔΟ-
ΞΟΝ ΝΑΟ(Ν) ΣΟΥ

When rearranged in the proper sequence it reads:

Θεοτόκε Δέσποινα καί Μήτηρ τοῦ Κυρίου
σκέπε, φρούρει, φύλαττε τούς σούς
[οἰ]κέτας τούς ἀνακαινίσαντας τόν ἔνδοξον ναόν σου
Λέοντα θεοφιλέστατον ἐπίσκοπον καί
Νικήταν Πρωτοσπαθάριον καί Τουρμάρχην
Ναξίας καί Στέφανον κόμητα τόν Καμηλάρην καί
τούς ἐν πίστει ἐν φόβω εἰσιόντας ἁγίασον
αὐτοῖς[....]ινδικτιῶνος Ẽ´ ἔτους ϛφξ̃´

"Mother of God, our Lady and Mother of our Lord, protect, guard and save your suppliants who have renovated your glorious church, the Most Reverend Bishop Leo and the Protospatharios and Tourmarches of Naxia Nicetas and the Count and Kamelares Stephanos and those coming in faith and fear, bless them... 1052".

According to this inscription, therefore, the church was extensively renovated in A.D. 1052.

Four years later, in A.D. 1056, an unusually large painted funerary inscription (Plan no. 23) in the NW parecclesion of St. Akindynos records:

ΕΚΟΙΜΗΘΗ Η ΔΟΥΛΗ ΤΟΥ ΘΕΟΥ ΑΝΑ
Μ(ηνός) Μαρτίου ΣΤΑΣ Η´ ΙΝΔ(ικτιῶνος) Θ´ΕΤΟΥΣ
ϛΦΞΔ´

"The servant of God Anna departed on the 8th day of the month of March of the year 1056".

A marble lintel, built into the wall above the door of the west side, shows another inscription. This, too, is datable to Byzantine times and it records, though without giving a date, that:

†ΕΚΤΗCΘΟΙΣΑΝ ΕΚΚΛΗΣΙΕ ΤΟΥΤΕ ΣΥΝ ΤΟΥ ΠΡΟ-
ΠΥΛΗΟΥ
ΚΕ ΤΩΝ ΔΙΑΣΤΥΛΟΝ ΤΗΣ ΥΠΕΡΑΓΙΑΣ ΘΕ(ΟΤΟ)ΚΟΥ

"These churches with the propylon and the diastylon were built for the Most Holy Mother of God".

Other inscriptions refer to later-date repairs and modifications. For example, on the lintel of the marble door-frame of the north cross-arm we read:

16 Ιω — ΣΠΑΝΟΣ 34

and on the doorjambs, in reversed order the same date and the name *CΠΑ/NOC*.

Again, on the west side, below the Byzantine inscription, a marble plaque with a cross shows the date 1713.

The Patriarchal sigils of the 16th century (1568, 1580) which refer to the "church of the Protothronos" include "the small parecclesia of St. George and St. Akindynos", no longer extant, at least as separate buildings. In one of the sigils, the Acrosticharios Nicetas Spanos is mentioned as founder. As already noted, the name Spanos occurs also in the inscription of the north doorway.

With respect to the dating of the building various views have been advanced, some before and some after the uncovering of the dated inscriptions.

N. Kalogeropoulos suggested the 12th-13th century, G. Demetrokallis the first millennium (end of 9th - 10th century). M. Chatzidakis assigned the painting of the dome at first to the 9th century and then to the 10th/11th century. This dating is accepted by M. Panayotidou who proposes, particularly for the painting of the dome, the date of A.D. 1000. In terms of architecture P. Vokotopoulos classifies the Protothrone among the earliest churches of the transitional type, dating it in the first half of the 9th century. The same, if not an even earlier date (late 8th century) is accepted by D. Pallas.

On the basis of written sources and, especially, on the evidence supplied by the architectural parts from various periods, of which the building is now composed, the history of the monument can be outlined as follows:

a) **Early Christian period.** Originally the church must have been a basilica. Surviving parts of this building include: the apse of the holy bema with the synthronon, the outer walls of the parabemata-pastophoria, and the two eastern piers in front of the sanctuary that are now built into the partition walls of the sanctuary. Sections of the original masonry are recognizable from the preserved paintings and from the seams formed by the different coatings. Quite probably, extensive parts of the lateral walls of the church belong to this Early Christian phase.

b) **Middle Byzantine period.** According to the inscription, the church was extensively renovated in A.D. 1052. The architectural plan of the transitional type does not conform with this chronology. Since, however, no evidence exists (at least as yet) on the interim phase — possibly in the 9th century — that would follow the architectural plan of the transitional type, we accept that the modification took place when an attempt was made to convert the already existing longitudinal building into a domed church, thus transforming it, literally, into a church of the "transitional" type. In this phase the arms of the cross had a barrel-vault roof (as it has been discovered after the removal of later-date modifications).

c) **Post-Byzantine period.** Various minor alterations were carried out in this period. For instance, in 1643, when at the north cross arm a door was opened and also a window that destroyed the wall paintings. Quite probably, the door of the south cross arm was also opened at that time.

The west side with the Cycladic belfry appears to have been constructed in 1713. Probably the west dome was also built at that time and the *kosmetes* carved with the founder inscription bearing the date 1052 was then incorporated in the façade of the building.

During the post-Byzantine phase, at an indeterminable date, the barrel-vault roofs of the arms of the cross plan were converted into flat ones. In 1920-30, following a windstorm, the flat roofs were repaired and covered with a thin layer of concrete. In 1952-53, after a thunderbolt had struck down the 18th century belfry, the present-day triple-arched belfry was built above the façade of the later-date domed narthex.

Architecture

In its present form the church is of the transitional inscribed-cross type with dome, strikingly reminiscent of a basilica with its longitudinal plan, four-stepped semicircular synthronon, projecting semicircular apse at the centre of the east side, parabemata in the form of pastophoria, and corner bays forming parecclesia on the west side (Fig. 3).

Some repairs made by the local inhabitants most probably destroyed a number of the wall paintings, but have preserved the church in fairly good condition. In the last fifteen years the Archaeological Service has carried out various investigation and consolidation works in the NW parecclesion, the vaults of the church and, principally, the wall paintings.

Wall paintings

The large size of the church and the few windows it had — initially — made available many surfaces suitable for a painted decoration. Conservation works on the wall paintings included operations of consolidation, cleaning and detachment from the walls. The entire painted surface of the dome was removed without being cut. This exposed the earlier painting layer which was also detached. The later layer was consolidated and replaced on the dome, while the older layer was given a shape similar to the one it originally had, with the view to exhibit it in a museum. Two layers of wall paintings were detached from the curved walls of the sanctuary apse, revealing the third and oldest layer of paintings. Other paintings were uncovered on the south wall of the sanctuary, the vault of the south cross arm and very few traces on the other cross arms. These important operations were executed by the

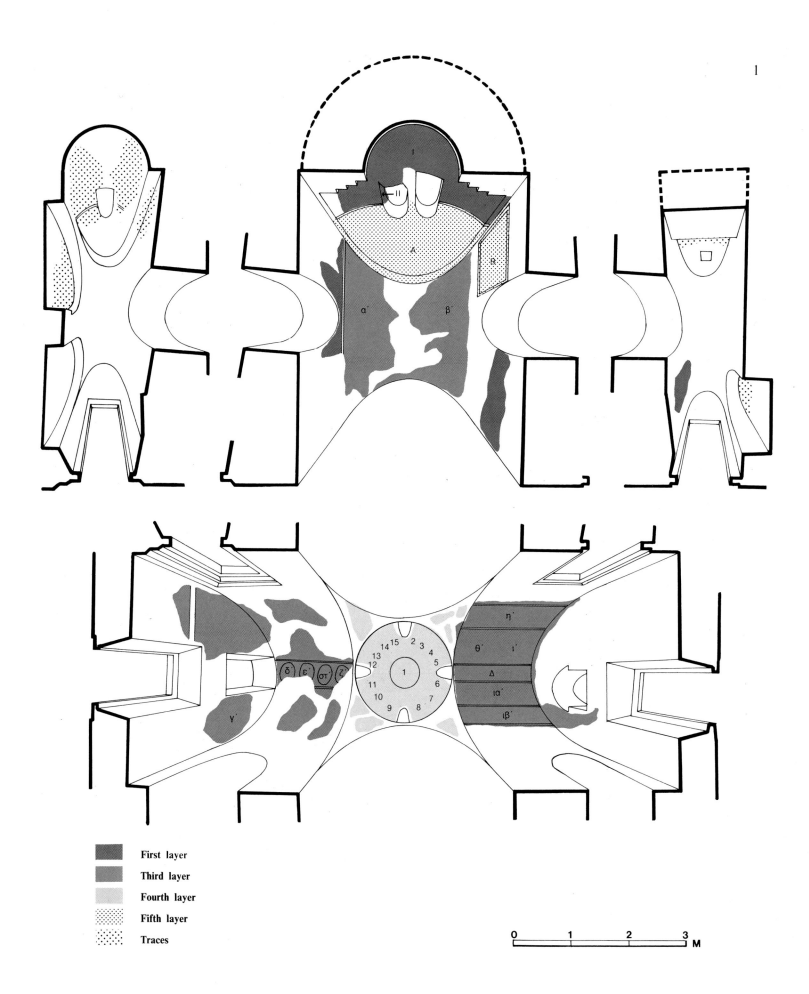

First layer

Third layer

Fourth layer

Fifth layer

Traces

0 1 2 3
|___|___|___|___| M

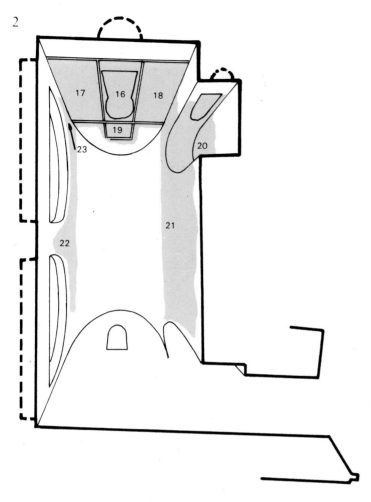

2

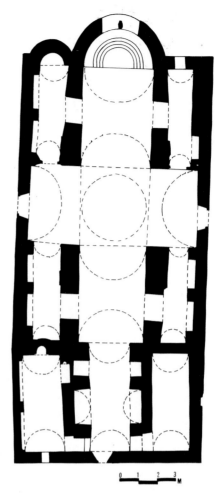

3

PROTOTHRONE

First layer. I. *Apostles* **II.** *St. Isidoros.* **Third layer. α.** *The Descent into Hell (traces).* **β.** *Peter's Denial (traces).* **γ.** *The Dormition of the Virgin (traces).* **δ.** *Prophet (traces).* **ε.** *Prophet (traces).* **στ.** *Hierarch (traces).* **ζ.** *Prophet (traces).* **η.** *The Calling of the Disciples.* **θ.** *The Annunciation.* **ι.** *The Visitation.* **ια.** *The Presentation of Christ in the Temple.* **ιβ.** *The Forty Martyrs.* **Dome. ιγ.** *Christ Pantocrator.* **ιδ.** *Prophet.* **ιε.** *Archangel.* **ιστ.** *Prophet.* **ιζ.** *Cherub.* **ιη.** *Prophet.* **ιθ.** *Archangel.* **κ.** *Prophet.* **κα.** *Cherub.* **κβ.** *Prophet.* **κγ.** *Archangel.* **κδ.** *Prophet Elijah.* **κε.** *Seraph.* **κστ.** *Prophet.* **κζ.** *Archangel.* **κη.** *Prophet Daniel.* **κθ.** *Cherub.* **Fourth Layer. Dome. 1.** *Christ Pantocrator.* **2.** *St. Demetrios.* **3.** *St. Theodore.* **4.** *Archangel Uriel.* **5.** *Prophet Jeremiah.* **6.** *Prophet Habakkuk.* **7.** *Archangel Gabriel.* **8.** *Prophet David.* **9.** *Prophet Zephaniah.* **10.** *Archangel Michael.* **11.** *Prophet Elijah.* **12.** *Prophet Daniel.* **13.** *Archangel Raphael.* **14.** *St. George.* **15.** *St. Nicholas.* **Parecclesion. 16.** *St. Akindynos.* **17.** *St. Philip.* **18.** *St. George.* **19.** *St. Irene.* **20.** *The Virgin.* **21.** *Graffiti.* **22.** *Saint (traces).* **23.** *Inscription.* **Fifth layer. A.** *Deesis.* **B.** *Annunciation.* **Δ.** *Decorative motif.*

4

1. *Protothrone. Perspective plan.*

2. *Protothrone. Perspective plan of the NW pareccle-sion.*

3. *Protothrone. Ground-plan.*

4. *Protothrone. West view.*

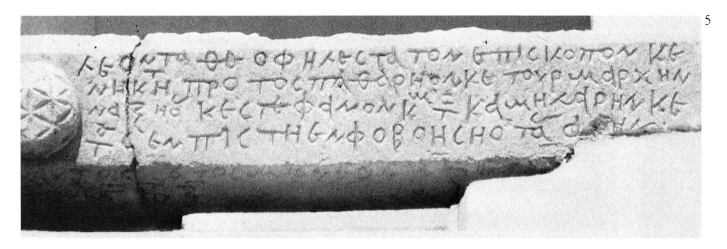

Ephorate of Byzantine Antiquities of the Islands. Mr. S. Baltoyannis was in charge of the conservation works.

The present-day iconography of the church is composed of painted parts from various periods. As a result the iconographic programme seen today has no unity, a fact largely due to the intervention of the Archaeological Service, which removed or left *in situ* paintings of different dates.

The successive phases, or layers, of painting in the Protothrone are as follows:

First layer, Early Christian period: Apostles in the holy bema and St. Isidoros. Remnants of representations on the north and south wall of the sanctuary and on the southeast pier.

Second layer, Middle Byzantine period: arcade with crosses in the holy bema. 9th century.

Third layer, Middle Byzantine period: first layer of the dome painting, wall paintings on the vaults (Annunciation, Visitation, Presentation of Christ in the Temple etc.). 11th century (1052).

Fourth layer, Middle Byzantine period: second layer of the dome painting, wall paintings in the NW parecclesion (after 1052). Late 11th century.

Fifth layer, Palaeologan period: Deesis on the half-dome of the sanctuary apse, Annunciation on the south wall of the sanctuary, Hierarchs in the holy bema. 13th century.

The iconography and its problems

Holy bema. The half-dome of the conch is painted with the composition of the Deesis (fifth layer, Fig. 6, Plan no. A), and the curved wall of the sanctuary shows a representation of the Apostles standing full-length (height approximately 1.90 m.) (first layer, Fig. 7, Plan no. I). An excellently preserved half-length portrait of St. Isidoros (first layer, Fig. 8, Plan No.

II) was discovered in the conch, on the north jamb of the window. The pier incorporated in the sanctuary wall has retained in poor condition the image of a standing deacon whose head has been destroyed by the cornice of later date. The north wall of the prothesis shows indistinct representations. On the other hand, the lower part of the south wall of the sanctuary has preserved in good condition a fine representation of the Annunciation (measuring 1.70×1.70 m.) (fifth layer, Fig. 25, Plan no. B).

Naos. The painting on the dome (fourth layer, Fig. 11) shows a central medallion with the portrait of Christ Pantocrator holding a closed Book of Gospels adorned with precious stones (Fig. 13, Plan no. 1). The remaining surface of the dome is filled with fourteen figures of prophets, archangels and saints in a circular arrangement: on the east side (Fig. 12) the Saints George (Plan no. 14), Nicholas (Plan no. 15), Demetrios (Plan. no. 2) and Theodore (Plan no. 3), then the Archangel Uriel (Plan no. 4) the Prophet Jeremiah (Plan no. 5), the Prophet Habakkuk (Plan no. 6), the Archangel Gabriel (Plan no. 7), the Prophet David (Plan no. 8), the Prophet Zephaniah (Plan no. 9), the Archangel Michael (Plan no. 10), the Prophet Elijah (Plan no. Il), the Prophet Daniel (Plan no. 12), and the cycle closes with the Archangel Raphael (Plan no. 13) dressed in imperial costume.

The best preserved of the large compositions on the vaults of the cross arms are those of the south arm (third layer). The paintings on the east side include the Annunciation (Fig. 14, Plan no. θ) and the Embracing of the Virgin and Elizabeth (Fig. 14, Plan no. ι), the two scenes being separated by the representation of a four-storeyed circular edifice. The west side shows the Presentation of Christ in the Temple (Fig. 15, Plan no. ια). The other vaults have not preserved their painted decoration, with the exception of a few fragments like

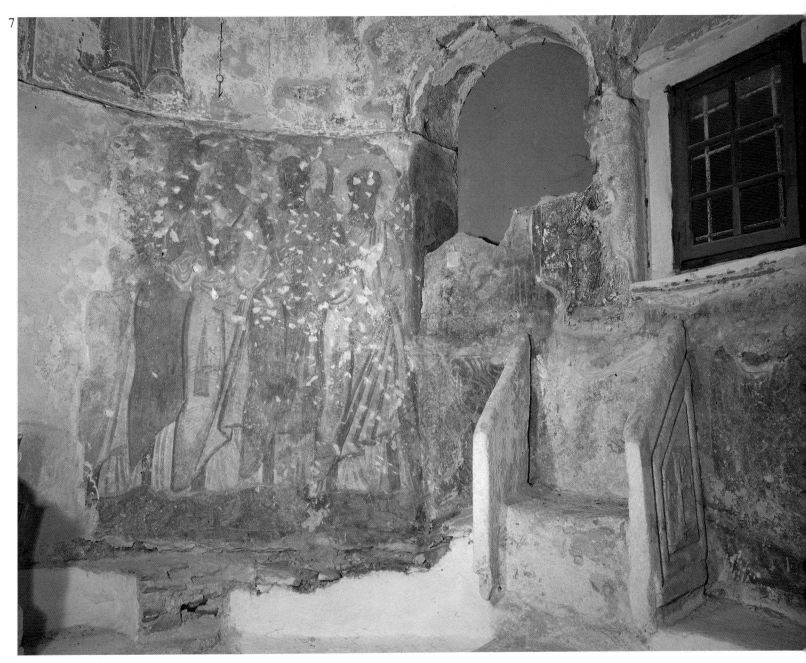

5. Protothrone. Inscription incorporated in the wall of the façade at the base of the belfry of later date.

6. Protothrone, holy bema, half-dome of the conch. The Deesis (13th century).

7. Protothrone, conch of the holy bema. Apostles (6th-7th century).

those from the Dormition of the Virgin on the north tympanum (Plan no. γ), and very few traces on the east vault of the sanctuary suggesting that the paintings represented the Descent into Hell (Plan no. α) and Peter's Denial (Plan no. β). Probably the other vaults had been storied with scenes from the cycle of the Twelve Feasts and some other secondary representations. From a band painted with medallions of saints along the key of the north vault, the figure of an hierarch is barely visible (Plan no. στ). The flat surface of the walls below the vaults must have been

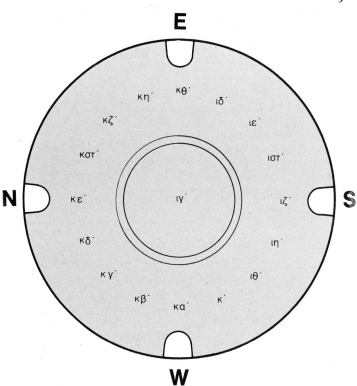

8. Protothrone, holy bema. St. Isidoros.

9. Protothrone, dome painting (earlier layer).

10. Protothrone, dome painting (later layer) (cf. Fig. 1 and Fig. 11).

11. Protothrone, dome painting of the later layer (second half of 11th century).

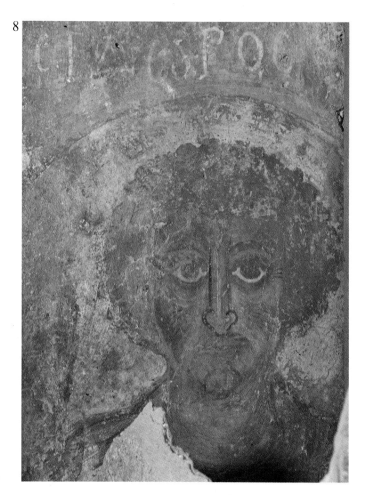

painted also. A representation of the Forty Martyrs (Plan no. ιβ) can be seen on the south cross arm, while the other scene cannot be identified. Remnants of painted decoration are found on the intrados (width 1.08 m.) of the southwest arch connecting the nave with the south aisle, where the Baptism and possibly the Transfiguration are visible.

The wall paintings of the NW parecclesion are fairly well preserved, particularly those on the east wall (Fig. 17). The small niche is painted with the half-length portrait of St. Akindynos (fourth layer, Fig. 19, Plan no. 16) to whom the chapel was most probably dedicated. The Saints Philip (Fig. 18, Plan no. 17) and George (Fig. 20, Plan no. 18) stand full-length on either side of the niche, while St. Irene (Plan no. 19) is depicted half-length above the niche. In the south wall on the tympanum of the arch of an arcosolium, a female figure (the Virgin?) (Fig. no. 20) in an attitude of prayer, turned three-quarters to the east, is barely visible.

The present-day iconography of the church is composed of paintings from different phases, extending over long periods. The iconographic programme therefore is rather idiomorphic.

Holy bema. The depiction of the Apostles (first layer) on the curved wall of the sanctuary apse is en-

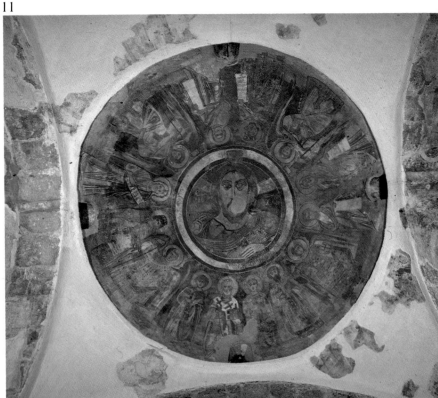

countered mainly in churches of the Early Christian period, as for instance in the small churches of Bawit in Egypt (5th and 6th century), which show the Apostles painted in array in a disposition similar to that in the Protothrone. A corresponding iconography is found in the nearby cave church of the Kaloritsa, not far from the Protothrone.

The portrayal of St. Isidoros (Plan no. II) on the window jamb in the sanctuary is not in accordance with the customary iconography. Apparently it depicts the martyr saint Isidoros of Chios rather than St. Isidoros Pelousiotis who would have been represented as "an old man with a pointed beard". If so, however, the head of Isidoros does not conform to the description of the *Hermeneia,* which specifies that this martyr should be represented as "young with an adolescent beard" but "resembling St. Artemios", i.e. in the facial type of Christ. In the Protothrone St. Isidoros (Fig. 8) is young, beardless, with curly almost red hair, which together with the dark complexion give the face African-like features. This rendering is perhaps a reminder of the martyr's Egyptian origin mentioned more than ˙once in the ecclesiastical hymns commemorating his martyrdom: "scion of Egypt", "the defender from Egypt", "breed of Alexandria, pride of Egypt".

The depiction of the Deesis on the half-dome of the sanctuary apse, though not the rule for Middle Byzantine iconography, is found in churches of Cappadocia, Trebizond, Georgia, Asia Minor, as well as in Crete, Rhodes, Mani, and Naxos. The composition is of an eschatological character and is related to Early Christian conceptions of a similar nature. The wall painting of the Annunciation on the south wall of the sanctuary is a divergence from the usual iconographic programme. The painting of an arcade with large crosses — now removed from the curved wall of the apse — has analogies in monuments and other works of art dating from the Iconoclast period.

Naos. Both layers of the dome paintings are of particular interest. The presence of the four saints in the second layer, that of a later date, is the most characteristic peculiarity. The painting of saints on the dome is not frequent in Middle Byzantine art though some exceptions are known, as for example in the church of St. Sozon at Geraki. During the Early Christian period, however, it was a favourite subject. One splendid example is the monumental composition decorating the dome of the Rotunda in Thessaloniki. Early Christian recollections are perhaps the basis for this iconography.

The origin of the whole composition painted on the dome is again the vision of Isaiah, with the Pantocrator surrounded by the powers of heaven. The dome

12. *Protothrone, dome painting. The Archangel Raphael, the Saints George, Nicholas, Demetrios and Theodore, the Archangel Uriel (detail of Fig. 11).*

13. *Protothrone, dome painting. Christ Pantocrator (detail of Fig. 11).*

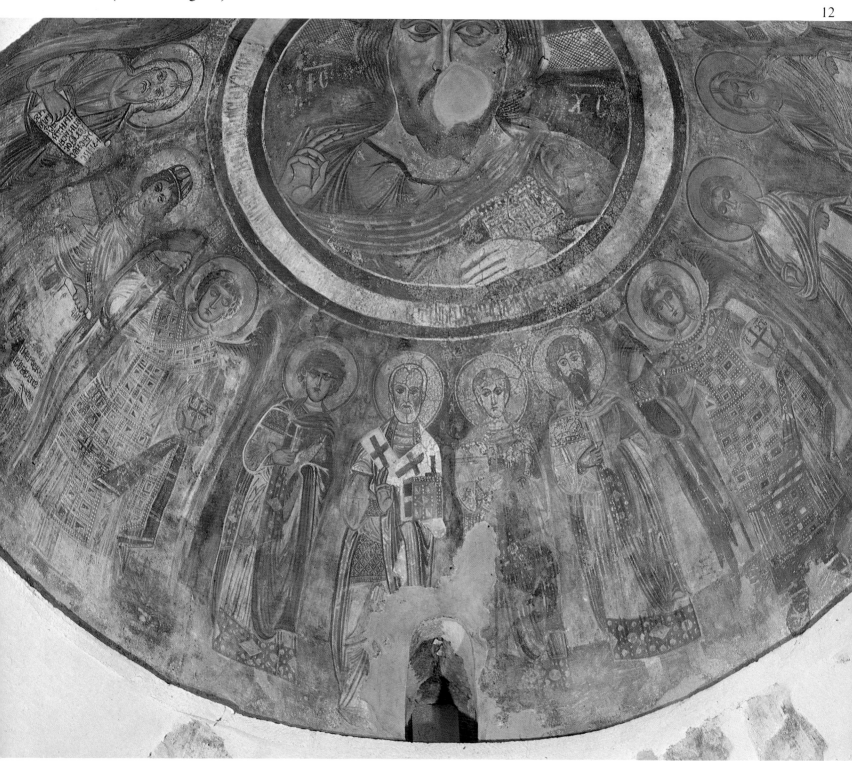

13

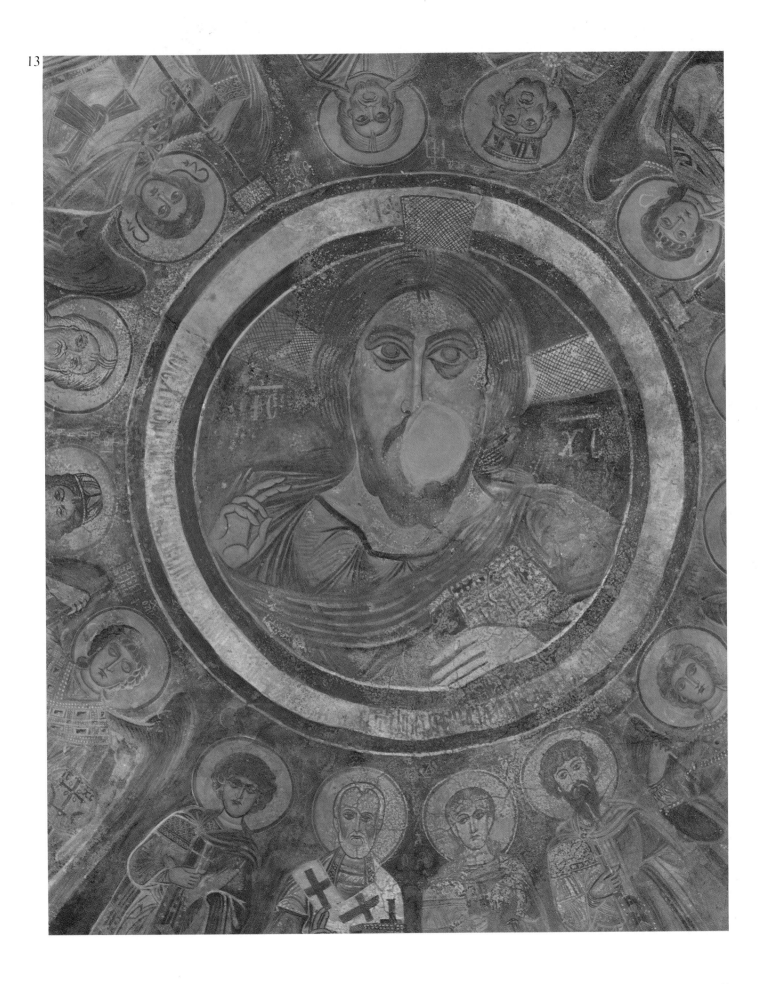

14

15

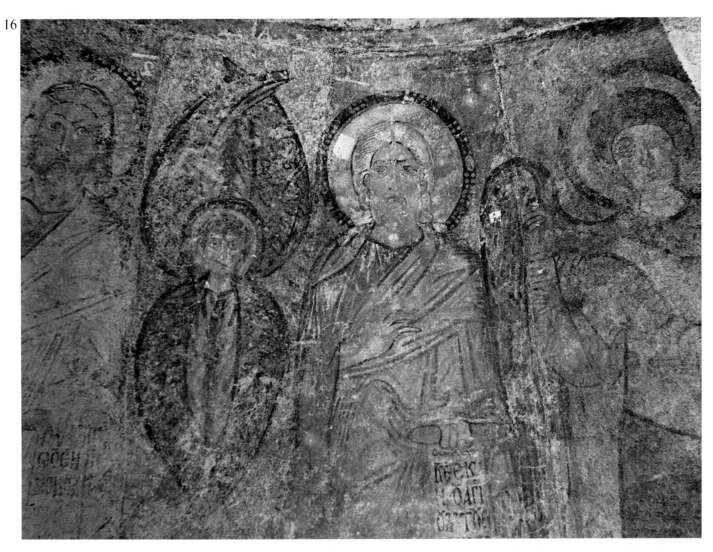

14. *Protothrone, E. half of the S. cross-arm vault. The Annunciation and the Visitation.*

15. *Protothrone, W. half of the S. cross-arm vault.*

The Presentation of Christ in the Temple.

16. *Protothrone, dome painting of the earlier layer (detached).*

painting of the Protothrone can be interpreted perhaps as a synoptic representation of the Old Testament (prophets) and the New Testament (saints), centred round the image of Christ. Anyhow, the reason for the choice of the particular saints included in the painting remains unknown and can only be conjectured. In an island church St. Nicholas would certainly find a place. The feast days of St. Demetrios and St. George mark the two seasons of agricultural occupations, as they are celebrated at the beginning of autumn and of spring, respectively. Beyond that, we cannot exclude the possibility that the selection was made by some of the donors or renovators of the church, with the intention to honour and worship these particular saints.

The iconographic programme of the vaults seems to have followed more closely the established pattern, in spite of the fact that the composition of the Visitation is of exceptionally large scale and that the scene of the Dormition of the Virgin is given an unusual place on the north tympanum. Such divergences may find an explanation in the fact that the church was dedicated to the Holy Virgin.

Style and chronology

First layer. On the curved wall of the sanctuary apse the Apostles (Fig. 7), tall and imposing, stand overlapping one another. They are painted with broad brush strokes, and the voluminous forms of their bodies are accented by the structural arrangement in the

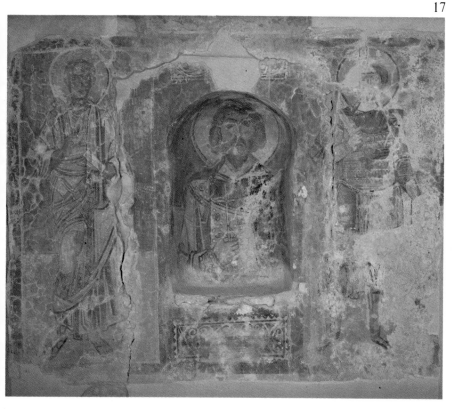

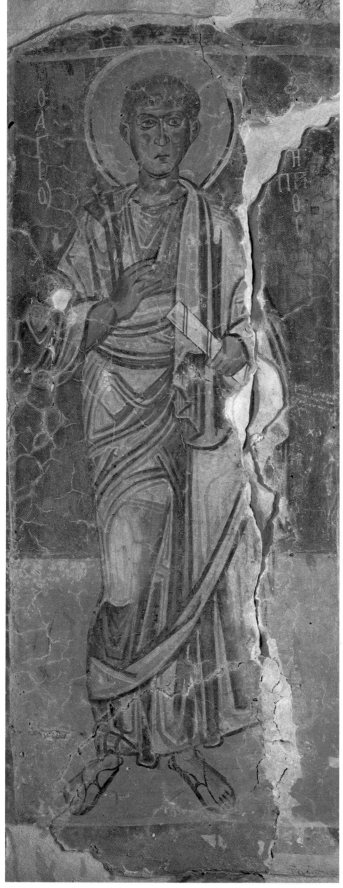

rich folds of their ancient raiment. The neatly drawn heads with the short hair and beard heighten the robustness of the figures. The contour of the heads, the posture of the bodies, the drapery, call to mind late Roman and — even more so — Early Christian representations like those at Ravenna or in St. Demetrios at Thessaloniki. The poor preservation of the faces and their very dark colouring (possibly due to chemical reactions) do not permit detailed observation. Anyhow, on the basis of the above general characteristics, a dating to the 6th-7th century is possible. The same date is assignable to the portrait of St. Isidoros (Fig. 8) with the thick curly hair and the big expressive eyes. This early dating is supported by the style of the lettering in the inscriptions accompanying the painting.

Second layer. The immediately next in date layer — now detached — shows large crosses with slender arms having triangular ends, painted under an elegant well designed arcade, as well as birds and fish that have not survived in good condition — a particularly well executed work for this type of representation.

Although comparative material is scant, this wall painting could be assigned to the 9th century on the basis of the subject and in association with the aniconic trends of that age. This dating is further supported

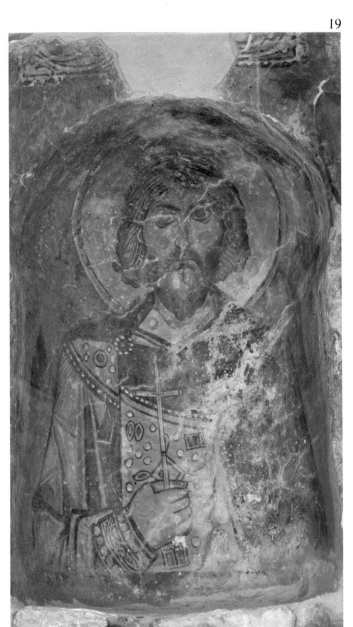

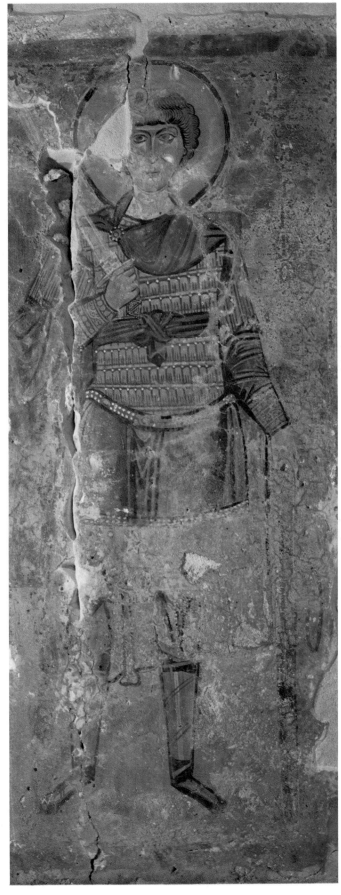

17. Protothrone, NW parecclesion. The Saints Philip, Akindynos and George (later 11th - early 12th century).

18. Protothrone, NW parecclesion. St. Philip (detail of Fig. 17).

19. Protothrone, NW parecclesion. St. Akindynos (detail of Fig. 17).

20. Protothrone, NW parecclesion. St. George (detail of Fig. 17).

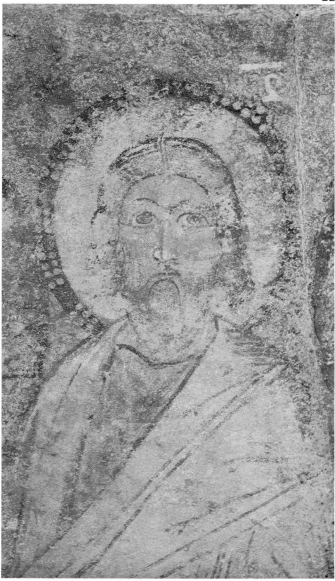

21, 22, 23. Protothrone, dome painting of the earlier layer. Prophets (detached).

24. Protothrone, dome painting of the earlier layer. The Prophet Daniel (detached).

by the sequence of this layer in the successive phases of the painted decoration.

Third layer. The older layer of the dome paintings — now housed outside the church — is characterized by a bold and lively style. The composition is well balanced with the large cherubim (Plan no. ιζ, κα, κθ) and seraphim (Plan no. κε), above the small windows, marking the four cardinal points. Between them, two prophets flank a majestic archangel. In the centre, the imposing Pantocrator (Plan no. ιγ) has not survived in good condition except for the halo, which is adorned with precious stones, and some remains of colouring suggestive of a modelling through the use of many hues combining olive green and pale pink shades. The same delicate tones are used in modelling the heads of the prophets. Aged faces are framed by thick white

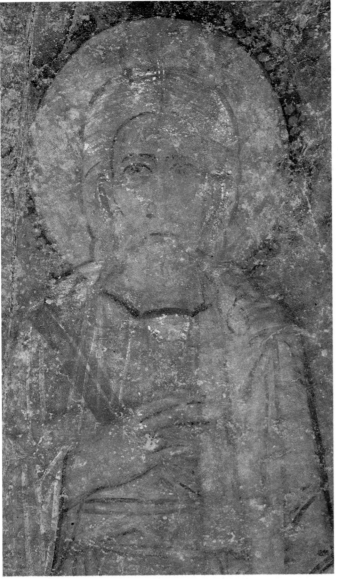

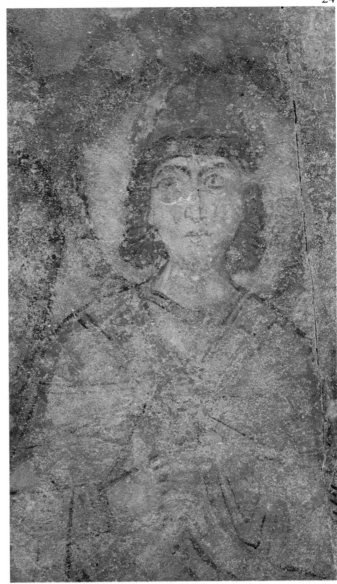

hair (Fig. 21, 22, 23) with the strands rendered in crude red. The face of younger prophets, like that of Daniel (Fig. 24, Plan no. κη), is again modelled in the same olive green tints softened with ochre, while facial features are traced with crude red. The prophets are dressed in the Greek fashion, but the folds, wide and soft, do not always follow a structural arrangement. Stress is laid on the monumental and imposing rather than the naturalistic effect.

The archangels wear either broad imperial *loroi* with large ornaments or a green tunic and mantle. They hold fans and glass globes and their wings are exceptionally large. The cherubim with the four large wings have almost illusional faces painted in pale pink hues.

The representations decorating the vaults of the

cross arms belong to the same layer. Those of the south arm are in a better state of preservation. Further proof for the identification of the layer is provided by the similarity between the decorative subject encircling the Pantocrator on the dome and that composing the ornamental band along the key of the south vault, which divides it into two halves. On the east side are depicted the scenes of the Annunciation and the Visitation in an almost unified composition, separated only by the representation of a tall circular building, a rotunda, with four chromatic zones. This painting of the Annunciation lacks the grace and complexity of the painting of the same subject on the south wall of the sanctuary. It shows two plain figures, solidly built but without particular elegance. The round shape of the Virgin's head and her huge eyes

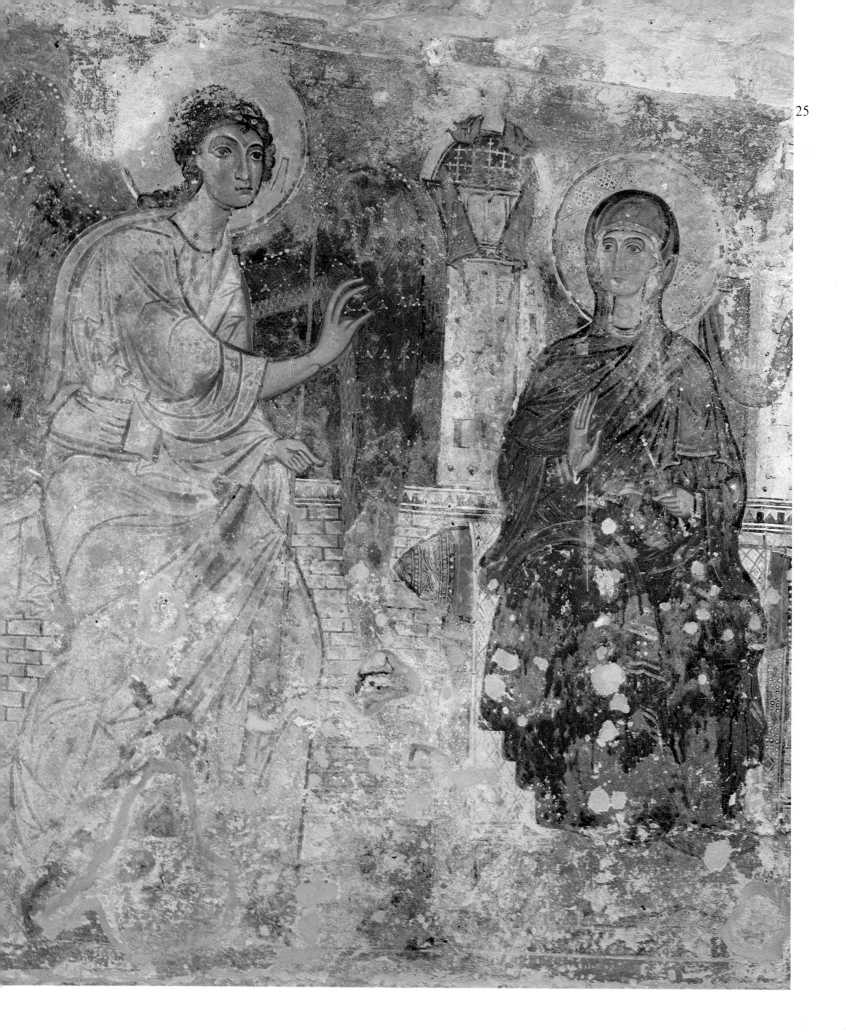

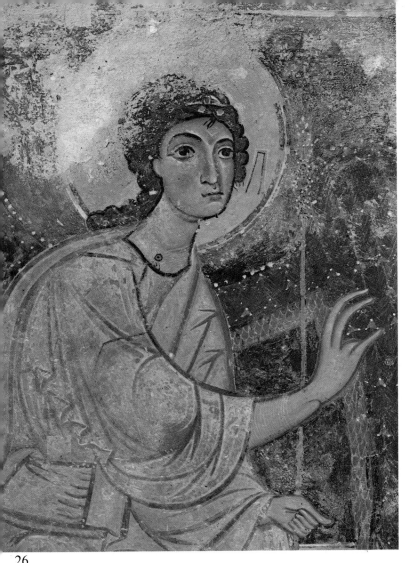

25. Protothrone, sanctuary, S. wall. The Annunciation (later 12th - early 13th century).

26. Protothrone, S. wall of the sanctuary. The angel of

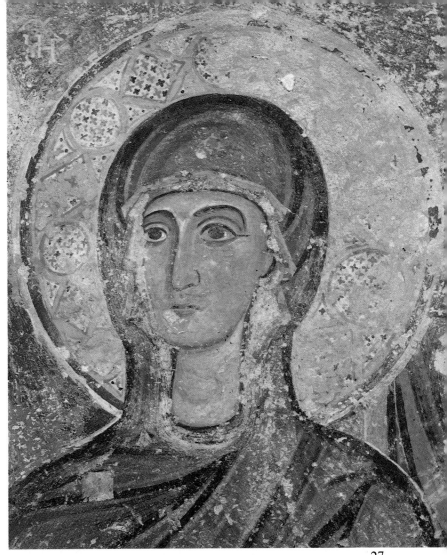

the Annunciation (detail of Fig. 25).

27. Protothrone, S. wall of the sanctuary. The Virgin of the Annunciation (detail of Fig. 25).

which fill almost the whole of her face point to Byzantine works that are in closer touch with everyday reality without losing their spirituality.

The scene showing the meeting of the two future mothers, Mary and her cousin Elizabeth, is painted in the same style. The Presentation of Christ in the Temple (Fig. 15) occupies part of the west side of the vault, in a monumental easy composition. In the centre, Simeon, bent by long years of waiting, extends his hands towards the Christ Child held in the arms of the lissom Virgin. The infant Christ with arms outstretched towards Simeon and the Virgin is virtually the centre of the picture, his spread arms filling the gap and imparting a dynamic quality to the composition. The painter is master of his expressive means, with a sure brush and a concise emphatic rendering of facial features.

The figures in the Annunciation and in the Presentation of Christ in the Temple disclose an affinity to mosaics and wall paintings of the 11th century, especially to the wall paintings of Qarabach Kilisse in Cappadocia (1060-61), both in the overall modelling of the face and in the preference for the curved line. These compositions of the Protothrone also have common points with the wall paintings of the Panagia Chalkeon at Thessaloniki (1029), the murals of the Crypt of Hosios Loukas (early 11th century) and the mosaics of Sancta Sophia at Kiev. The conception of serenity in the composition, the monumental quality of the architectural and other decorative elements, which distinguish the large mosaic ensembles of the 11th century, are also dominant in the wall paintings of the Protothrone, and suggest a dating to that century. Consequently, we believe that the date 1052 recorded in the marble inscription as the year of "renovation" of the church marks the time when the whole

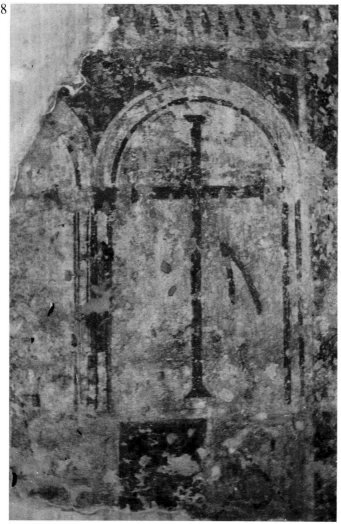

28. *Protothrone, conch of the holy bema. Aniconic decoration.*

naos was painted and is therefore assignable to the earliest layer of paintings on the dome and on the vaults of the cross arms.

Fourth layer. The composition of the second painting layer of the dome, seen today in its original position, is basically the same with that of the earlier one. The difference is that, instead of the four cherubim and two prophets, four saints were added on the east side. This painting, too, is characterized by a monumental quality, frontal attitudes, and wide folds of drapery perhaps somewhat more linear. It also displays a certain rigidity and conventionality in the modelling of facial features, a more concise conception and an indifference to beauty, if not its avoidance. These characteristic points distinguish one of the

painting trends of the 11th century, during which the second layer of the dome must have been painted. If we accept A.D. 1052 as the date for the first painting of the dome, then the chronological margin between the two layers is reduced. We believe that the overpainting of the dome followed a short time after the initial storying, i.e. within the second half of the 11th century, while the rest of the church retained the decoration of A.D. 1052. Since no serious damages were discovered on the first layer to justify these alterations, the overpainting may have been due to a wish for a change in the iconography.

The portraits of saints in the NW parecclesion have all the characteristics noted in the second layer of the dome painting. In particular, the facial type of St. Akindynos (Fig. 19) resembles that of the Pantocrator (Fig. 13). There are, however, certain differences such as the red spot on the cheeks, the vigorous lines, and a simplification indicating artistic notions of the late 11th - early 12th century. The existence of the funerary inscription is a determining factor in assigning these wall paintings to a date after 1056. Thus, a dating to the late 11th or early 12th century is most likely.

Fifth layer. A painting layer on the curved wall of the sanctuary apse — now detached — had a representation of co-officiating hierarchs. Only parts of a single figure have been preserved. The hierarch is portrayed in a three-quarters attitude, wearing a *polystavrion* and an *omophorion* with large crosses and holding a scroll inscribed with a blessing from the Holy Liturgy, "Lord, our God, save thy people and bless thine inheritance", found in the text usually held by St. James, the Brother of Christ. The head, preserved in good condition, is modelled in a manner stressing the round shape of the skull and beard. The plastic drawing and the gradation of colouring to convey mass relate this work to the requirements of the new Palaeologan style, as seen in churches of the Greek islands and of mainland Greece. The wall painting can be assigned to the 13th century.

The composition of the Deesis (Fig. 6) in the conch is dominated by the figure of Christ who is shown seated on a huge throne with a flat back. The throne fills almost half the painted surface and its converging lines adapt it to the area available. The imposing figure of Christ with the beautiful head framed by thick hair has the characteristic features associated with a refined tendency. White lines trace vividly the folds of Christ's purple *chiton* and grey-blue

28

himation. The same colour hues, in an inverse arrangement, are used for the elegant figure of the Virgin (brick-coloured *maphorion* over a grey-blue dress), while St. John, his fine features particularly marked, wears an ochre-coloured *phelonion.* The earthy colouring of the three figures and the cold blue of the background are not a particularly happy combination. The nobility of the figures, the rich drapery as well as the whole character of the mural permit an association with the Palaeologan art, as interpreted by local painters.

The representation of the Annunciation (Fig. 25) on the south wall of the sanctuary is one of the best preserved. The young girl, whose big almond-shaped eyes impart spirituality to the delicate sweet face (Fig. 27), is seated daintly on the embroidered cushion, holding in her left hand a spindle with red yarn. The purple *maphorion* emphasizes the holiness of Mary, while the halo, adorned with small blue and red crosses — an influence from polychrome enamels — lends a young girl's charm to the figure. The angel, tall with a rather small head and slender neck (Fig. 25), is dressed in the Greek fashion with a blue *chiton* and a light-red *himation.* Turned three-quarters towards the Virgin, he delivers the divine salutation. His outspread wings, dark-purple in colour and studded with rows of white gems, bridge the space between the two figures. A magnificent edifice of ashlar masonry, below, and a curtained window, above, complete the composition. The faces are modelled in soft gradations of colour, with almost indiscernible brush strokes, whereas the features (long arched eyebrows, nose, small mouth) are rendered in brown and lighter shades. A small horizontal line drawn from the outer corner of the eye meets the arc of the brow. The representation combines traits from the monumental serenity of Comnenian art with the particular sensibility and plasticity that distinguish the art of icon-painting in the Palaeologan era. Therefore, we believe that this painting of the Annunciation can be assigned a date in the late 12th or early 13th century.

The church of the Protothrone is beyond doubt a monument of exceptional importance. It has remained alive and functioning for more than 14 centuries, during which it has been decorated with splendid paintings from many periods. The fact that it is not located in a large urban centre but on an island of the windy Aegean Sea, proves how deep the roots of Byzantine art are in the Greek territory.

Nicos Zias

Bibliography

N.D. Kalogeropoulos, «Τριάκοντα πέντε ἄγνωστοι βυζαντινοί ναοί τῆς Νάξου», *Νέα Ἑστία*, Vol. ΙΔ΄ (1933), No. 160, p. 873-874 (and reprint p. 18-19).

M. Chatzidakis, «Medieval painting in southern Greece» *Connoiseur,* May 1962, No. 603, p. 29-34. Also published in *Studies in Byzantine Art and Archaeology,* Ed. Variorum Reprints, London 1972.

C. Dimitrokallis, "Gli Affreschi Byzantini deli' Isola di Nasso", *Felix Ravenna,* Vol. XLIII (1966), p. 54-55, Fig. 4-5 and reprinted in the author's book *Συμβολαί εἰς τήν μελέτην τῶν Βυζαντινῶν Μνημείων της Νάξου,* Vol. Α΄, Athens 1972, p. 157 ff.

N. Panayotidis, "Les monuments de Grèce depuis la fin de la crise iconoclaste jusqu'à l' an mille", Paris 1969, p. 174 ff. (unpublished dissertation for a Ph.D. degree, III cycle).

N. Kephaleniadis, «Ἡ Πρωτόθρονος Χαλκίου (Παναγία ἡ Εὐαγγελίστρια)», *Ναξιακή Πρόοδος,* Naxos 1969 (and reprint).

M. Chatzidakis, *Byzanz und der Christliche Osten,* Berlin 1968, p. 237, Pl. 177a (= *Propyläen Kunstgeschichte* 3).

N. Zias, «Ἐκ τῶν ἀποκαλυφθεισῶν τοιχογραφιῶν εἰς Πρωτόθρονον Νάξου», *Ἀρχαιολογικά Ἀνάλεκτα Ἀθηνῶν,* Vol. IV (1971), 3, p. 368-377.

N. Kephaleniadis, *Οἱ ἐκκλησίες τῆς Νάξου καί οἱ θρύλοι των,* Athens 1971, p. 5-6.

M. Chatzidakis, «Ἐπιτάφια χρονολογημένη ἐπιγραφή στήν Πρωτόθρονη Νάξου», *Δελτίον Χριστιανικῆς Ἀρχαιολογικῆς Ἑταιρείας,* per. Δ΄, Vol. Ζ΄ (1973-4), Athens 1974, p. 78.

S. Baltoyiannis, «Συντήρησις - ἀποκατάστασις τοιχογραφιῶν (Πρωτόθρονος) — Πρώτη ἔκθεσις ἐργασιῶν», *Ἀρχαιολογικόν Δελτίον,* Vol. 26 (1971): *Χρονικά,* Athens 1975, p. 475-481, Pl. 495-496.

N. Zias, «Βυζαντινά καί Νεώτερα Μνημεῖα Νήσων Αἰγαίου. Πρωτόθρονος», *Ἀρχαιολογικόν Δελτίον,* Vol. 26 (1971): *Χρονικά,* Athens 1975, p. 474-475, Pl. 490-494.

P. Vokotopoulos, *Ἡ ἐκκλησιαστική ἀρχιτεκτονική εἰς τήν Δυτικήν Στερεάν Ἑλλάδα καί τήν Ἤπειρον, ἀπό τό τέλος τοῦ 7ου μέχρι τοῦ τέλους τοῦ 10ου αἰῶνος,* Thessaloniki 1975, p. 119[2], 121, 122, 124, 134[2], 154[3], 162[1], 168[2].

D. Pallas, «Ἡ Παναγία τῆς Σκριποῦς», *Ἐπετηρίς Ἑταιρείας Στερεοελλαδικῶν Μελετῶν,* Vol. ΣΤ΄, Athens 1976-1977, p. 2[2], 6, 7, 34[10], 37[124].

S. Baltoyiannis, "Conservation and restoration of the wall paintings in the church of the Protothronos Naxos. Part I. Removal of the painting", *Studies in conservation,* Vol. 21 (1976), London, p. 51-62.

N. Zias, «Βυζαντινά, Μεσαιωνικά καί Νεώτερα Μνημεῖα Νήσων Αἰγαίου, Πρωτόθρονος», *Ἀρχαιολογικόν Δελτίον,* Vol. 27 (1972): *Χρονικά,* Athens 1977, p. 613, Pl. 566-567· Vol. 28 (1973), Athens 1978, p. 551, Pl. 513.

M. Chatzidakis, "L'art dans le Naxos byzantin et le contexte historique", *XVe Congrès Internationale des Sciences Historiques, Bucarest 10-17 Août 1980: Rapports,* Vol. III, Bucharest 1980, p. 13-15.

HAGIOS IOANNIS THEOLOGOS AT ADISAROU

Architecture

The church of St. John the Theologian (Fig. 1, 2) stands on a site called "at Adisarou" or "at the Fountain of Adisarou", opposite Lathrinos, not far from the village of Damarionas, in the SW region of Naxos that was once protected by the great Byzantine Castle of Apaliro. Like other Middle Byzantine churches of the island (St. Kyriake at Apeiranthos, St. George at Apeiranthos, St. Artemios at Sangri, St. Demetrios at Kynidaros), it is single-aisled with vaults and a dome and it has the same or similar architectural and structural characteristics: a simple stone construction, a projecting large semicircular apse, a dome resting on a low drum, and an articulation of three bays in the interior by means of transverse arches and blank arcading on the long sides. The apse has preserved remains of a two-stepped synthronon, which must have had originally a bishop's throne in the centre. The interior measures 7.70 × 2.50 m., or, including the depth of the apse and of the blank arcades, 8.95 × 3.27 m. The doorway and the small window on the west side are framed with marble members, perhaps from the nearby site of the ancient Telesterion of Demeter which was superseded by an Early Christian basilica. At about the middle of the north and south sides there must have been two facing doors — later condemned — which may have given access to adjacent compartments (there are traces of a vaulted structure on the exterior of the south side). The western part of the south wall and the corresponding vault, that had been ruined at some time, were rebuilt.

Wall paintings

Recent works undertaken by the Second Ephorate of Byzantine Antiquities (1980-1983) have brought to light aniconic wall paintings that had decorated only the sanctuary of the church (Fig. 3), as in the case of St. Artemios at Sangri. Sections of wall paintings from two subsequent phases of decoration—limited to certain parts of the church — were also discovered under coatings of later date. These include the composition of the Deesis on the half-dome of the apse (Fig. 3, 4), the portrayals of St. John the Theologian, titular saint of the church, and an unidentified female saint (Marina?) on the two western pilasters (13th century), and of the saints Mamas and George, on the two central blind arches (14th century). Under the layer of aniconic wall paintings, almost the whole of the interior was found to have been covered with a smooth plaster coating with, here and there, indistinct designs in black and crude red colour and an archaic small black cross unskilfully painted on the jamb of the south blocked up door, probably by the craftsman who worked the coating when the church was being built. The two small windows at the base of the half dome of the apse had been blocked with masonry to accommodate the 13th century painting of the Deesis.

Aniconic wall paintings

The aniconic wall paintings of the church have survived to a relatively large extent, permitting a reconstruction of the original decorative programme in the parts where it has perished. Geometric and floral motifs, vividly painted in many colours, black, crude red, warm ochre-yellow, green, on the white undercoating, spread over all the surfaces of the eastern part of the church: the apse and its front (Fig. 3-5), the barrel-vault and the lower side walls (Fig. 6, 7, 9), the intrados and east front of the transverse arch that supports the dome and separates the sanctuary from the nave (Fig. 8, 9).

In the apse, at the base of the half-dome and between the two small windows (Fig. 3, 4), a panel was painted with a cross of unequal arms under an arch (the extremities of the cross arms are visible). The front of the arch was painted with small tangent circles imitating a marble revetment, while an enclosed spiked rosette at the right corner recalls *opus sectile*. The field below the panel contained an inscription, in majuscule letters, of which only the left part of the last

line has preserved the words: *TON ΘΕΟΝ* (the Lord). Immediately below, on the whitish band framing the dark-coloured cornice, another archaic inscription reads: *...ΤΕΚΝΟΝ ΠΑΝΥΚΗ...* (...children and the whole house...). The principal inscription was written in capital letters on the *kosmetes*, the narrow stone moulding that marks the base-line of the half-dome. To the right can be read with difficulty: *...ΤΗΝ ΠΑΡ-ΘΕΝΟΝ ΘΕΟ[ΤΟΚΟΝ...]* ...(...the Virgin Mother of God...). Perhaps the church was at the time dedicated to the Holy Virgin. The palaeographic features of the painted inscriptions support a dating of the aniconic decoration to the 9th century.

To the left and right of the windows, the register which had at the centre a cross under an arch, was painted with looped circles, originally three on either side, with a composite star-like cruciform rosette in the circles and bud flowers in the interspaces (Fig. 4, 5). Right above this register, a large circle was painted at the centre of the half-dome. Part of this painting has survived to the right (Fig. 3, 4) and shows a large polychrome circle adorned with bands running through a series of interlaced circular patterns. This great circle probably enclosed the holy cross, the dominant symbol of aniconic decorations. Aniconic wall paintings in other churches of Naxos also show a cross inscribed within a circle in the same place of the apse, as for example in the chapel of St. George near Apeiranthos and in the cemeterial church of St. John the Theologian at Danakos. The area outside the circle is decorated with a pattern of scales arranged in the same direction, imitating peacock feathers (a greater part is preserved on the right), with white pearl-like dots on the contour of the scales and wavy lines inside, converging round a circular central element. A similar scale pattern is found in the same place in the churches of St. Kyriake at Apeiranthos (Fig. 4) and of St. Artemios at Sangri (Fig. 12).

On the curved lower part of the apse (Fig. 3-5) the painting imitates architectural decoration with marble revetments and *opus sectile*. In the middle, where the episcopal seat would be, a panel is formed, above, by a large toothed pattern, composed of polychrome quadrilaterals in a diagonal arrangement, and, below, by an inserted smaller panel with small tangent circles imitating marble revetment. On either side, originally three narrow panels framed two large panels. The latter are decorated with a rhomboid pattern, its angles

forming loops, containing a cross-like rosette inscribed within a circle. The lavish pattern, which resembles a polychrome *opus sectile,* varies from panel to panel in the supplementary details.

The toothed pattern drawn in perspective on the central panel of the apse is repeated on the arch at the front of the east wall (Fig. 3, 4) and on the arches of the blank arcading of the north and south sides (Fig. 7).

Three decorative zones, converging at the lower ends, articulate the front of the apse (Fig. 3, 4). On the curve of the arch a pattern is formed by overlapping circles; in the middle zone the subject is not discernible; the higher zone is painted with the toothed pattern. All three registers are interrupted at the centre by a circle composed of a double rope-like band with loops (like those of the circles on the half-dome). A cross is inscribed within the circle.

On the vault (Fig. 6, 7, 9) the decoration probably imitates a coffered ceiling. Octagons and small squares containing four-petalled cross-like flowers are arranged in cross-forming patterns. A related design of hexagons and squares adorns most of the surface of the intrados of the transverse arch (Fig. 3, 8). The hexagons, placed so as to form cross patterns, enclose fusiform motifs with heart-shaped leaves. The squares contain the typical cross-like rosettes with alternate ensiform and curved petals. The lower part of the intrados, on either side, is decorated with smaller panels showing a chequered pattern: adjoining squares enclosing four-petalled and round small flowers. Lower, on the pilasters (Fig. 3), there are remains of indistinct decorations. On the east front of the transverse arch (Fig. 9) spreads a stylized tendril forming spirals in a striking dark-coloured design painted on the whitish coating. The similarly monochrome linear design of a lily has survived on the east of the north pilaster, below. A corresponding motif would have been painted on the east side of the south pilaster.

The decorative subjects on the surfaces of the side walls vary. The only common decoration is the toothed pattern which circumscribes the arches of the blank arcading.

The tympanum of the north blind arch (Fig. 7) is divided horizontally into two sections. Below, there are traces from a broad panel with inset oblique lozenges and semicircles resting upon the centres of the lozenges' sides. Above, a design shows horizontal rows of scales between bands, with an upright flower

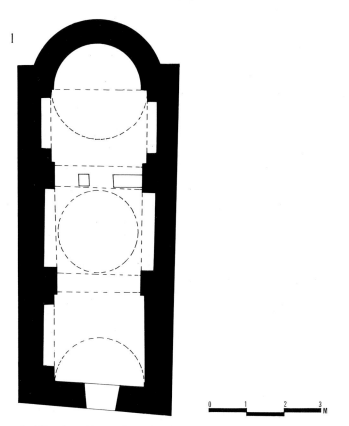

1. Hagios Ioannis Theologos at Adisarou. Ground-plan.

2. Hagios Ioannis Theologos at Adisarou. SW view.

within each scale and a heart-shaped small leaf in the space between the scales. The left side of the intrados of the arch has preserved a decorative zone of looped circles enclosing floral motifs. The upper left-hand corner of the spandrel shows a large lily-flower. The same motif must have adorned the right-hand corner.

The tympanum of the south blind arch has lost the lower part of its decoration, probably a panel corresponding to that of the north arch. The upper part is covered with tangent circles and curvilinear quadrangles in the interspaces, with quatrefoils in the circles and other floral ornaments. The intrados of the arch shows a partly preserved design of diagonally crossing lines that form polychrome lozenges ornamented with floral motifs. The front of the wall has preserved fairly well a finely executed design on a dark red background: adjoining squares, traversed by diagonal lines, are enclosing cruciform quatrefoils.

The wall paintings of St. John the Theologian at Adisarou in Naxos are remarkable for the variety of the subjects and their artistic quality, the full colours, the steady line of the drawing and the maturity of the composition. The experienced painter traced with a

sharp tool the preliminary drawing, when this was needed (circular designs at the apse). At places he plotted the pattern with a grid of drawn lines (vault, arch). During the actual painting he was compelled to make some changes in the original design which he executed with a free and easy hand (east front of the transverse arch).

The decoration of architectural type reveals an artisan skilful and experienced in this kind of monumental painting. The patterns are studied in their proportions and form, suitable for the surfaces they are painted on, with accented joints wherever necessary, closely knit and conveniently arranged. They are self-contained decorations forming a well structured whole.

The models of all the decorative subjects are to be found in Early Christian art. Besides, the wall paintings of St. John the Theologian have a close connection with the Early Christian decorations of architectural type. In the work of later date the manner and character of painting are changed, but the ancient designs have been retained. Heavier and of closer articulation, they are used here to decorate walls, with a

horror vacui quite evident in the sophisticated colour variations, the pronounced ribbon-like contours and outlines, the ornamentation of geometric patterns with rosettes, half - rosettes, quatrefoils, heart-shaped leaflets, volutes, "pearls" and other supplementary elements which are strongly reminiscent of mosaic floors. Where the subject is simple, as in the case of the monochrome tendril (Fig. 9) and the similarly linear lily on the east front and on the north pilaster of the transverse arch, the stylization, the importance of the line and the dominant spreading of the design on the painted surface correspond to a different notion of its decorative function.

In general, the geometric motifs compose a framework which is often organized in cruciform patterns. This frame accepts, encloses, supports and highlights the cross-like floral ornaments which enliven and decorate the whole composition, without diminishing the geometric precision of the painting's basic fabric.

Problems of dating and interpretation

The aniconic wall paintings of Naxos known from older and recent finds are quite numerous. The three ensembles that have survived in greater part are those of St. Kyriake at Apeiranthos, of St. John at Adisarou and of St. Artemios at Sangri. Parts of aniconic decoration have been noted or exposed in the great church of the Protothrone at Chalki in the plain of Tragaia, in the cemeterial church of St. John the Theologian at the village Danakos, in St. George near Apeiranthos (conch of the parecclesion), in the church of St. Kyriake and the nearby smaller one of St. George at the site "Kakavas" in Apeiranthos, not far from the previously mentioned church of St. George, in the church of Panagia Monasteriotissa at the village Engares, near the old ruined quarter of Mesa Geitonia, in St. Demetrios (the katholikon of an abandoned monastery) at the sites "Chalandra" near Kynidaros, in the cave church of Panagia Kaloritsa near the village Damarionas, not very far from St. John the Theologian at Adisarou. Traces of aniconic wall paintings exist in the church of St. John the Theologian at Kaloxylo in the plain of Tragaia, in the Prophet Elijah at Potamia and in St. Panteleimon at the site "Mersini" near Apeiranthos.

Aniconic decorations have, therefore, survived in eleven, or possibly fourteen, churches of Naxos. As a

rule they are the original painted decorations of the churches — which often have two or more layers of wall paintings — with one known exception of the Protothrone where the aniconic decoration is subsequent to the original painting. The churches are of various types: single-aisled with a dome, single-aisled with a vaulted roof, of basilical plan (there are indications that the double-aisled church at Danakos was originally three-aisled) and of the free-standing cross plan with a dome. There is positive evidence suggesting that the inscribed-cross plan with a dome of the transitional type encountered in the Protothrone was originally that of a three-aisled basilica. It is not clear, however, to which building phase the aniconic paintings belong. All these churches are dispersed over the large central area of the island, in plains, valleys and mountains, on sites important to the local productivity (agriculture, cattle-breeding, emery quarries). As can be deduced from their location, they were built in places with a tradition for monuments, while their varied size indicates that they served the worshipping needs of townships (Protothrone) or of semi-rural and agricultural communities. Evidence of their use throughout the centuries, either uninterruptedly or for long intervals of time, is provided by the usually successive painting layers dating from two, three or even more periods.

The best known, more or less contemporaneous, aniconic decorations of Naxian churches are closely associated with the other aniconic wall paintings of the Greek islands and mainland: the church of St. Nicholas at Castelli Mirabellou in Crete, of St. Procopios in Mesa Mani, of Episcope in Eurytania, as well as of a ruined church in Thessaloniki. These wall paintings are usually dated to the 9th century, and more specifically in the Iconoclast period. They display affinities in the manner of painting, a similar conception in the composition of the programme and the use of common decorative features such as: the peculiar and characteristic in these wall paintings cruciform rosette with the alternating ensiform and curved petals either in a single or in successive rows, the crosses under arches and within circles, the patterns with the large loops, the tangent or intersecting circles etc.

The surviving numerous aniconic wall paintings of churches on Naxos, in association with the location and the size of the buildings, bear witness to the extent of an aniconic current in art that seems to have

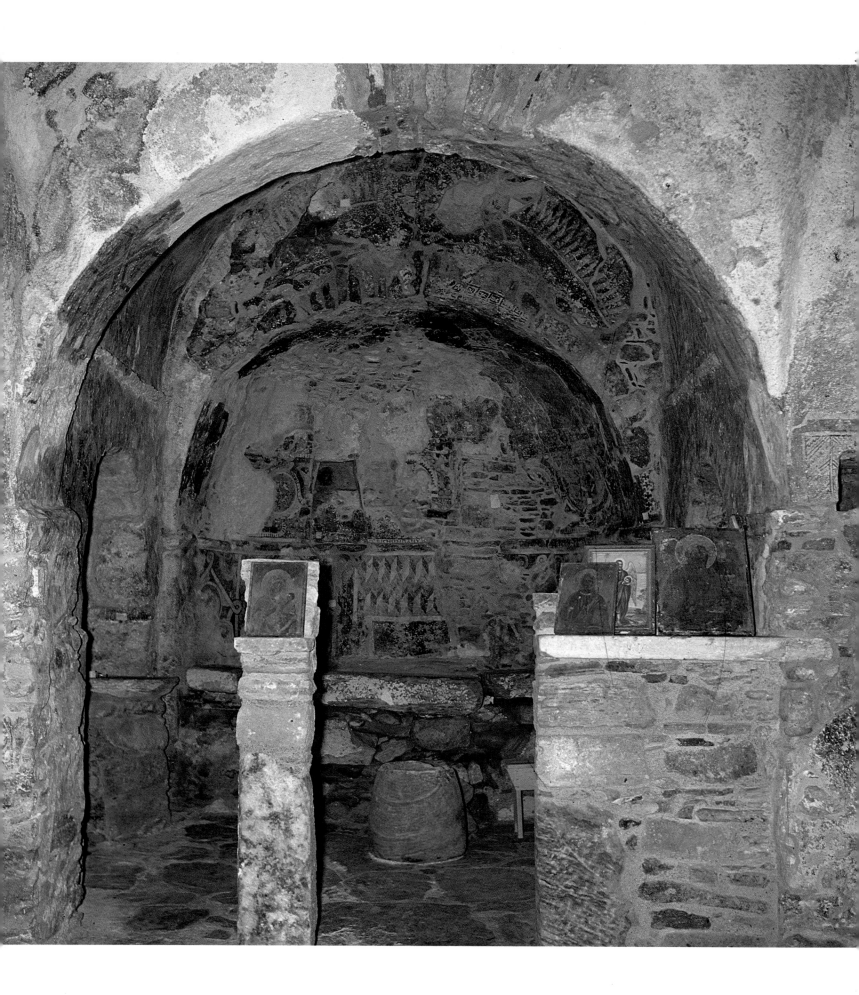

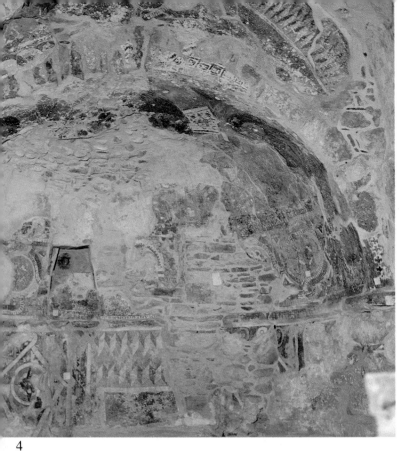

4

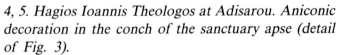

3. *Hagios Ioannis Theologos at Adisarou. View towards the apse.*

4, 5. *Hagios Ioannis Theologos at Adisarou. Aniconic decoration in the conch of the sanctuary apse (detail of Fig. 3).*

6. *Hagios Ioannis Theologos at Adisarou. Decorative pattern on the vault of the sanctuary.*

7. *Hagios Ioannis Theologos at Adisarou. Aniconic decoration on the north side of the sanctuary (detail).*

6

5

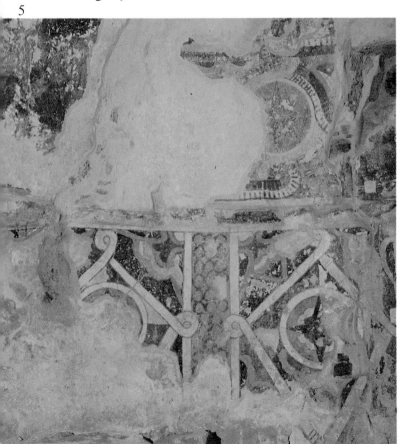

7

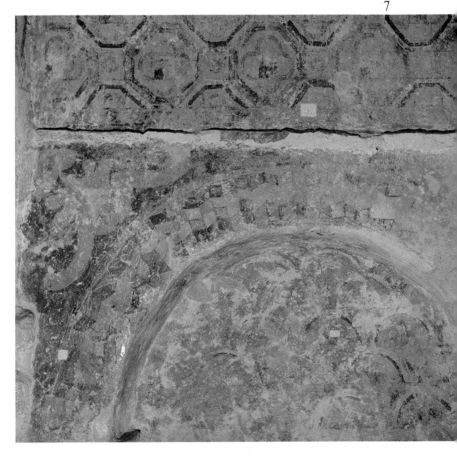

8. Hagios Ioannis Theologos at Adisarou. Decorative pattern on the intrados of the transverse arch.

spread unhindered over the island and to have been generally accepted. This is a most interesting occurrence, the study of which may shed light on an unknown and significant chapter of the island's history. It is not known whether and to what extent this trend is related to the Iconoclast movement nor how long it prevailed, whether it is connected with a certain political attitude of the islanders who, for reasons of wider interest, resorted to aniconic decoration in the face of the Arab threat which made its presence felt in the Cyclades. Nor do we know if it is related and in what way to the possibly important position Naxos had then in the administration of the Aegean.

A clue, or one of the important clues, for the interpretation of this trend is provided by the wall paintings of the large, and in all probability episcopal, church of the Protothrone at Chalki (see relevant chapter). This church has preserved an aniconic decoration on the curved wall of the sanctuary apse: crosses under an arcading with schematized trees on either side of the crosses, a toothed design and other decorative elements which complete the subject. Under the layer of the aniconic representations was discovered the earlier wall painting with the full-length Apostles from the original painted decoration of the apse. Datable to the 7th century, this painting can perhaps be associated with the presence on the island for about a year of Pope Martin I, banished from Rome about A.D. 653 (Chatzidakis).

This succession of iconic and aniconic painting in a church as important as the Protothrone, leads to certain thoughts.It suggests: a) the probably official acceptance of aniconic art by the clergy, the local authorities and the population of the island. b) the later appearance here of aniconic paintings, at a definite period of time and obviously for serious reasons, since in the same church there exists an earlier important iconic decoration. c) hence, the rather unlikely possibility of associating the wall paintings of the Protothrone and of other churches on the island with the continuation of an aniconic practice from Early Christian times; all the more so, since in Naxos, only iconic paintings have survived from the pre-Iconoclast period (Protothrone, Drosiani). d) the possibility of assigning this trend to the Iconoclast period, a possibility further supported by the fact that the wall paintings before and after the aniconic representations in the same position of the apse in the Protothrone are datable to the 7th and the 10th century respectively.

The great number of aniconic wall paintings in Naxos reveals that this kind of decoration — irrespective of the reason for which it had been adopted — thrived on the largest of the Cycladic islands for an indeterminable length of time. The technique and the subjects vary, betraying individual inspiration and the use of a rich repertoire of decorative motifs. The style of painting and the palaeographic features of the surviving inscriptions support a dating of the wall paint-

9. *Hagios Ioannis Theologos at Adisarou. Ornamental design on the front of the transverse arch (detail).*

ings to the 9th century. Their affinity to other aniconic decorations in Greece, and to certain "iconoclast" wall paintings in Cappadocia and at the Midye Monastery in Turkish Thrace, is based on similarities noted in specific decorative subjects and also in the manner and organization of the painting, particularly that of the sanctuary apse, which is most important for the programme. This affinity denotes that aniconic art in Naxos was expressed in forms and types "established" in other parts, most probably at the same epoch.

The aniconic wall paintings of St. John the Theologian at Adisarou have a place in this framework. They are among the best examples of this art found on the island of Naxos and elsewhere. Their style compares to some extent with that of the aniconic paintings in the Protothrone and in St. Kyriake at Apeiranthos, and marks a peak in the period during which they were painted. A number of decorative subjects, especially those of the architectural type, like the narrow and broad panels on the curved wall of the apse, the octagons imitating coffers on the vault, and the homologous hexagons on the arch, add to our knowledge of the repertory used by the painters of those times. They also stress the close ties of 9th century wall paintings with the decorative stock of Early Christian art, an art revived, transformed and enriched, giving expression to new ideas.

Myrtali Acheimastou-Potamianou

Bibliography

D. Evangelidis, «Εἰκονομαχικά μνημεῖα ἐν Θεσσαλονίκῃ», 'Αρχαιολογική 'Εφημερίς, 1937, p. 341 ff.

A. Grabar, "L' iconoclasme byzantin", *Dossier Archéologique,* Paris 1957.

A. Vasilaki, «Εἰκονομαχικές ἐκκλησίες στή Νάξο», Δελτίον Χριστιανικῆς 'Αρχαιολογικῆς 'Εταιρείας, per. Δ΄, Vol. Γ΄ (1962-63), p. 49 ff.

N.B. Drandakis, Βυζαντιναί τοιχογραφίαι τῆς Μέσα Μάνης, Athens 1964, p. 6 ff.

G.C. Miles, "Byzantium and the Arabs: Relations in Crete and the Aegean area", *Dumbarton Oaks Papers,* Vol. 18(1964), p. 10 ff.

N.B. Drandakis, 'Αρχαιολογικόν Δελτίον, Vol. 20(1965): Χρονικά, p. 544 ff.

M. Chatzidakis, 'Αρχαιολογικόν Δελτίον, Vol. 21(1966): Χρονικά, p. 28· Vol. 22(1967), p. 30.

A.K. Orlandos, 'Αρχαιολογικόν Δελτίον, Vol. 24(1969): Χρονικά, p. 18.

E. Borboudakis, 'Αρχαιολογικόν Δελτίον, Vol. 24(1969): Χρονικά, p. 446 ff.

D.I. Pallas, "Eine anikonische lineare Wanddekoration auf der Insel Ikaria, zur Tradition der bilderlosen Kirchenaustattung", *Jahrbuch der Österreichischen Byzantinistik,* Vol. 23 (1974), p. 271 ff.

S. Eyice et Thierry, "Le Monastère et la source sainte de Midye en Thrace Turque", *Cahiers Archéologiques,* Vol. XX (1970), p. 56, 76.

M. Chatzidakis, Βυζαντινές τοιχογραφίες καί εἰκόνες, Athens 1976, p. 22, 48 ff. (Catologue of the Exhibition in the National Gallery, Sept.-Dec. 1976).

H. Ahrweiler, "The Geography of the Iconoclast World", *Iconoclasm,* Ed. A. Bryer and J. Herrin (Ninth Spring Symposium of Byzantine Studies, University of Birmingham March 1975), Chapt. IV, Birmingham 1977, p. 21-27.

M. Chatzidakis, «Ἡ μεσοβυζαντινή τέχνη», 'Ιστορία τοῦ 'Ελληνικοῦ 'Έθνους, Vol. Η΄, Athens 1979, p. 285 ff.

M. Chatzidakis, "L' art dans le Naxos byzantin et le contexte historique", *XVe Congrès Internationale des Sciences Historiques, Bucarest 10-17 Août 1980: Rapports,* τόμ. III, Bucarest 1980, p. 14.

P. Asimakopoulou-Atzaka, Ἡ τεχνική *opus sectile* στήν ἐντοίχια διακόσμηση, Thessaloniki 1980.

Kl. Gallas — Kl. Wessel — M. Borboudakis, *Byzantinisches Creta, Reise und Studium,* Munich 1983, p. 80 ff., 422 ff.

M. Acheimastou-Potamianou, «Νέος ἀνεικονικός διάκοσμος ἐκκλησίας στή Νάξο. Οἱ τοιχογραφίες τοῦ 'Αγίου 'Ιωάννη τοῦ Θεολόγου στ' 'Αδησαροῦ», Δελτίον Χριστιανικῆς 'Αρχαιολογικῆς 'Εταιρείας, per. Δ΄, Vol. ΙΒ΄, p. 320-379.

G. Mastoropoulos, «Ἕνας ναξιακός ναός μέ ἄγνωστο ἀνεικονικό διάκοσμο», Δ΄ Συμπόσιο Βυζαντινῆς καί Μεταβυζαντινῆς 'Αρχαιολογίας καί Τέχνης: Περιλήψεις 'Ανακοινώσεων, Athens 1984, p. 32 ff.

D.I. Pallas, "Les décorations aniconiques des églises dans les îles de l' Archipel", *Studien zur spätantiken und byzantinischen Kunst,* Fr. W. Deichmann gewidmet, 10 (1986), Part II, p. 171 ff.

HAGIA KYRIAKE — HAGIOS ARTEMIOS

Most of the churches with aniconic decoration in Greece were located on the island of Naxos. Of these, St. George at Apeiranthos and the Panagia at Engares have retained a few faint fragments. St. Kyriake at Kalloni, north of Apeiranthos, and St. Artemios at the site Stavros, two hundred metres left of the main road connecting Chora with Chalki, opposite the tower of Bazaios, have preserved in good condition almost the whole of their aniconic decoration.

N.D. Kalogeropoulos (1933) located and mentioned the churches of St. Kyriake and St. Artemios, without dating them. Much later (1961-62) the "Team for the Discovery and Investigation of Byzantine Wall Paintings in Greece" included St. Kyriake and St. Artemios among the nearly forty churches they had discovered, photographed and partly drawn. The two churches were subsequently studied and published. This publication assigned them to the 8th-9th century, and more precisely in the reign of Theophilus (A.D. 829-842).

Architecture

The church of St. Kyriake (total dimensions 11.10 × 7.10 m.) (Fig. 1) is composed of a single-aisled naos with a dome, a vaulted parecclesion on the south side and a common, also vaulted, narthex on the west side with a single lateral entrance from the south. The main church and the parecclesion have large semicircular sanctuary apses to the east. As indicated by the uniform continuous masonry and the interior articulation of the compartments (Fig. 2), all parts are contemporary. The walls built of local undressed greyish stones with very little mortar, give the impression of dry masonry. The limited possibilities of the materials used have determined the exterior aspect of the building: unarticulated walls devoid of any decoration, few and small windows, in short, an aspect reminding one of a castle rather than a church. Only the pitched roofs and the heavy cylindrical dome reveal the architectural plan of the church. The east wall of the narthex was pierced by two doors leading to the main

church and the parecclesion. The one to the parecclesion is now blocked up; the other, almost square, with monolith jambs and lintel has a megalithic appearance. On the north and south sides the dome is supported by shallow blind arches. A large arched opening through the south blind arch and two smaller ones on either side (one of them in the sanctuary) facilitate communication with the parecclesion and indicate that it was a contemporary construction. The sanctuary occupies the entire east part of the main church. In the apse, a low, built, synthronon has an episcopal throne in the middle, marked off by a vertical slab on either side (Fig. 4). The walls of the main church have a similar low built bench. The spring of the vaults and the base-line of the low drum of the dome are accented with a cornice of schist. The floor was paved with large slabs, none of which was found in position as they had been broken and scattered by robbers digging for hidden treasures.

St. Artemios is a simple single-aisled domed church, which has neither a narthex nor a parecclesion (Fig. 7, 8). In addition to the architectural type, the other common features with the church of St. Kyriake are: the masonry, with even less mortar; the large semicircular apse, in this case without a window; and the heavy cylindrical dome, with an even lower drum and fewer openings. Here too, the sanctuary occupies the whole of the east section (Fig. 9). The floor, of slabs and natural rock, has survived intact. Built in a more unpretentious and clumsy manner, this church looks older than that of St. Kyriake.

Painting

The original painted decoration of St. Kyriake has been preserved on the blind arches, on the intrados of the eastern and middle arched openings giving access to the parecclesion, and in the entire sanctuary (walls, apse, vault). Neither the western part of the naos, nor the parecclesion and narthex bear any traces of this first phase, since probably they had not been decorated then. The same is noted in St. Artemios, where

only the sanctuary had been painted. The original decoration was aniconic. A second layer, on the curved wall of the apse and on the half-dome, has preserved painting traces showing parts of haloes and an open Gospel Book, while the apse of the pareeclesion was painted with the Deesis. In detail, the aniconic paintings of St. Kyriake are as follows:

The curved wall of the apse, above the synthronon and to the right of the double-arched window, is divided into two panels by vertical borders filled with wavy lines imitating marble revetment. The section to the left of the window, though decorated with the same subject in a similar arrangement, has neither panels nor separating borders. On either side of the window, against the white wall-plastering, six scattered birds are depicted turned towards the window (Fig. 5, 6), with wavy lines and dots in red colour filling the interspaces. The birds are remarkable. They are drawn with a sharp outline and are painted in dark colour. Their feathers are rendered by curved lines extending from the head to the tail. Their legs are long, rigid, with pronounced joints and talons, like those of birds of prey. Their tall necks, adorned with a Sassanian ribbon-like motif, are curving sharply downwards as if the birds are pecking with their strong beaks at the dots and wavy lines of the field. On either side, the uppermost bird dominates with its size. This large bird and another smaller one have tufted tails. The left-hand representation shows, below, two confronting fishes and the small sketch of an animal. The two paintings present differences in execution. The birds on the left side are more schematic, painted in a clumsy and careless manner. The ends of the curved wall of the apse are painted alike (that on the left is better preserved) with a bejewelled cross flanked by two small palm-trees in pots. The half-dome has retained parts of the decoration. Above the cornice, there are two narrow bands with decorative motifs. Next, there is a pattern of large scales with sharp black outlines, white dots and a heart-shaped core. This scale pattern probably did not cover the entire surface. At about the centre of the composition, part of a curved wide band is visible — possibly from the circular frame of a cross. The band has a toothed ornament, similar to that on the arched opening of the south blind arch.

The north wall of the sanctuary, above a wide zone imitating marble revetment, is divided into two panels by borders, each containing a different motif: spiral tendrils, concentric tangent semicircles, a zigzag design forming triangles with palmettes. The right-hand panel, which is better preserved, contains a large cross on a stepped base. The arms of the cross extend to the edges of the panel, thus dividing the rectangular surface into four smaller rectangles. The two upper rectangles are divided into two triangles by lines joining the end of the upper arm to the ends of the horizontal arms. The triangles between the arms of the cross are light-coloured, the others are dark-coloured, filled with small elliptical motifs having a white contour. Quite probably, the left-hand panel was painted with the same subject. The narrow western part of the arched opening through the sanctuary's south wall looks like a pier and is decorated with three vertical bands. The middle one, more visible, is painted with looped circles filled with small elliptical motifs. The upper part shows a decoration of continuous oblique parallelograms, each surrounded by a small arrow starting from the right-hand acute angle. The lower section of the arched opening is painted with a rhomb and square imitating marble revetment and the intrados with a cross in a roundel encircled by intertwined tendrils. The vault of the sanctuary retains its entire decoration, though not in good condition. Simple lines divide it longitudinally into three unequal zones. The middle one contains intersecting circles with rosettes; the left, looped circles with rosettes within the circles and in the interspaces; the right repeats exactly the same pattern on a larger scale.

The tympanum of the south blind arch is covered with intersecting circles forming rosettes, the curve of the arch is circumscribed by a toothed band, and the intrados is filled with a continuous spiral design (Fig. 3). The once vivid colours have now faded into an indistinct yellow-orange tint. The north blind arch has preserved less of its painted decoration. Its wall is horizontally divided into two zones. On the lower and narrower zone, thick black wavy lines imitate marble revetment. The upper zone seems to have been painted with two or three crosses within ornate frames. The best preserved is the one to the east, with a damaged illegible inscription in capital letters around the lower arm of the cross. Remains of a spiral decoration are visible on the intrados.

The painted decoration in St. Artemios, though better preserved, is even more restricted. It covers

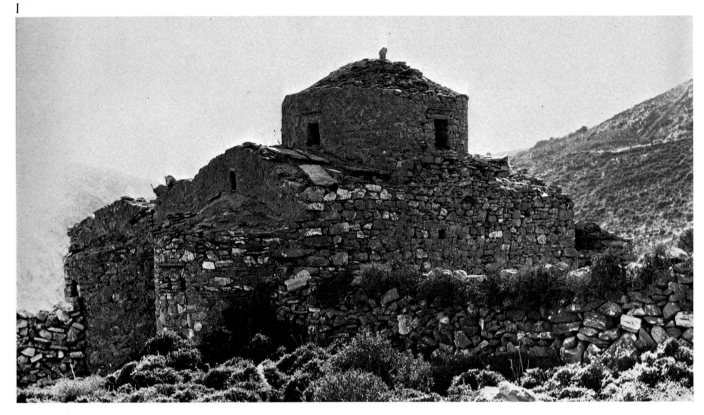

1

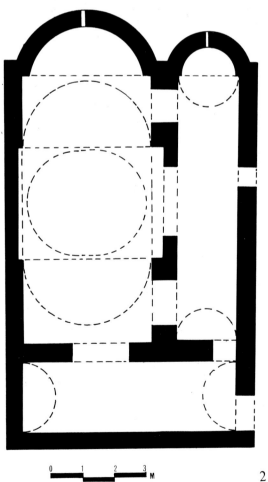

2

1. *Hagia Kyriake. NE view.*

2. *Hagia Kyriake. Ground-plan.*

3. *Hagia Kyriake. Decorative motif on the intrados of the south blind arch of the sanctuary.*

4. *Hagia Kyriake. View towards the sanctuary apse.*

5, 6. *Hagia Kyriake. Panels painted with birds on the curved wall of the sanctuary apse.*

7

7. *Hagios Artemios. Ground-plan.*

only the walls, the vault and the apse of the sanctuary, as well as the east front and the intrados of the east arch.

In the sanctuary apse, below the cornice, are a few remains from a painting imitating marble revetment. The half-dome has preserved in poor condition only a scale pattern (Fig. 12), similar to that of St. Kyriake. The walls of the sanctuary, below the cornice, show few traces of the decoration. It seems that the surface was divided into panels imitating marble revetment in various colours (like those of St. Kyriake). Perhaps some of the panels contained a cross. Immediately above the cornice of the north wall of the sanctuary, the vault has a wide zone divided by one horizontal and many vertical lines into two rows of squares. The squares of the upper row are filled with spirals and those of the lower with spiral tendrils. Both designs are interlinked over the dividing lines. On the corresponding part of the vault above the south wall, a wider zone contains three rows of double volutes, reminiscent of Ionic capitals, interconnected both horizontally and vertically (Fig. 13). Within the volutes, white dots form rosettes while the interstices are filled with stylized leaves and lozenges. Between this zone and

the cornice an inscription in capital letters reads:

ΜΝΗΣΘΗΤΗ K̄Ē TON ΔΟΥΛΟ COY YKONOMON ON ΓΙΝΟΣΚΗ K̄C̄ TA ONOMATA AMHN.

"Remember Lord, thy servant Oikonomos whose names thou knowest. Amen". The position of the inscription, the lettering and the misspelling are reminiscent of similar inscriptions in Cappadocia. The rest of the vault is divided into three unequal zones, exactly as in St. Kyriake. The seriously damaged middle zone, like that of St. Kyriake, shows intersecting circles with rosettes. The lateral zones are divided by horizontal and vertical black lines into small squares which contain alternately: a) a rosette in a circle and b) a rhomb with four heart-shaped leaves at the angles, a circle at the centre, and a trefoil design on the exterior of each side (Fig. 11, 14). No rule or compasses were used for this composition and all straight lines and circles were drawn by a not very careful or steady hand. The east arch has preserved parts of its decoration: on the front a spiral tendril and on the intrados a running spiral, a variation of the motif used in St. Kyriake. The colours are, invariably, white or yellowish against a dark green background.

The decoration in the two monuments presents many similarities and also important differences. In both, the painting is limited to certain parts of the church. A scale pattern decorates the half-dome of the two sanctuary apses, while in both cases the eastern vault is unequally divided into zones with the middle one containing the same motif. Many of the subjects are different (cf. the decoration on the vaults) and so is the quality of the painting. In St. Artemios the decoration is more unrefined, more schematic, and the colouring harsh and unvarying.

These wall paintings, though certainly no masterpieces, are rare in Greece for their type and the extent of their preservation. Their comparative study and dating present difficulties and problems.

Compared with the scant remains of aniconic decorations dated to the Iconoclast period in Thessaloniki, Mani, Nicaea and Constantinople, they have in common the motif of the bejewelled cross, a subject, however, known from earlier times (Ephesus, Sinai), whereas no point of contact seems to exist between the other decorative motifs. A comparison with the aniconic decorations in Cappadocia leads no further, for here too there is a difference of decorative concep-

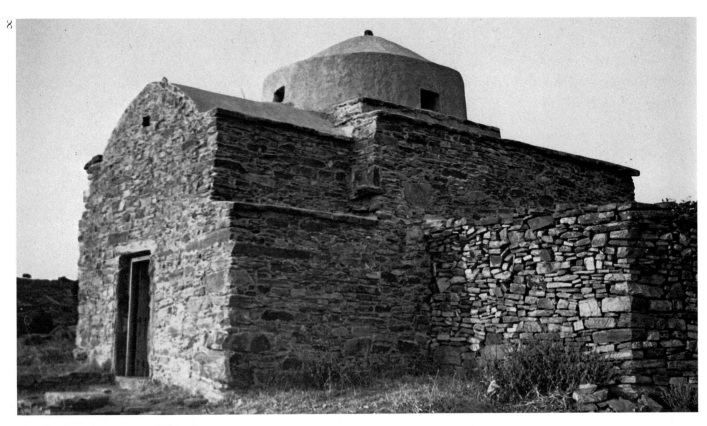

8. *Hagios Artemios. SW view.*

tion and even of repertoire, while subjects common to both paintings are too usual (e.g. looped circles) to be of any help. On the other hand, it is impossible not to associate the wall paintings of these two churches of Naxos (especially that in the apse of St. Kyriake, Fig. 5, 6) with the descriptions made by the iconodules on the manner of church decoration imposed by the iconoclasts (*"Therefore, holy figures were pulled down from all churches and in their stead beasts and birds were set up and painted..."*, as recorded by Theophanes Continuatus in his Chronicle III, 10, Migne P.G. 100, v. 1113). In these texts there is also a reference to Arab influence on the architecture and painting of the iconoclasts, mainly during the reign of Theophilus. These sources and the destruction of monuments dating from the Iconoclast period, make necessary an investigation in this direction, i.e. in monuments of Islamic art. The birds in the apse of St. Kyriake recall depictions of birds on textiles and metal objects of Sassanian and post-Sassanian art of the 6th-9th century. The ribbon-like motif adorning the neck of the birds is also of Sassanian origin — a feature adopted and widely used by Roman and Early Christian as well as Byzantine art. A number of de-

corative motifs in the same church, such as the oblique parallelograms, are found in several variations on textiles from Samarra in Mesopotamia (9th century). In St. Artemios, the painting of the vault with small squares (Fig. 11, 14) seems to imitate a revetment of tiles — a form of decoration well-liked in the East and very common in Islamic art. Again, other subjects (imitation of marble revetment, scales, intersecting circles with rosettes, spirals) belong to a Graeco-Roman tradition continued by Byzantine and Islamic art, though the form prevailing in the two Naxian churches displays a resemblance to 9th century Islamic art (Samarra, Qairawan, Qusayr' Amra, Sus).

Therefore, according to the evidence available to this day, the decoration of these two churches of Naxos is assignable to the 8th-9th century, and most probably to the reign of Theophilus (A.D. 829-842). It is perhaps worth noting that the iconoclastic decorations in St. Sophia at Thessaloniki, St. Eirene at Constantinople and the Dormition at Nicaea, all dated to the 8th century, do not disclose an influence from Islamic art. On the contrary, the general impression given by the aniconic paintings in St. Kyriake and St. Artemios is quite different. The assemblage of a varie-

ty of decorative motifs, the manner in which they are interlinked, the *horror vacui*, suggest an Oriental notion and call to mind Moslem monuments. Besides, the large-scale introduction of Islamic elements into Byzantine art occurred, according to the written sources, during the reign of Theophilus.

Agapi Vasilaki-Karakatsani

Bibliography

A. Vasilaki, «Εἰκονομαχικές ἐκκλησίες στή Νάξο», *Δελτίον Χριστιανικῆς Ἀρχαιολογικῆς Ἑταιρείας,* per. Δ΄, Vol. Γ΄ (1962-63), p. 49-74.

A. Bryer — J. Herrin (ed.), *Iconoclasm,* (Papers given in the ninth Spring Symposium of Byzantine Studies. University of Birmingham 1975), Birmingham 1977.

M. Chatzidakis, "L' art dans le Naxos byzantin et le contexte historique", *XVe Congrès Internationale des Sciences Historiques, Bucarest 10-17 Août 1980: Rapports,* Vol. III, Bucharest 1980, p. 14.

M. Acheimastou-Potamianou «Νέος ἀνεικονικός διάκοσμος ἐκκλησίας στή Νάξο. Οἱ τοιχογραφίες τοῦ ῾Αγίου ᾿Ιωάννη τοῦ Θεολόγου στ᾿ ᾿Αδησαροῦ», *Δελτίον Χριστιανικῆς Ἀρχαιολογικῆς Ἑταιρείας,* per. Δ΄, vol. ΙΒ΄ (1984), p. 329-379.

D.I. Pallas, "Les décorations aniconiques des églises dans les îles de l' Archipel", *Studien zur spätantiken und byzantinischen Kunst,* Fr. W. Deichmann gewidmet, 10(1986), part II, p. 171-179.

9

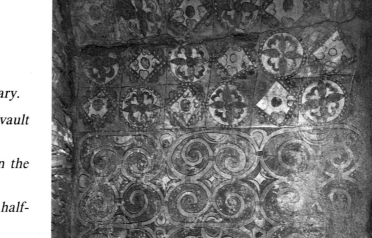

10

9. Hagios Artemios. View torwards the sanctuary.

10. Hagios Artemios. Decorative patterns on the vault of the sanctuary.

11. Hagios Artemios. Detail of the decoration in the sanctuary.

12. Hagios Artemios. Decorative motifs on the half-dome of the sanctuary apse.

13, 14. Hagios Artemios, vault of the sanctuary. Details of the aniconic decoration and a painted inscription.

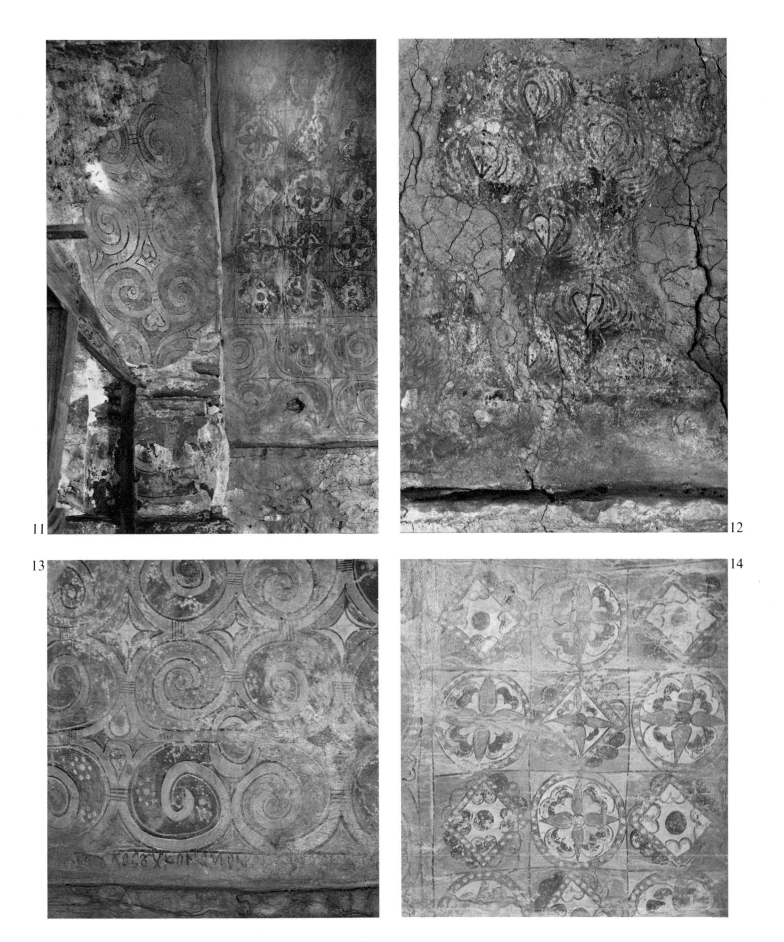

HAGIOS GEORGIOS DIASORITIS

The church of St. George Diasoritis stands in the midst of olive groves in the fertile plain of Tragaia, near Chalki. No information exists on the building and painting of this important monument. In the narthex of later date, the lintel of the door giving access to the main church has preserved part of an illegible painted inscription, in three lines, with invocations for salvation and reference to the Prodigal Son and the Publican (Plan no. 101). In the southeast corner of the narthex, a miniature portrayal of St. Eustathios has an interesting inscription (Plan no. 103, 104), which reads:

<div align="center">

† Δ(ΕΗCΙC) ΤΟΥ ΔΟΥΛΟΥ ΤΟΥ [ΘΕΟΥ]
ΙΩΑΝΝΟΥ ΠΡΩΤΟCΠΑ
ΘΑΡΙΟΥ

</div>

"Invocation of the servant of God Ioannes Protospatharios".

This single reference, probably recording the contribution of a higher Byzantine official to the storying of the church, is of wider significance. In the large church of the Protothrone at Chalki, the known inscription of the year 1052 mentions Nicetas, the previous *Protospatharios* and *Tourmarches* of Naxia, who had participated in the renovation of what seems to have been the episcopal church. The inscriptions of the Protothrone and of St. George Diasoritis suggest that Chalki was an important administrative centre having control over the inland regions of the island during the Middle Byzantine period.

The church of St. George is mentioned as the katholikon of a former monastery. Visible remains of buildings in the surrounding area are scant. In any case, the architecture of the building, the excellent wall paintings of the 11th century and those of later painting layers, the arcosolia in the narthex and the inscription of the *Protospatharios* Ioannes imply that St. George Diasoritis must have been one of the important churches of this region.

From the now lost templon, only the sockets used for its propping remain on the floor and on the walls. The few surviving sculptures are Early Christian architectural members. An ancient inscribed plaque has been used on the lintel of the door leading to the main church.

After its consolidation (A.K. Orlandos), the building is in good condition. The wall paintings have survived to a great extent, but most are incrusted with solidified salts. Works for the conservation and cleaning of the wall paintings have been undertaken periodically, since 1978, by the Second Ephorate of Byzantine Antiquities in the Cyclades. The wall paintings in the sanctuary and partly those in the main church have been cleaned. Questions related to the identification of certain representations and figures, as well as to the distinction of the painting layers and their dating, cannot be answered before completion of the cleaning operations.

Architecture

The church is of the inscribed-cross type, with a dome resting upon four built piers and with a lower narthex to the west. This type is rather rare in Naxos. Slightly irregular in plan, the interior measures 5.40×8.50 m. approximately. The cross arms are barrel-vaulted and the corner bays have an unusual kind of ceiling with two equal barrel-vaults intersecting to form a diagonal groin. The semicircular apse of the sanctuary takes up almost the entire width and height of the eastern cross-arm. Two niches in the parabemata, on either side of the apse, are hollowed into the thickness of the east wall and have projecting altar slabs. Decorative stone mouldings run along the walls marking the springing lines of the vaults in the corner bays and in the cross arms, articulating the surfaces and defining the three registers of the painted decoration. The interior, with its symmetrical and distinct compartments, gives an impression of monumentality.

The narthex was not built much later. It has a vaulted ceiling and is divided into three bays by transverse arches and blind arches on the east and west side. Two arcosolia with now empty tombs were built into the thickness of the north and south wall, opposite each other.

The simple and unadorned exterior of the tile-roofed stone structure shows an effective synthesis of architectural parts with the usual in Naxos semicircular apse and cylindrical drum. The uncovering of a small section of the base walling during recent works has added height to the building. The church is en-

tered by a single rectangular door, with a high reliev-ing arch, on the west side. On the same side, four stone pilasters at regular intervals betray the existence of a portico in earlier times. The pointed single-arched belfry must be of later date. Rising to the left of the door axis, it is an odd structure with proportions that do not match the façade of the church. The interior is dimly lit by a few small windows, either arched or rec-tangular. The little diffused light softens the architec-tural forms and the painted figures and produces an effect of mystic symbolism as it reveals the central cross plan of the church.

Painting

The wall paintings uniformly covering the main church and the sanctuary are thought to have been part of the original decoration of the interior. It is too soon yet to examine the few traces of a possibly earlier painting. The iconographic programme, balanced and orderly, with a hierarchical arrangement of subjects, has the typical marks of 11th century painting. Por-trayals of single saintly figures are prevalent while compositional representations are rather limited. The correct fitting of the subjects to the architectural sur-faces reveals a knowledge of form and function, which puts to advantage the available space and enhances the painting. The whole has a monumental character, producing an effect of hieratic solemnity and deco-rum. The iconographic ensemble shows that art on the island had kept pace with the established programmes for the painting of large contemporary churches of the inscribed-cross type with dome.

Christ Pantocrator in the dome (Plan no. 9) sur-rounded by the full-length figures in the drum (Plan no. 10), and the Virgin and Child in the half-dome of the apse (Fig. 4, Plan no. 1α) are the two focal points of the decoration. The composition in the dome is co-vered with crystalized salts. The representation in the apse is overpainted with a later, probably 12th cen-tury, wall painting of the Panagia Blachernitissa (Fig. 4, Plan no. 1β). Of the original representation (Plan no. 1α) only a small part is visible at the centre: the right hand of the Virgin in front of the Child who extends his hand sideways.

The composition of the apse has a parallel in the Panagia Chalkeon at Thessaloniki, with the Virgin depicted in the half-dome (Fig. 4, Plan no. 1), the frontal standing figures of the hierarchs in the upper register of the curved wall (Fig. 4, 5, 6, Plan no. 2-5), and the portraits of honoured saints below (Fig. 4, 9,

Plan no. 6-8). Hierarchs are also pictured on the three sides —those facing the sanctuary— of the east piers (Fig. 4, 13, 14, Plan no. 11, 18, 51, 52, 64, 65), whereas the west piers are painted with portraits of soldier saints and martyr saints.

The wall paintings of the cross arms (Fig. 4) are divided into three zones. The vaults have Christologi-cal representations from the cycle of the Twelve Feasts. The two lower registers contain busts of saints in roundels (Fig. 4, 15, 16, 18) and full-length figures of saints. Scenic compositions and single figures alter-nate in the two lower zones of the corner bays.

The Evangelical scenes on the vaults of the cross arms are arranged in the usual manner. The south vault shows the Nativity (Plan no. 27) on the east side and the Presentation of Christ in the Temple (Plan no. 28) on the west side. The north vault has the Baptism to the west (Plan no. 46) and the Entry into Jerusalem to the east (Plan no. 47). The entire east vault is paint-ed with the Ascension (Fig. 4, 7, Plan no. 15) and the west with the Pentecost (Plan no. 38). The uppermost zone on the front of the walls is likewise decorated with representations from the Twelve Feasts cycle. The Annunciation (Fig. 4, 8, Plan no. 56-57), which opens the cycle, occupies the customary place in the sanctuary, on either side of the apse. The Archangel Gabriel is pictured to the left and the Virgin, standing under the arched opening of a "marble" structure, is portrayed to the right.

St. George, the Archangel Michael and St. John the Prodrome are given a special place in the icono-graphic programme.

The portrayal of St. George in the sanctuary apse confirms that the church has been consecrated from the beginning to this saint. St. George (Fig. 4, 9, Plan no. 6) is painted in the middle of the third, lower, reg-ister, within an ornate rectangular frame like that of a portable icon. On either side his parents (Plan no. 7, 8) are pictured in roundels within rectangular frames ornamented with a field of tendrils and palmettes. Another three representations are dedicated to the tit-ulary saint of the church. In the Deesis (Fig. 11, Plan no. 36) he is given the place of St. John the Baptist. On the vault of the northwest corner bay he is shown rescuing the princess from the dragon (Plan no. 84). On the south wall of the southwest corner bay he is pictured on horseback killing Diocletian (Plan no. 75).

According to the established programmes of the 11th and 12th centuries, the Archangel Michael and St. John the Baptist are honoured in the parabemata.

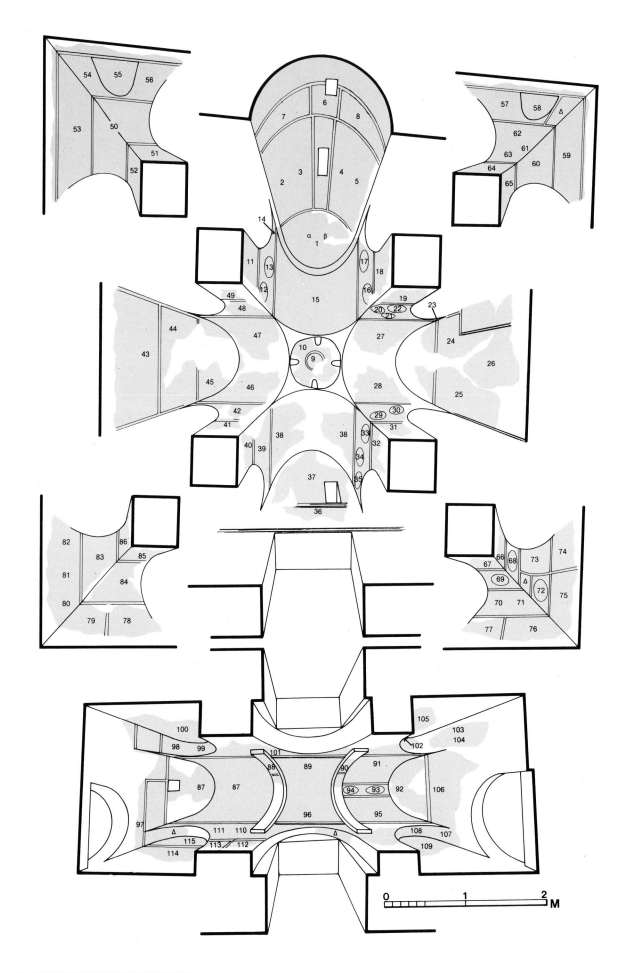

2

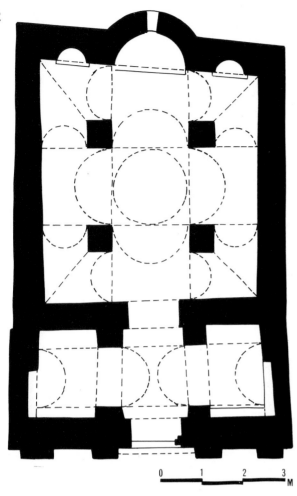

0 1 2 3
M

1α. *The Virgin and Child (fragment).* **1β.** *The Virgin Platytera.* **2.** *St. Gregory the Theologian.* **3.** *St. Basil.* **4.** *St. John Chrysostom.* **5.** *St. Nicholas.* **6.** *St. George.* **7.** *Gerontius.* **8.** *St. Polychronia.* **9.** *Christ Pantocrator.* **10.** *Full-length figures.* **11.** *St. John Eleimon.* **12.** *St. Photios.* **13.** *St. Aniketos.* **14.** *St. Tryphon.* **15.** *The Ascension.* **16.** *St. Floros.* **17.** *St. Lauros.* **18.** *Hierarch.* **19.** *The Virgin and Christ.* **20.** *St. Menas (?)* **21.** *St. Victor.* **22.** *St. Vincentios.* **23.** *Martyr saint.* **24, 25.** *Sts. Anargyroi.* **26.** *Praying female saint.* **27.** *The Nativity.* **28.** *The Presentation of Christ in the Temple.* **29.** *St. Provos.* **30.** *St. Tarachos.* **31.** *Saint.* **32.** *Military saint.* **33-35.** *Busts of saints.* **36.** *Three-figured composition of the Deesis.* **37.** *Unidentified representation.* **38.** *The Pentecost.* **39.** *Busts of saints.* **40.** *Military saint.* **41.** *Saint.* **42.** *Busts of saints.* **43.** *Archangel.* **44.** *Unidentified representation.* **45.** *Unidentified representation.* **46.** *The Baptism.* **47.** *The Entry into Jerusalem.* **48.** *Busts of saints.* **49.** *Unidentified figure (fragment).* **50.** *The Assembly of the Angels.* **51.** *St. Blasios.* **52.** *St. Polycarpos.* **53.** *The Archangel Michael appears to Joshua.* **54.** *St. Stephanos.* **55.** *The Archangel Michael.* **56.** *The Archangel Gabriel from the scene of the Annunciation.* **57.** *The Virgin from the scene of the Annunciation.* **58.** *St. John the Prodrome.* **59.** *The Forerunner preaching in the desert.* **60.** *The Beheading of St. John the Prodrome.* **61.** *The Prophet David.* **62.** *The Prophet Isaiah (?).* **63.** *The King-Prophet Solomon.* **64.** *St. Theophylactos.* **65.** *St. Phocas.* **66.** *Saint.* **67.** *Saint.* **68-73.** *Prophets.* **74.** *Female saint.* **75.** *St. George kills Diocletian.* **76.** *St. Theodore slays the dragon.* **77.** *Female saint.* **78.** *Military saint.* **79.** *The vision of St. Eustathios.* **80.** *St. Julitte with Kerykos (?).* **81, 82.** *The Sts. Helena and Constantine.* **83.** *The Miracle at Chonae.* **84.** *St. George slays the dragon.* **85.** *St. Eustratios.* **86.** *Saint.* **87.** *The Last Judgement.* **88.** *Prophet.* **89.** *The Deesis.* **90.** *St. Damian.* **91.** *Unidentified representation.* **92.** *Unidentified representation.* **93, 94.** *Busts of saints.* **95.** *Unidentified representation.* **96.** *The Parable of the ten virgins.* **97.** *The Parable of the rich man and the beggar Lazarus.* **98.** *Saint.* **99.** *Saint.* **100.** *St. George (?).* **101.** *Inscription.* **102.** *Hierarch.* **103.** *Inscription of Ioannis the Protospatharios.* **104.** *St. Eustathios.* **105.** *Saint and male figure in prayer.* **106.** *Hierarchs.* **107.** *St. Simeon Stylites.* **108.** *Stylite saint.* **109.** *The Crucifixion.* **110.** *Saint.* **111.** *Saint.* **112-115.** *Unidentified representations.*

3

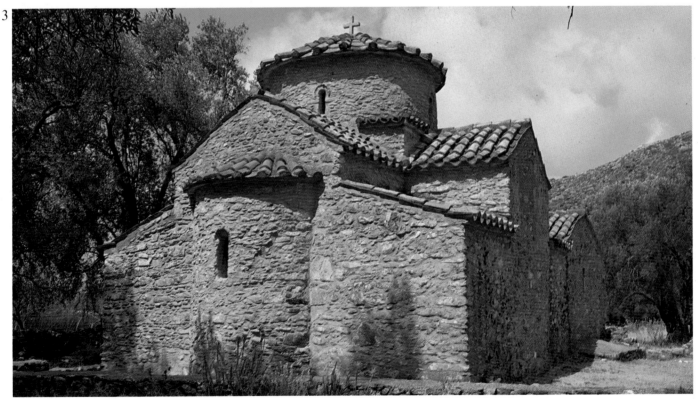

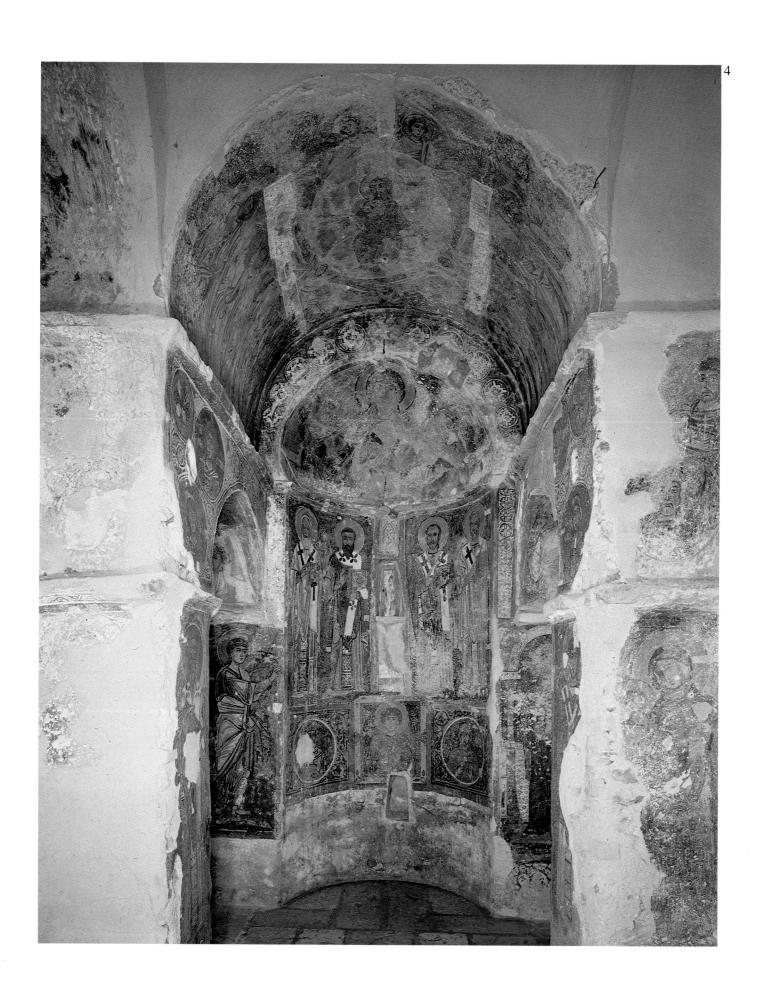

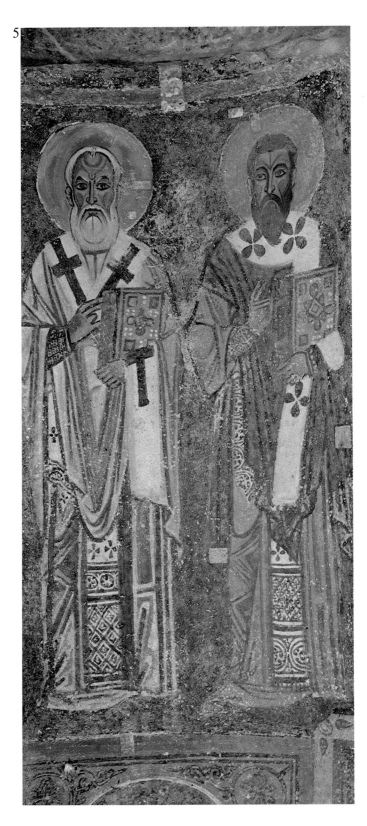

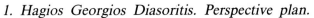

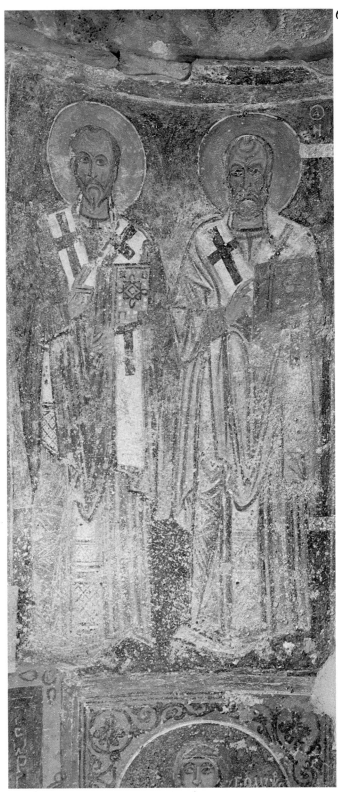

1. *Hagios Georgios Diasoritis. Perspective plan.*
2. *Hagios Georgios Diasoritis. Ground-plan.*
3. *Hagios Georgios Diasoritis. NE view.*
4. *Hagios Georgios Diasoritis. View towards the sanctuary.*

5. *Hagios Georgios Diasoritis, sanctuary apse. St. Gregory the Theologian and St. Basil (detail of Fig. 4).*
6. *Hagios Georgios Diasoritis, sanctuary vault. St. John Chrysostom and St. Nicholas (detail of Fig. 4).*

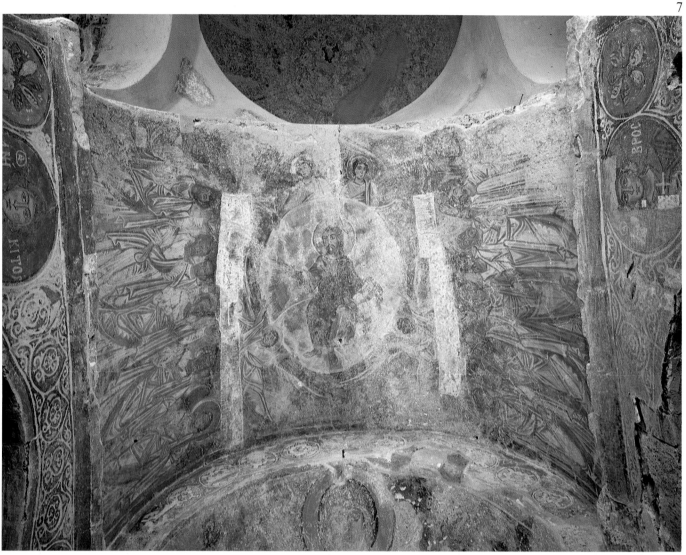

7. *Hagios Georgios Diasoritis, sanctuary vault. The Ascension.*
8. *Hagios Georgios Diasoritis, sanctuary. The* Archangel Gabriel *(detail of Fig. 4).*
9. *Hagios Georgios Diasoritis, triptych painted in the sanctuary apse. St. George (detail of Fig. 4).*

The Archangel Michael is portrayed, standing and holding a sceptre, in the niche of the prothesis (Plan no. 55) and the Forerunner, holding a cross, in the niche of the diaconicon (Plan no. 58). In the prothesis, to the left of the niche, St. Stephanos the Archdeacon (Plan no. 54) is depicted censing towards the Archangel. A large composition on the north wall of the prothesis shows the Archangel Michael appearing to Joshua (Fig. 10, Plan no. 53). The double vault is decorated with the *CYNAΞIC TΩN ACΩ[MA]TΩN* ("the Assembly of the Bodiless", i.e. of the Angels) (Fig. 17, Plan no. 50): six angels holding sceptres are pictured with the lower part of their bodies "missing". The Archangel Michael is depicted again on the vault of the northwest corner bay, which is painted with the

scene of the Miracle at Chonae (Plan no. 83). The scene on the south wall of the diaconicon shows the Forerunner preaching in the desert (Plan no. 59). Addressing the Pharisees and Sadducees to the right, he points to the left, where *"the axe is laid unto the root of the trees"* (Matthew 3, 7-10, Luke 3, 7-9). The south part of the vault shows the *AΠOTOMH TOY ΠPOΔPOMOY* ("the Beheading of the Forerunner") (Fig. 12, Plan no. 60), and the east part the King-Prophets David (Plan no. 61) and Solomon (Plan no. 63) and possibly the Prophet Isaiah (Plan no. 62). The prophets hold unrolled scrolls inscribed with passages referring to Sion and, in a symbolic projection, to the Holy Virgin, who is painted to the east. Their presence emphasizes the prophetic function of "St. John,

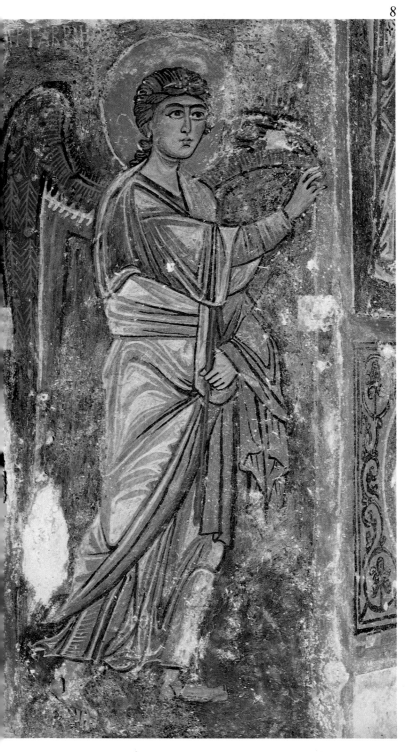

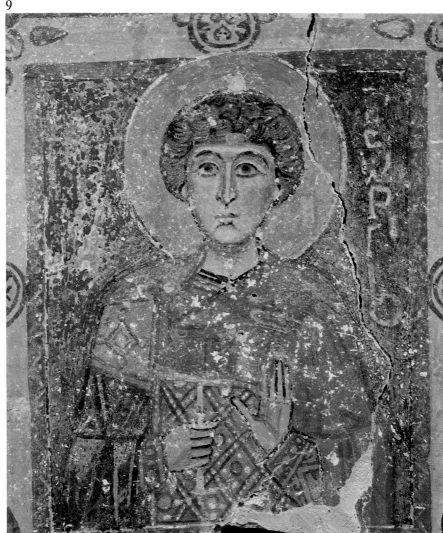

the Prophet, Forerunner and Baptist" (Liturgy of St. John Chrysostom). Elijah, Zechariah, Jonah and other prophets are portrayed on the double vault of the southwest corner bay (Plan no. 68-73). Three of the six prophets are painted in roundels set on a field of tendrils and palmettes.

The wall paintings are covered at places by a second painting layer. As already mentioned the Virgin Blachernitissa in the half-dome of the sanctuary apse belongs to this second layer, which also includes: the lovely full-length Virgin carrying the Christ Child on the right arm (Fig. 4, Plan no. 19), painted on the west side of the southeast pier in a style which differs from that of the Virgin in the half-dome; the large-scale figure of the Archangel Michael (Plan no. 43), pictured in the lower register on the north wall of the northern cross arm, and the orant female saint depicted opposite, on the south wall of the southern cross

10. Hagios Georgios Diasoritis, N. wall of the prothesis. The Archangel Michael appears to Joshua.

11. St. George Diasoritis, W. wall. St. George from the Deesis.

12. Hagios Georgios Diasoritis, double vault of the diaconicon. The Beheading of St. John the Baptist (detail).

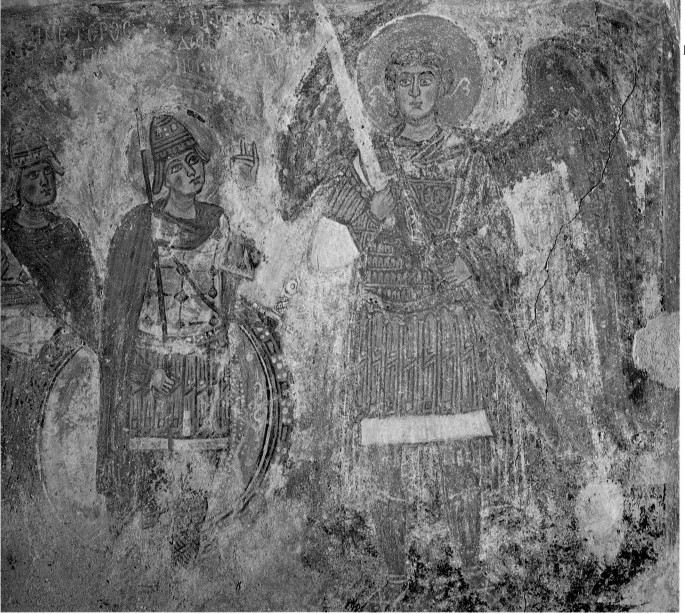

arm (Plan no. 26), both works of the 13th century that can be attributed to the same artist; some small fragments of wall paintings in the northwest corner bay. Restricted to the half-dome of the apse and the lower registers of walls, they are all partial overpaintings that cannot be associated with certainty with one of the decorative phases of the narthex.

Two or three layers of wall paintings, perhaps of the 12th century or later, are also found in the narthex. Some are covered with crystalized salts while others are completely ruined. Here the figures are painted on a smaller scale, fitted to the area available. The use of the narthex for entombments is evident in the iconographic programme. The three-figured composition of the Deesis (Plan no. 89), the Judge of the Second Coming (Plan no. 87), with the Forerunner, the angels and the Apostles, the scene of Hell with the "fiery angel", as recorded in the inscription, and the damned in the coils of snakes, the rich man and the

beggar Lazarus (Plan no. 97), and the Parable of the ten virgins (Plan no. 96) are among the visible subjects painted together with a great many inscriptions in the central and the northern bay of the narthex. On the east blind arch of the southern bay, the figure of a saint is visible at the centre. To the left, painted on a smaller scale, a donor or departed is shown standing in attitude of prayer (Plan no. 105). To the right, barely visible in the corner, St. Eustathios (Plan no. 104) is pictured on horseback in a small-scale painting resembling a portable icon with the supplicatory inscription of Ioannes the *Protospatharios* (Plan no. 103). This is perhaps a painting of the second layer and so makes difficult an association of the inscription with the figure of the praying donor on the tympanum of the blind arch, which is part of the original decoration. The figure in prayer is of particular interest. The man's proud bearing and his attire denote a person of authority. He is dressed in the fashion of 11th century

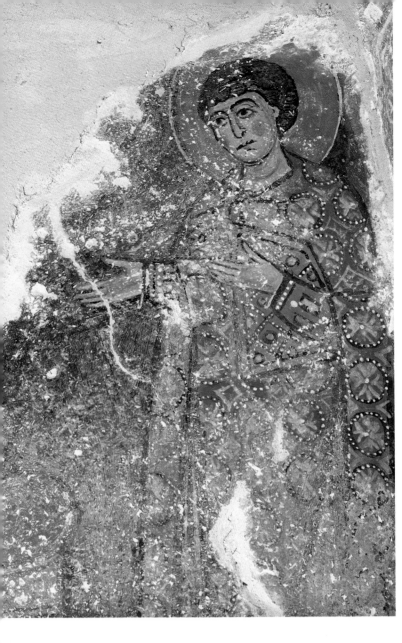

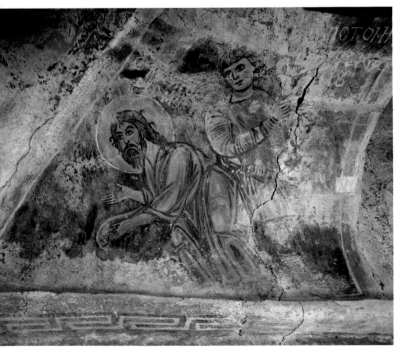

court officials of Constantinople, as they are pictured in miniature illustrations in Pseudo-Oppian's *Cynegetica,* Venice, and in the *Homilies* of St. Gregory of Nazianzus, Moscow (Julian and officials): he wears an inner garment with a very high striped collar and a girded overcoat with *appliqués* strips on the sleeves, open in front, with wide lapels reaching to the shoulders.

The original wall paintings

The original decoration of the church, to which reference can be made today, has been preserved to an extent unique for Naxos and the wider island area of the Aegean. The only other contemporary example surviving to a similar extent is the mosaic decoration of the Nea Moni in Chios. The gradual uncovering of the wall paintings and their cleaning from the crystalized salts will permit a more thorough study of both the iconographic programme and the painting style.

The most important of the remarkable iconographic representations is that of the honoured St. George in the sanctuary apse, with his mother Polychronia to his left and an elderly saint to his right (Fig. 4, 9, Plan no. 6-8). The noble venerable figure of the latter, traces of the name inscription and the position of the portrait, corresponding to that of Polychronia's portrait, at the side of the great martyr, permit an identification with the saint's father, the senator Gerontius. Shown in the dress and posture of martyrs, like St. George, Gerontius and Polychronia take the place of accompanying figures in an iconic composition of genealogical character, revealing an interesting aspect of the particular veneration in which the saint was held. We find again Gerontius and Polychronia in the 13th century wall paintings of the church of St. George Xiphephoros at Apodoulou. Amariou in Crete. Portrayed standing and holding the martyrs' cross, on the pilasters, they flank the riding figure of St. George, painted on the tympanum of the north blind arch.

The honourary place of the triptych in the apse of the Diasoritis, in the lower register of the curved wall, behind the altar where —as in our days— devotional icons were kept to be brought out and placed on the icon-stand on feast days, is rather unusual. Similar instances are encountered in the Panagia Chalkeon and in three churches of the 12th and 13th century: the Panagia at Asinou, Cyprus, the Holy Apostles at Perachorio, Cyprus, and the Hagios Vasilios at Gefyra, Arta. Also unusual is the frame of St. George's por-

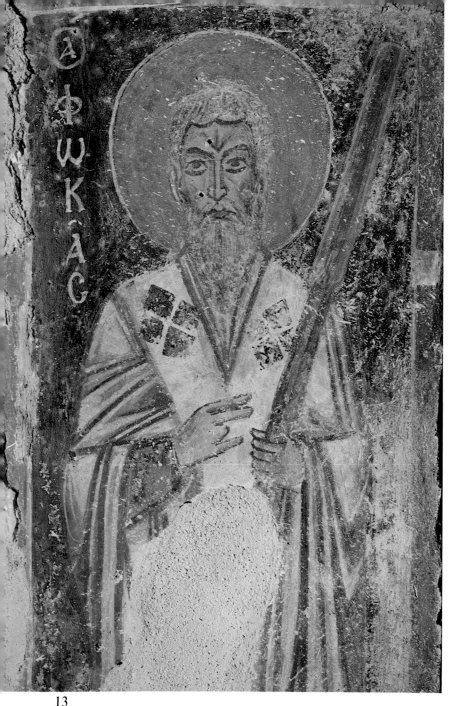

13

13. *Hagios Georgios Diasoritis, diaconicon. St. Phocas.*

14. *Hagios Georgios Diasoritis, sanctuary. St. John Eleimon.*

trait, which is decorated as if it were that of a portable icon, like those of wall paintings in the church of St. Barbara at Sighanle, Cappadocia. The whole representation, perfectly set on the curved wall of the apse in the small church of St. George Diasoritis, has no parallel. Its position and arrangement, its iconic completeness and the particularity of the subject suggest the existence of a portable triptych which may have served as model for this wall painting — perhaps a triptych owned by the founder of the church, who wished to have it painted on the wall of the apse. The founder's eventual participation to a certain extent in the formation of the iconographic programme can be detected in further characteristic parts of the decoration, which suggest that the expense for the storying of the church may have been defrayed by an officer of

the army or a person of his entourage acting on his behalf. There are many relevant indications.

The entire arrangement and quality of the paintings are of wider interest, exceeding the limited boundaries of this particular island. They also make possible the detection of the ideal which links the iconographic structure of this work to the wishes of the unknown founder.

Two groups of painters seem to have worked for the painting decoration of St. George Diasoritis. One group is responsible for the greater part of the decoration. The noticeable differences in the painting of the northwest compartment, though not due to an essential change of style, indicate that it was executed by another hand.

The technique used is a mixed one: fresco painting

and, when dry, addition of distinctive details in the modelling of the faces, the drapery and the decorative elements. The working sequence is visible in various parts, for example in the triptych of the apse, the top part of which overlaps the representation of the hierarchs, and in the painting of the Archangel Gabriel, to the left, which covers a small part of the triptych.

The representations in the sanctuary apse, part of the scene of the Ascension and other compositions are painted by the hand of a master. The host of figures on the northern side of the Ascension is perhaps by a second painter. A third one probably did the wall paintings in the parabemata.

The cleaned parts of the wall paintings disclose the knowledge and experience of the master painter, who organized the iconographic programme with conciseness and order. Rhythm, symmetry and clarity are his principal qualities. The proper arrangement, relation and balance between subjects on the available surfaces are organized with a geometric precision and a monumental consistence conveying the reserved and serene spirit of 11th century painting. Axial divergences, coincidences and oppositions give life to the whole representation and movement to the action.

The balanced composition of the apse (Fig. 4, Plan no. 1-8) is a characteristic example. The vertical disposition of the hierarchs' figures is counterbalanced by the horizontal development of the triptych, below, while the prominent position of St. George on the vertical axis in counterpoised by the dominant figure of the Virgin high on the half-dome. In the scene of the Ascension (Fig. 4, 7, Plan no. 15) four ethereal angels in harmonious pairs lift a glory painted with shafts of light and the figure of the Ascending Christ. On either side the disciples, led by an angel, stand in solemn postures befitting the miraculous event. Their thoughtful countenance and expressive gestures denote agitation, astonishment, sadness — feelings that are impressed on the onlooker in a more direct manner through the disordered heavy and intricate drapery of their garments. The composition depicting the Beheading of St. John the Baptist (Fig. 12, Plan no. 60) is adapted to the triangular shape of the vault. The young executioner stands to the right, lifting his sword. In front of him, to the left, the figure of St. John, who bends his body and extends his hands, fills the remaining space. In the corner, opposite the beheader, the tower of a gaol indicates the place of the action and adds, by its position in the curve of the vault, an impression of depth to the whole scene. The

Appearance of the Archangel Michael to Joshua (Fig. 10, Plan no. 53) and the Preaching of St. John the Baptist (Plan no. 59) show the participants in array, a disposition suitable for flat surfaces, while the proportional arrangement intensifies the narrative quality of the composition. The placing of the Archangel Michael and of St. John somewhat off the central axis imparts an effect of agility to the representation and makes possible the viewing of the principal figures through the arched openings leading from the holy bema to the prothesis and the diaconicon.

The single figures of saints, painted either frontally or turned sideways, have a stately imposing appearance, regular proportions and broad high shoulders. Their faces have clear-cut features and wide-open eyes, usually glancing to one side and made larger by the shadow of the lashes. The repetitive uniformity of posture and gesture emphasizes the solemn priest-like look and produces an effect of unearthly peace — a tranquility reached after the turmoils and anxieties of life that are reflected on the faces of the saints and give warmth to their features. This tenseness is sustained by the raised eye-brows and the furrows of the austere yet compassionate countenance of the aged saints with the fiery eyes (Fig. 5, 6, 13, 14). Young saints have pure mobile features, bright eyes and an imperceptible smile that softens the grave expression (Fig. 15-18). The deep folds, which "carve" successive shapes into the garments, mould, dissolve and recompose forcefully the position and movements of the invisible limbs. The colour, which gives depth and light to the linear forms, smooths the contours and imparts a relief-like quality to the figures.

Countenances vary in a pursuit leading almost to the individualization of facial features, but always within the limitations and possibilities prescribed by conventional iconography. A typical example is provided by the peculiar cast of features of St. Nicholas' portrait in the apse (Fig. 6, Plan no. 5). The painting has as a model a rare icon kept in St. Catherine's Monastery at Sinai. Similarly, the varied figures of angels in the Ascension and in the scenes of the prothesis (Fig. 7, 17) reveal a wealth of accumulated experience and indicate the tendencies and potentialities of the painter or painters of the Diasoritis. The Archangel Gabriel of the Annunciation (Fig. 8, Plan no. 56), and also the angel leading the Apostles on the northern side of the scene of the Ascension (Fig. 7, Plan no. 15), have plump round faces with rosy cheeks that call to mind the mosaic portraits of the Emperor

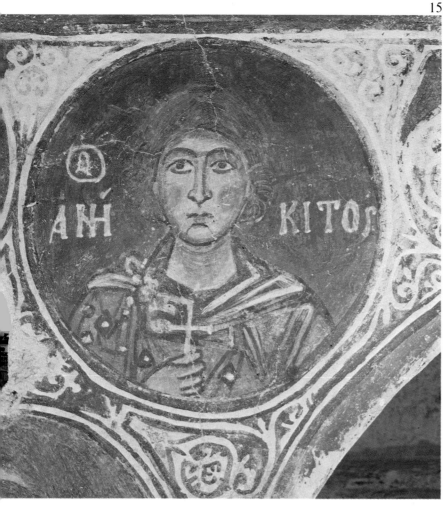

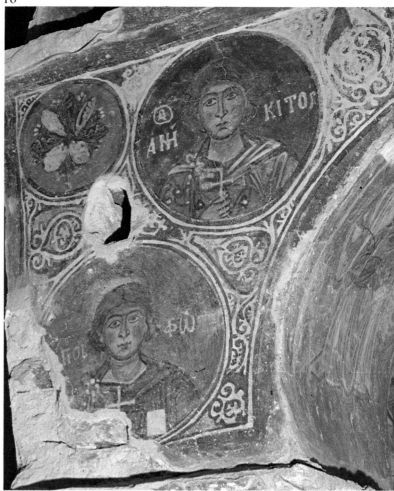

15. *Hagios Georgios Diasoritis, sanctuary. St. Aniketos.*

16. *Hagios Georgios Diasoritis, sanctuary. St. Aniketos and St. Photios.*

Constantine Monomachus and the Empress Zoe at Hagia Sophia in Constantinople. On the southern side of the Ascension, the angel with the big exquisite eyes in a face of disarming youthful sensitivity and beauty comes very close to classical models. The two angels at the top of Christ's glory present a contrast. The one to the left is an ethereal figure painted in a manner that can be traced back to ancient tradition. The other, to the right, has a tender serious face modelled with clear undisturbed lines, like those of the other angels in the Assembly of the Angels.

The combination of line and colour, the often pronounced schematization, and the rich chromatic scale of shades and tones are distinctive marks of the paintings in St. George Diasoritis and define their expressive and rather peculiar style. The line is of primary importance: in broad and usually clear strokes of the brush it draws, insisting on form and detail with a striking forceful effect. The persistent use of line is more evident in the garments of the holy figures — for example, of St. John Eleimon (Fig. 14, Plan no. 11), of the Archangel Gabriel (Fig. 8, Plan no. 56), of the angels and Apostles in the scene of the Ascension (Fig. 7, Plan no. 15) — where it decomposes and divides planes into complex angular and curvilinear shapes forming a pattern of multiple motion. Colour plays an important part in the dispersion and restructure of the disrupted many-faceted planes into a painted surface of uniform style and cohesion. The wheat-coloured or sun-tanned faces are modelled with clarity and flexibility. Features and volumes are painted in flowing or vigorous lines, in the case of elderly wrinkled saints. Warm tones alternate with green shades along the edges which highlight the red spots on the cheeks and create lively countenances. In the northwest bay the modelling and colouring are of a lower tone. The palette is of lighter tints, the drawing is finer and the drapery simpler.

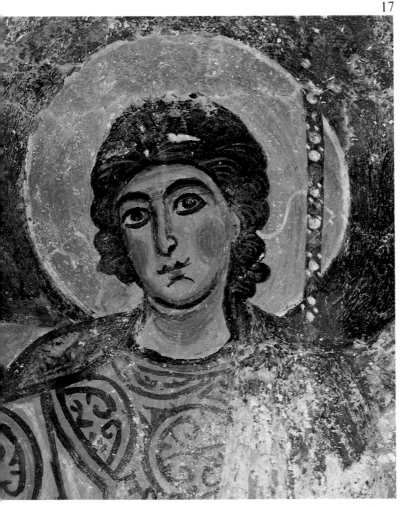

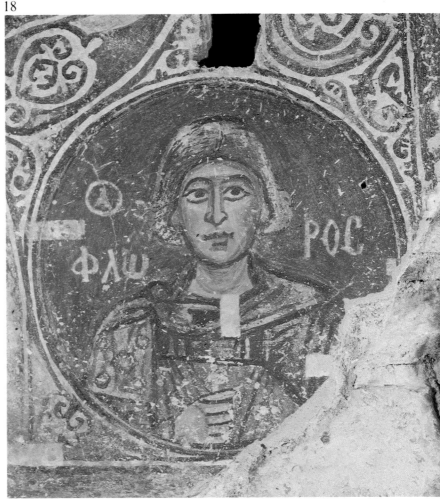

17. Hagios Georgios Diasoritis, prothesis. Angel from the Assembly of the Angels (detail).

18. Hagios Georgios Diasoritis, sanctuary. St. Floros.

A classification of the wall paintings of the Diasoritis to a group of other closely related works is not easy. Comparison of some parts with wall paintings in the Panagia Chalkeon and in Hagia Sophia at Thessaloniki, in Qarabach Kilisse at Cappadocia, in the Protothrone at Naxos, in St. Merkourios and St. Nicholas at Corfu, with mosaics and wall paintings in S. Sophia at Kiev and other works, suggest a dating after the mid-11th century. The wall paintings of St. George Diasoritis have certain common characteristics with those of the nearby church of the Protothrone, particularly with the dome painting of the second layer and the paintings of the south cross arm and the northwest parecclesion. They share common traits of style, but even more the ethos reflected in the holy figures, and reveal a relation between the two monuments justified by their proximity in place and time.

Myrtali Acheimastou-Potamianou

Bibliography

G. Demetrokallis, «῾Ο Ναός τοῦ ῾Αγίου Γεωργίου τοῦ Διασορίτου εἰς Τραγαίαν Νάξου», *Τεχνικά Χρονικά*, Aug. 1962, No. 217, p. 17 ff.

Id., *Συμβολαί εἰς τήν μελέτην τῶν Βυζαντινῶν Μνημείων τῆς Νάξου*, Vol. Α΄, Athens 1972, p. 29, ff.

M. Acheimastou - Potamianou, «Βυζαντινά μεσαιωνικά καί νεότερα μνημεῖα Νήσων Αἰγαίου», *᾿Αρχαιολογικόν Δελτίον*, Vol. 33 (1978): *Χρονικά*, p. 345-346, Pl. 165γ-168.

Id., «᾿Εφορεία Βυζαντινῶν ᾿Αρχαιοτήτων Κυκλάδων», *᾿Αρχαιολογικόν Δελτίον*, Vol. 34 (1979): *Χρονικά*, p. 373-374, Pl. 174-177α.

Id., «῾Ο ναός τοῦ ῾Αγίου Γεωργίου τοῦ Διασορίτη στή Νάξο, Παρατηρήσεις στίς τοιχογραφίες τοῦ 11ου αἰώνα», Δ΄ Συμπόσιο Βυζαντινῆς καί Μεταβυζαντινῆς ᾿Αρχαιολογίας καί Τέχνης, *Περιλήψεις ἀνακοινώσεων*, Athens 1984, p. 8, ff.

HAGIOS NIKOLAOS AT SANGRI

The church of St. Nicholas stands in the fields, a short distance SE of Sangri, in an area strewn with small and often frescoed Byzantine churches. Although we have no information on the date the church was built, a surviving inscription painted on the cornice of the sanctuary conch records the date of the later layer of wall paintings. The inscription reads:

(Ἱ)στορήθει ὁ θεῖος κ[(αί)πανσε]πτος ναός τοῦ ὁσίου (πα-τρό)ς ἡ(μ)ῶν Νικο(λάου) ...(ανα)γνώστου κ(αί) τῆς συμ-βίου αὐτοῦ Εἰρήνης † ἔτος ͵ϚΨΟ�App Ινδ(ικτιῶνος) ΙΓ.

"This holy and most venerable church of our Father St. Nicholas was storied... reader and his wife Eirene in the year 1270".

We know, therefore, that this painting layer is dated to A.D. 1270. The few investigators, who occasionally gave their attention to the church, advanced different views on the dating of the monument. N. Kalogeropoulos believed that the older layers "are to be assigned to the 9th - 10th century", while K. Kalokyris was of the opinion that the year 1270 refers to the earliest layer. Recent works have established that this dated inscription belongs to the latest of the three painting layers.

Architecture

This elegant and charming church (Fig. 3) is of the single-aisled domed type customary in Naxos. The dome and its cylindrical drum rest upon four arches, of which two are built into the thickness of the north and south walls. The recesses of the lateral blind arches and the projecting pilasters of the east and west arches divide, in a way, the interior into three parts. From the outside this division is discernible in the different levels of the roofing.

There are only four lights in the dome and one in the apse. Traces of a door can be seen on the south wall. The simple compact masonry is of common flat-shaped stones and its warm earthy colours make the church look like a part of the natural scenery. A few white stones —used as cornerstones to strengthen the building— define unobtrusively the outline of the church. The roof is gabled and vaulted in the interior.

The sanctuary has preserved part of a simple epis-copal throne and the built altar, which incorporates an archaic Doric capital. The base of a Roman sprinkler served as prothesis, while the templon has not survived.

The very good condition of the building required only minor consolidation works (re-tiling of the roof etc.) by the Archaeological Service. The absence of windows makes available in this church of relatively small dimensions many flat and curved surfaces suitable for a painted decoration.

Painting

The church must have been painted twice or perhaps, in places, three times. The third layer, dated to 1270, is the best preserved. The compositions that have been cleaned in the apse and the east vault (Fig. 4) belong to this layer.

The state of preservation of the wall paintings in the naos is as follows: none have survived in the dome. The greater parts of the painted pendentives and tympana are still covered with crystalized salts. The north tympanum is badly damaged but the lower part of the wall has preserved, in fairly good condition, small portions of two earlier layers (Fig. 6). The paintings of the eastern section, especially those of the vault, appear as if burnt, and those of the south wall are in the same condition.

The wall paintings of 1270 are arranged as follows: The half-dome of the sanctuary is dominated by the figure of the Panagia Blachernitissa (Fig. 5, Pl. no. 4). Lower, on the curved wall, St. John Chrysostom (Plan no. 1) and St. Basil (Fig. 7, Plan no. 2) are shown co-officiating. The central part, today ruined, was probably painted with the *Melismos*. The narrow parts of the east wall on either side of the apse are decorated with a representation of the Annunciation in two halves — the angel on the north part (Plan no. 6) and the Virgin, standing in front of a small throne, on the south part (Fig. 8, Plan no. 5). The front of the arch of the conch is painted with the Holy Mandelion at the centre (Fig. 5, Plan no. 9), with the busts of the Apostles Peter (Fig. 5, Plan no. 8) and Paul (Fig. 5, Plan no. 10) to the left and right, and, lower, with the half-length portraits of St. Eleutherios (Fig. 5, Plan

no. 7) and St. George Diasoritis (Fig. 5, Plan no. 11). The north wall of the sanctuary shows standing full-length St. Stephanos the Protomartyr (Plan no. 17) and, possibly, St. Nicholas (Plan no. 18). The south wall has three bishops wearing *polystavria* (Plan no. 12, 13, 14).

The soffit of the east arch is painted with the standing full-length figures of the Sts. Anargyroi, Cosmas (Plan no. 20) and Damian (Plan no. 22), while the soffit of the west arch is painted with the Apostles (Plan no. 36, 37). The north wall has three layers of wall paintings. A half-ruined representation of the Sts. Constantine and Helena belongs to the layer of 1270 (Plan no. 33, 34). From the second layer we have a fairly well preserved archangel (Fig. 9, Plan no. γ) wearing imperial garments and standing in an attitude of worship towards the enthroned Christ (Plan no. β), and part of an inscription reading: Θεοφιλεστά-του ἐπισκόπου... ("of the Right Reverend Bishop..."). A painting of the Virgin and Child (Fig. 6) probably belongs to this layer.

The decoration of the pendentives also belongs to the layer of 1270 and shows, alternately, *tetramorpha* (Fig. 10, Plan no. 27, 29) and *hexapteryga* (Plan no. 28, 30). The keystones of the arches are decorated with rosettes.

The walls of the west part are covered by successive painting layers. One of them, on the south wall, has preserved a portrayal of St. Mercurios on horseback (Plan no. 38) and fragments of an inscription:

...Μιχ του Μιτζου...

From the cycle of the Twelve Feasts the third layer (1270) includes eight scenes adapted to the available surfaces and the small size of the church. The storying starts from the east wall, where, as already mentioned, the scene of the Annunciation (Plan no. 5, 6) is painted. It continues with the Nativity (Fig. 11, Plan no. 15) and the Baptism (Fig. 13, Plan no. 16) on the east vault, the Transfiguration (Plan no. 32) on the tympanum of the north blind arch and the Crucifixion (Plan no. 26) on the tympanum of the south blind arch, then with the Entry into Jerusalem (Plan no. 39) and the Anastasis (Descent into Hell) (Plan no. 40) on the west vault, and, last, with the scene of the Dormition (Plan no. 42) on the west wall. A departure from the established programme is noted in the decoration of the pendentives, where the Evangelists are replaced by *hexapteryga* (six-winged angels) and *tetramorpha* — though a tetramorph is, in fact, a figure combining the symbols of the four Evangelists. A certain particulari-

ty is also noted in the painting of the front of the sanctuary arch with the portrayals of the two leading Apostles and, especially, of St. Eleutherios and St. George Diasoritis.

The composition of the Nativity is in accordance with the known iconography, without the Adoration of the Magi. The shape of the mountain departs from the usual triangular form and is extended to encompass most of the separate subjects: the relatively small cave with the built manger and the reclining figure of the Virgin (Fig. 11), the Bath of the Infant Christ in a richly decorated basin (Fig. 11), Joseph with the old shepherd standing behind him, and the other shepherd playing on a long wind instrument (Fig. 12). The costume and haircut of this last figure are Frankish and his presence is the most interesting iconographic innovation of the composition, because it supplies a lively testimony of the history of Naxos in the time of the Venetian Sanudi.

The compositions lack depth, but some of the figures reveal realistic tendencies. In the scene of the Nativity colour is a very important factor. Against the deep blue of the sky, the mountain, in warm light hues of ochre, is dominated by the reclining figure of the Virgin, who is highlighted in blue and crude red colours. Secondary figures in lighter tints fill the lower part of the composition.

Two flat-painted mountains compose the setting for the scene of the Baptism: a reddish one, to the left, with the extremely ascetic figure of the Forerunner and a greenish one, to the right, with the three angels. An unusual feature is the personification of the Jordan River as an old man who, from the waist down, has a scaled fish tail. This composite figure calls to mind Hellenistic zodiac symbols expressed in a popular medieval manner. The slender schematized figure of Christ (Fig. 13) is painted with an almost geometric simplification of the anatomical forms and the posture of the body is reminiscent of a distant classical model. The green preliminary underpaint used for the painting of St. John the Baptist increases the leanness and spirituality of the schematic figure.

Today, the painting layer of 1270 dominates the interior of the church, while surviving small parts of the two earlier layers permit some comparisons. The head of the Virgin (Fig. 6) in the layer with the green preliminary underpaint reveals a composure and freedom of design of classical conception, datable to the late 9th or the 10th century. The Virgin and Christ of the second layer have more intense expressions. The

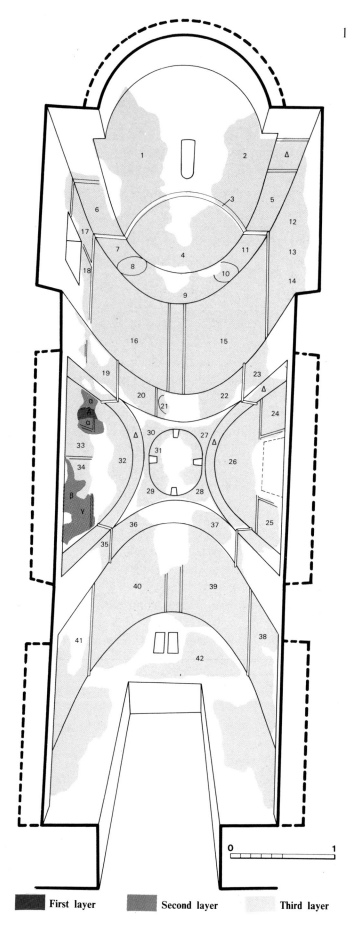

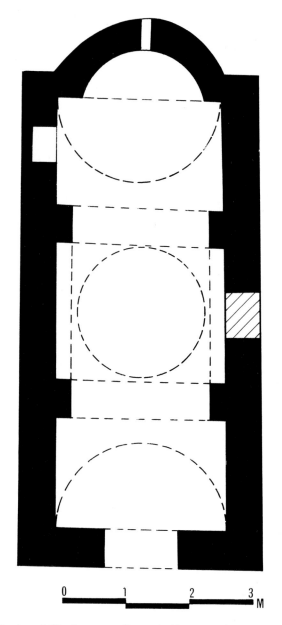

First layer **Second layer** **Third layer**

1. *Hagios Nikolaos at Sangri. Perspective plan.*

2. *Hagios Nikolaos at Sangri. Ground-plan.*

HAGIOS NIKOLAOS AT SANGRI

First layer. A. *The Virgin.* **Second layer. α.** *The Virgin and Child.* **β.** *Christ Pantocrator.* **γ.** *Archangel.* **Third layer. 1.** *St. John Chrysostom.* **2.** *St. Basil.* **3.** *Inscription.* **4.** *The Virgin Platytera.* **5.** *The Virgin from the scene of the Annunciation.* **6.** *The Archangel Gabriel from the scene of the Annunciation.* **7.** *St. Eleutherios.* **8.** *St. Peter the Apostle.* **9.** *The Holy Mandelion.* **10.** *St. Paul the Apostle.* **11.** *St. George Diasoritis.* **12, 13, 14.** *Hierarchs.* **15.** *The Nativity.* **16.** *The Baptism.* **17.** *St. Stephanos.* **18.** *St. Nicholas.* **19.** *Saint.* **20.** *St. Cosmas.* **21.** *Saint.* **22.** *St. Damian.* **23, 24, 25.** *Saints.* **26.** *The Crucifixion.* **27.** *Tetramorphon.* **28.** *Hexapterygon.* **29.** *Tetramorphon.* **30.** *Hexapterygon.* **31.** *Traces.* **32.** *The Transfiguration (traces).* **33.** *St. Constantine.* **34.** *St. Helena.* **35.** *Saint (traces).* **36, 37.** *Apostles.* **38.** *St. Mercurios on horseback (fragment).* **39.** *The Entry into Jerusalem (traces).* **40.** *The Descent into Hell (traces).* **41.** *Traces.* **42.** *The Dormition of the Virgin (traces).* **Δ.** *Decorative motif.*

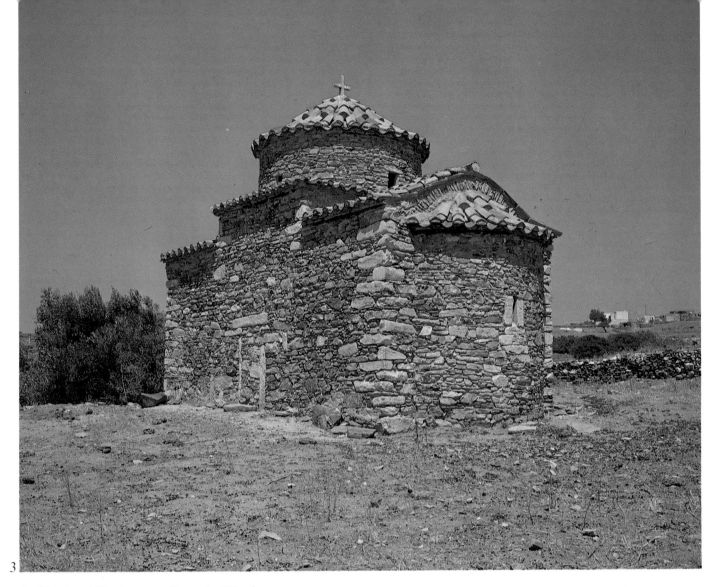

3. *Hagios Nikolaos at Sangri. SE view.*

surviving archangel of the second layer (Fig. 9), with the fine expression, the gentle inclination of the head, the ethereal body under the ornate imperial robe, reminds one of Comnenian art. By contrast, the Nativity, the Baptism and the portrait of St. George Diasoritis from the painting layer of 1270 are "expressionistic" and anticlassical. Here the linear element is the chief medium of expression, defining the elongated form of hunan figures and the details of the flat scenery. Lines are often intricate, intersecting and agitated as, for example, in the painting of the Virgin of the Nativity.

The figures of the compositions have no volume and move in a chromatic field without depth, functioning only with the intensity of the colours: the warm ochre hues of the Nativity, the red and vivid green of the Baptism. A lively green underpaint is used to model the faces and naked parts of the bodies on which details are added or highlighted in broad white strokes of the brush. Spots of crude red enliven the cheeks, as can be seen in the better-preserved portrait of St. George Diasoritis.

Though executed at a time when Byzantine art was being oriented towards a new conception of form with greater emphasis on plasticity and the sense of volume and space, the painting layer of 1270 in St. Nicholas is associated with a conservative Greek tradition (Omorphi Ekklesia, Aegina, 1284, Panagia at Yallou, Naxos, 1288, etc.), interspersed with a few minor iconographic elements of Frankish origin. Compositions are enriched with shapes denoting scenery, and a predilection is shown for vivid luminous colours. At any rate, the general conditions prevailing in this regional district, under a foreign non-Orthodox occupation, find expression in a linear conservatism. This may well be explained as an effort to preserve the religious and national characteristics, but also as the result of the absence of wider horizons in this small village of the Cycladic island.

Nicos Zias

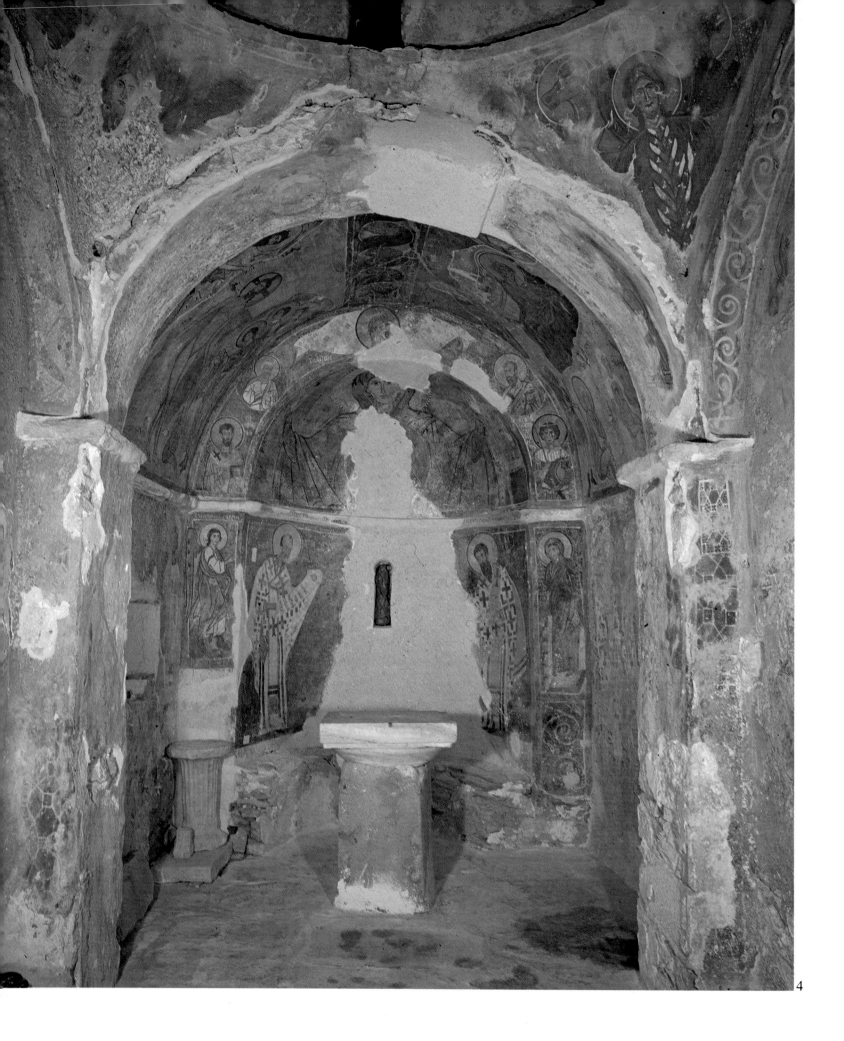

4

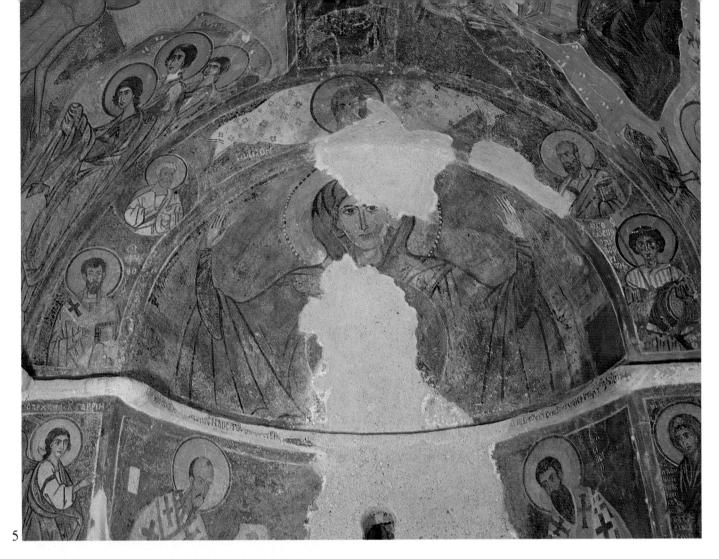

5

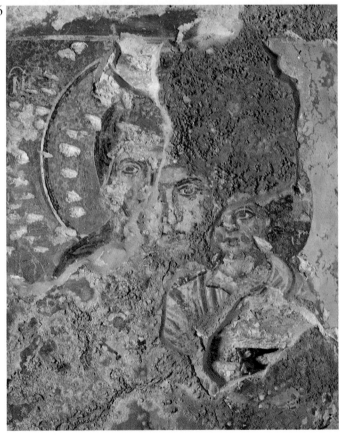

6

Bibliography

N. Kalogeropoulos, «Τριάκοντα πέντε ἄγνωστοι βυζαντινοί ναοί τῆς Νάξου», *N. Ἑστία,* Vol. ΙΔ΄ (1933), No. 160, p. 71, 72 (and reprint p. 16).

K. Kalokyris, «Ἔρευναι Χριστιανικῶν Μνημείων εἰς τάς νήσους Νάξον, Ἀμοργόν καί Λέσβον», *Ἐπιστημονική Ἐπετηρίς τῆς Θεολογικῆς Σχολῆς τοῦ Πανεπιστημίου Ἀθηνῶν,* Vol. ΙΔ΄ (1958-1960), Athens 1963, p. 497-499 (and reprint p. 15-17).

N. Kontoleon, *Εἰδήσεις περί τῶν Χριστιανικῶν Μνημείων τῆς Νάξου,* Vol. in memory of K. Amantos, Athens 1960, Fig. 12, 13.

G. Demetrokallis, «Χρονολογημένες βυζαντινές ἐπιγραφές τοῦ ΙΓ΄ καί ΙΔ΄ αἰώνα ἀπό τή Νάξο», *Ἐπιθεώρηση Τέχνης* 90 (1962) and reprint in the author's book, *Συμβολαί εἰς τήν μελέτην τῶν Βυζαντινῶν Μνημείων τῆς Νάξου,* Vol. Α΄, Athens 1972, p. 21.

Id., "Gli Affreschi Bizantini dell' Isola di Nasso", *Felix Ravenna,* Vol. XLIII (1966), and reprint in the author's book, *Συμβολαί...* p. 163, Fig. 8, 9, 10; p. 188, Fig. 10· p. 189, Fig. 11.

N. Drandakis, *Εἰκονογραφία τῶν Τριῶν Ἱεραρχῶν,* Ioannina 1969, p. 10, 26, 48, Pl. 5α.

N. Zias, «Ἅγιος Νικόλαος εἰς Σαγκρί», *Ἀρχαιολογικόν Δελτίον,* Vol. 28 (1973), *Χρονικά,* Athens 1978, p. 554, Pl. 517β, 518α-β.

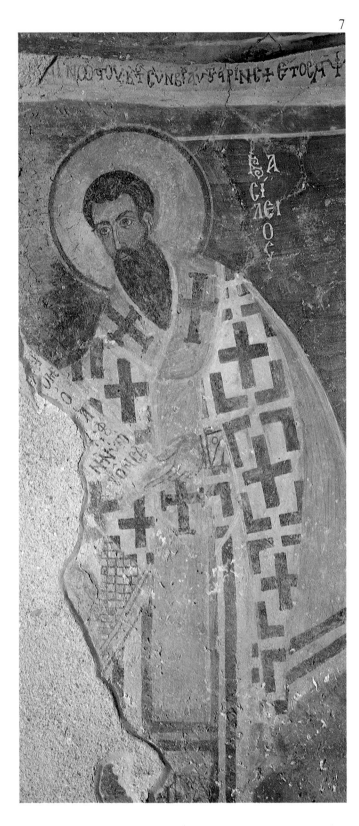

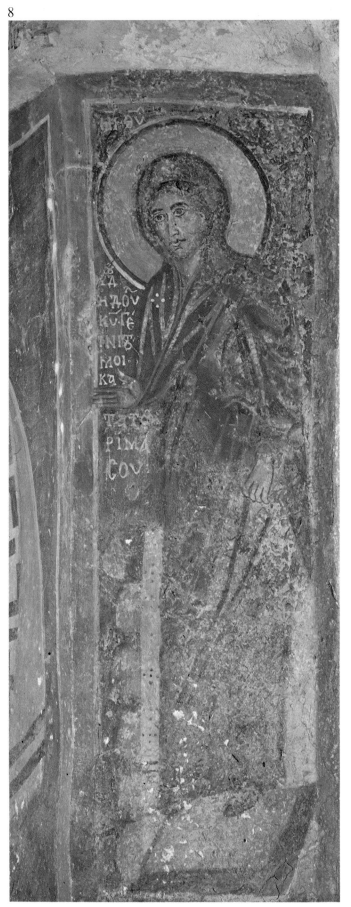

4. Hagios Nikolaos at Sangri. View towards the sanctuary.

5. Hagios Nikolaos at Sangri, conch of the holy bema. The Virgin Platytera and Saints (detail of Fig. 4).

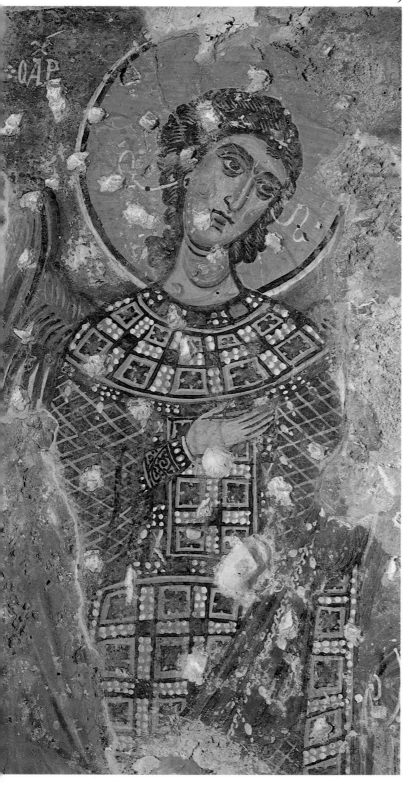

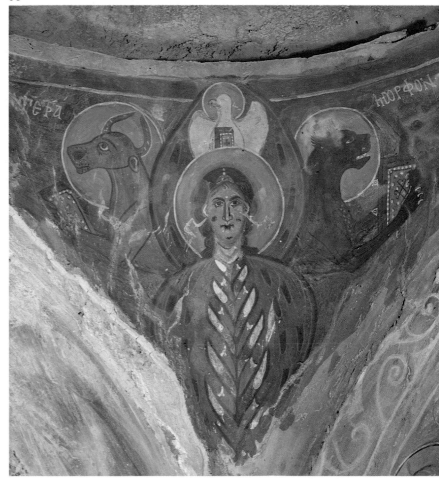

6. Hagios Nikolaos at Sangri. Three layers of wall paintings on the N. wall of the naos.

7. Hagios Nikolaos at Sangri, conch of the holy bema. St. Basil (detail of Fig. 4).

8. Hagios Nikolaos at Sangri, E. wall of the holy bema. The Virgin from the scene of the Annunciation (detail of Fig. 4).

9. Hagios Nikolaos at Sangri, N. wall of the naos. Archangel from the second painting layer.

10. Hagios Nikolaos at Sangri, SE pendentive. Tetramorph.

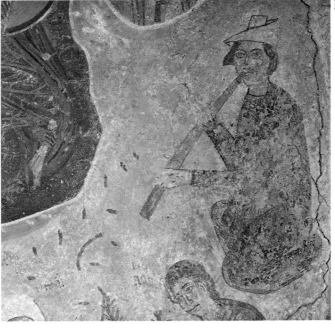

11. *Hagios Nikolaos at Sangri, S. half of the east vault. The Nativity.*

12. *Hagios Nikolaos at Sangri. Shepherd playing on a wind instrument (detail of Fig. 11).*

13. *Hagios Nikolaos at Sangri, N. Half of the east vault. The Baptism.*

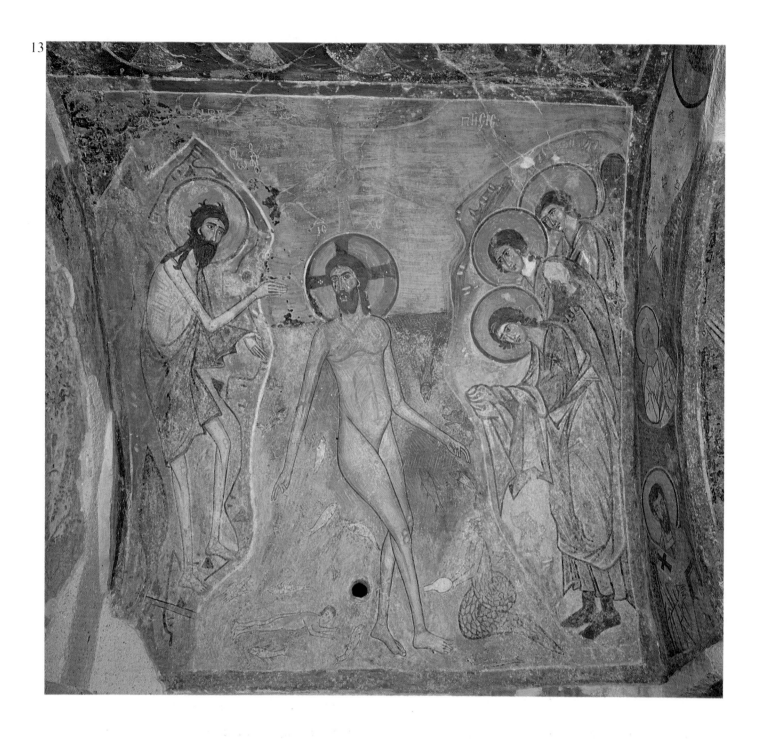

HAGIOS IOANNIS AT KERAMI

In the verdant olive-growing plain of Tragaia — the region of central Naxos so rich in Byzantine churches — to the left of the road leading from Chalki to Apeiranthos and just outside Kerami, stands the small but heavily proportioned church of St. John the Theologian (Fig. 3).

The church was investigated by K. Kalokyris, who assigns it to the 13th century, and by M. Sotiriou, who dates its wall paintings to the same period, i.e. the "early Palaeologan Revival".

Architecture

The church is square, of the single-aisled type with a dome. The large dome — in proportion to the size of the church — looks rather like a quadrilateral with rounded angles. Two of the four arches supporting the dome are built into the thickness of the lateral walls. The diameter of the sanctuary apse is almost equal to the width of the naos. From the outside the building has the appearance of a cube surmounted by a dome with a tapering cylindrical drum. The apse, semicircular on the outside, is so high as to give the impression that its half-dome is very lowered. The walls, built of common undressed stones, are entirely coated with a very hard mixture of powdered brick (*kourasani*) and pumice stone. The general appearance of the building is archaic.

Inscriptions have not survived and no information on the history of the monument is available. A vaulted extension to the west and a single-arched belfry are later additions, while remains of an eastward prolongation of the north and south walls indicate, perhaps, an older building phase.

Following consolidation works undertaken by the Archaeological Service (1971-1972), the formerly dilapidated monument is at present in a fair state of preservation. The half-dome of the apse was consolidated and part of the sanctuary wall was rebuilt. The interior arches added at a later date in order to strengthen the westward extension were removed and so was the arch of the south wall, which had been actually transformed into a double arch. The original Holy Table was found and restored. Lastly, the floor was paved with slabs. For greater safety, two buttresses were built outside, against the south wall. Despite its small interior dimensions (2.33×3.42 m.), the few and small lights of the church leave enough surfaces suitable for a painted decoration.

Painting

The original decoration is not all in a good state of preservation. Some of the wall paintings have survived to a great extent — for example, in the dome — others are fragmentary — in the sanctuary apse — and some are completely ruined — in the lower part of the walls (Fig. 4).

Conservation works on the wall paintings undertaken in 1971-72 included their consolidation, whenever necessary, and their cleaning. Some of the wall paintings were exposed following the removal of the props that had been used at times to support the building.

Although the iconographic programme has not been preserved in its entirety, it can be reconstructed to a great extent. On the half-dome of the apse conservation works have uncovered a few fragments, probably from the neck of the figure of Christ, and very few traces, from other figures that must have belonged to a representation of the Deesis (Fig. 4, Plan no. 9), a composition often seen in Naxos (the Protothrone, St. John the Theologian at Apeiranthos, St. George at Lathrinos etc.). The curved wall of the apse is painted with the usual co-officiating hierarchs, three on either side of a Holy Table covered with a sumptuous cloth. The Holy Table has a disproportionately large paten with the inscription:

ΛΑΒΕΤΕ... (φαγ)/ΕΤΕ ΤΟΥΤΟ ΕΣΤΙ ΤΟ σ(ΩΜΑ) ΜΟΥ

(*"Take, eat; this is my body"*) and the representation of the Infant Christ as the Lamb. The north half of the composition includes St. John Eleimon (Plan no. 1), St. Basil (Plan no. 2) and St. John Chrysostom (Plan no. 3). Two of the hierarchs of the south half are greatly damaged (Plan no. 5, 6), the third is St. Polycarpos of Smyrna (Plan no. 7).

The dome is painted with the Pantocrator (Plan no. 10) in the usual type, in a medallion with cross arms extending towards the cardinal points and decorated with a pattern of double circles (Fig. 5). Diago-

nally placed, four full-length majestic angels with out-spread wings (Plan no. 11-14) raise their hands above their head and support the central medallion. Around the Pantocrator an inscription (Fig. 5) reads:

Ο ΚΗΡΗΟC ΕΚ ΤΟΥ ΟΥΡΑΝΟΥ (διέκυψεν ἐπί τούς Υἱούς) ΤωΝ ΑΝΘΡΟΠωΝ

("*The Lord looked down from heaven upon the children of men*", Psalm 14, 2). The pendentives are painted with the four Evangelists. The NW pendentive shows St. Luke with the beginning of his Gospel:

ΕΠΙΔΗΠΕΡ ΠΟΛΙ...

("*Forasmuch as many...*") (Fig. 7, Plan no. 17). On the SW pendentive St. Mark is seated at a fully equipped copyist's desk with a rich architectural background and writing the opening words of the Gospel:

ΑΡΧΙ του Ε

("*The beginning of the G[ospel]*") (Fig. 8, Plan no. 16). The SE pendentive has preserved only the grey-haired head and upper half of the figure of St. John and part of the architecture-scape (Plan no. 15), while the painting of the NE pendentive, now totally ruined, must have shown St. Matthew (Plan no. 18).

The intrados of the four arches supporting the dome are decorated with busts of saints and prophets in coloured medallions. Of the eight medallions painted on the soffit of the east arch, two are preserved in good condition: those with the busts of St. John (Plan no. 20) and of Sampson (Plan no. 25). The south arch has St. Artemios (Plan no. 32), St. Euthymios (Plan no. 33), St.Barlaam (Plan no. 34), St.Cosmas the Poet (Plan no. 35) and the Prophet Ezekiel (Fig. 10, Plan no. 36). The west arch shows the Prophet Isaiah (Fig. 9, Plan no. 38), the five Saints from Sebasteia, Orestes (Plan no. 40), Auxentios (Plan no. 42), Eugenios (Plan no. 43), Eustratios (Plan no. 44), possibly Mardarios, and a young prophet (Plan no. 45). The north arch has the Prophet Zephaniah and the Apostles Simon (Plan no. 58), Andrew (Plan no. 55) and Paul (Plan no. 54).

The pilasters supporting the arches are painted with standing figures. Christ (Plan no. 52) is portrayed on the east pilaster of the north arch and St. John the Baptist (Plan no. 30) on the east pilaster of the south arch. A representation of the Descent into Hell (Plan no. 51) has survived fairly well on the tympanum of the north arch. The figures of Solomon, David and St. John the Baptist (Fig. 11) are in better condition. Below, on the wall, are the full-length figures of St. Artemios (Plan no. 47), the Sts. Theodoroi (Plan no. 48, 49) and the Virgin (Plan no. 50).

The tympanum of the south wall was painted with the Nativity (Plan no. 28) (it now shows traces of Joseph, the Bathing of the Infant Christ, the head of a shepherd) and the Baptism (Plan no. 29) (an angel has survived in better state and fragments from the other figures).

The iconographic programme follows the established pattern. The sole figure of the Pantocrator occupies the centre of the dome. In this case, however, the medallion is depicted with the arms of a cross and four standing angels supporting with their raised hands the vault of heaven. These motifs associate the representation with Early Christian works (in S. Vitale and in the Chapel of the Archiepiscopal Palace, Ravenna) expressing eschatological and doxological conceptions of the times, which have now become symbols of man's victory and salvation through Jesus Christ. Likewise, the painting of the intrados with saints and prophets appears to have been organized according to a unified iconographical and theological conception. The iconography starts with prophets (of the eight that were originally painted only two are recognizable: Isaiah and Ezekiel), while on some arches we find unities of saints, like the five martyrs from Sebasteia (Eustratios etc.), the Apostles and so on.

The fragmentary state in which the wall paintings have survived and the absence of entire compositions, except for the one in the dome, do not permit a thorough appraisal of the painter's abilities. We can, however, detect his stylistic affinities and innate talent, as well as his skill in rendering single figures. The oval of the Pantocrator's face, the short beard and pronounced downward curve of the moustache, the tranquil arc of the eyebrows, the relatively low forehead, the uniform pale modelling enlivened by the diffused red colouring of the cheeks, associate this painting with 12th century works encountered mainly in the periphery of the Byzantine Empire (Mani, Cyprus etc.).

The portrait of the Pantocrator does not seem to fit in the medallion, which is rather small compared to the size of the dome. The left hand holding the Gospel Book is omitted and only a part of the blessing right hand has been painted.

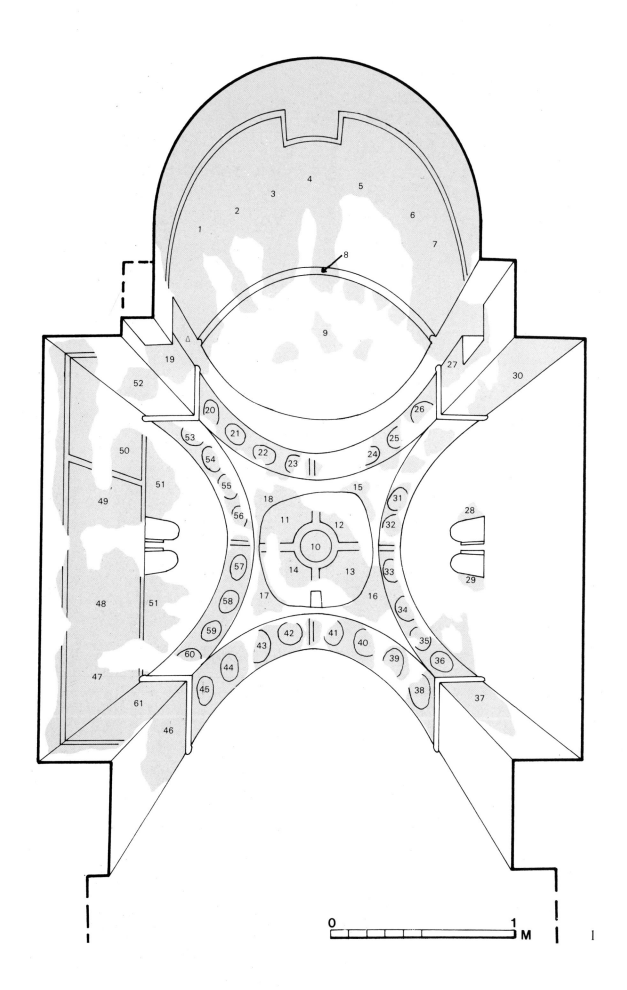

HAGIOS IOANNIS AT KERAMI

1. *St. John Eleimon.* **2.** *St. Basil.* **3.** *St. John Chrysostom.* **4.** *The Melismos.* **5, 6.** *Unidentified figures (fragments).* **7.** *St. Polycarpos of Smyrna.* **8.** *Inscription.* **9.** *The Deesis (fragments).* **10.** *Christ Pantocrator.* **11-14.** *Angels.* **15.** *St. John the Evangelist (fragment).* **16.** *St. Mark the Evangelist.* **17.** *St. Luke the Evangelist.* **18.** *St. Matthew the Evangelist (traces).* **19.** *Saint.* **20.** *St. John.* **21-24.** *Unidentified figures (fragments).* **25.** *Samson.* **26.** *Prophet.* **27.** *St. Stephanos.* **28.** *The Nativity (fragment).* **29.** *The Baptism (fragment).* **30.** *St. John the Baptist.* **31.** *Prophet.* **32.** *St. Arsenios.* **33.** *St. Euthymios.* **34.** *The Prophet Barlaam.* **35.** *St. Cosmas the Poet.* **36.** *The Prophet Ezekiel.* **37.** *Unidentified figure (traces).* **38.** *The Prophet Isaiah.* **39.** *Saint.* **40.** *St. Orestes.* **41.** *St. Mardarios.* **42.** *St. Auxentios.* **43.** *St. Eu(genios).* **44.** *St. Eustratios.* **45.** *Prophet.* **46.** *St. Isidoros.* **47.** *St. Artemios (fragment).* **48, 49.** *The Sts. Theodoroi (fragment).* **50.** *The Virgin (fragment).* **51.** *The Descent into Hell (fragment).* **52.** *Christ (fragment).* **53.** *Prophet.* **54.** *St. Paul.* **55.** *St. Andrew.* **56, 57.** *Apostles.* **58.** *St. Simon.* **59.** *St. Philemon.* **60.** *Prophet.* **61.** *Military saint.*

1. Hagios Ioannis at Kerami. Perspective plan.

2. Hagios Ioannis at Kerami. Ground-plan.

3. Hagios Ioannis at Kerami. SW view.

The composition with the four angels is one of the major achievements of the artist who painted the dome. The rhythmical postures, the raised hands and outspread wings, the wide opening of the mantle revealing the form of the body, the variation of colours in the garments, impart a controlled dynamism to this painting. On a green preliminary underpaint, red and brown strokes of the brush design the features of the faces and the dreamy eyes (Fig. 6). After seeing only part of one of these angels, M. Sotiriou remarked: "A Greek character is reflected in the rhythm and freedom of the entire composition and also in the purity of form, the gentle modelling, the sensitive design and the delicate relief of the features".

The most notable elements in the representation of St. Mark the Evagnelist are the writing implements and the architectural background. Tall and narrow buildings are set without order, as if space were insufficient. Distinction between sides — their perspective, so to speak — is indicated by colour: green for the façade, yellow for the sides, without gradation. On the faces of the Evangelists, fine green-coloured brush strokes are used for the shadowy parts while prominent features are painted in warm tones. In the medallions of saints, the modelling of faces is similar but the effect is further enhanced by the alternating, red, green, dark blue, colours of the field and the splendid raiment of the saints.

The iconographic elements noted above would be more appropriate to an epoch possibly before the 13th century. Nevertheless, the morphological characteristics, the plasticity, the rich colouring, the love of beauty, the ethos of the figures and their marked humanity, point to a revival of art and support a dating in the second half of the 13th century. The talented colourist of the church of St. John may have chosen for some representations iconographic models older than his time, probably prompted by his own or the donor's conservatism. However, his sensibility and skill make him accept the general contemporary trends of the major centres that had reached even this remote small village of Frankish-ruled Naxos. This he does certainly with the changes and adaptations imposed by the different circumstances which, in turn, are not unrelated to the prevailing political and economic situation of the island.

Nicos Zias

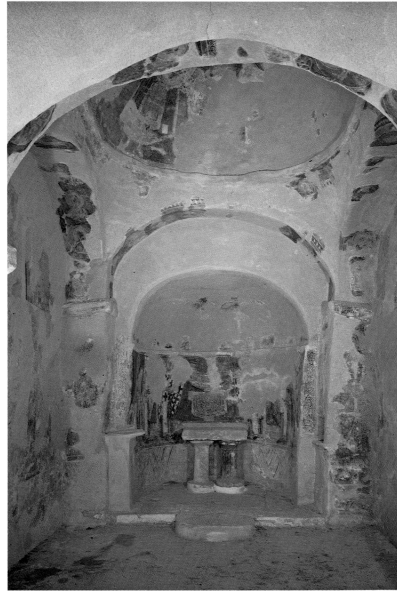

4

4. *Hagios Ioannis at Kerami. View towards the sanctuary.*
5. *Hagios Ioannis at Kerami. Dome painting.*

Bibliography

N. Kalokyris, «Ἔρευναι Χριστιανικῶν Μνημείων εἰς τάς νήσους Νάξον, Ἀμοργόν καί Λέσβον», Ἐπιστημονική Ἐπετηρίς τῆς Θεολογικῆς Σχολῆς τοῦ Πανεπιστημίου Ἀθηνῶν, Vol. ΙΔ΄ (1958-1960), Athens 1963 (and reprint p. 14-15).

M. Sotiriou, «Ἡ πρώιμος Παλαιολόγειος Ἀναγέννησις εἰς τάς χώρας καί τάς νήσους τῆς Ἑλλάδος κατά τόν 13ο αἰῶνα», Δελτίον Χριστιανικῆς Ἀρχαιολογικῆς Ἑταιρείας, per. Δ΄, Vol. Δ΄ (1960), p. 263-264, Pl. 56.

N. Zias, «Ἅγιος Ἰωάννης εἰς Κεραμί Τραγαίας Νάξου», Ἀρχαιολογικόν Δελτίον, Vol. 27(1972), Χρονικά, p. 614-615, Pl. 570α-β· Vol. 28(1973), p. 551-552, Pl. 514α, 515β.

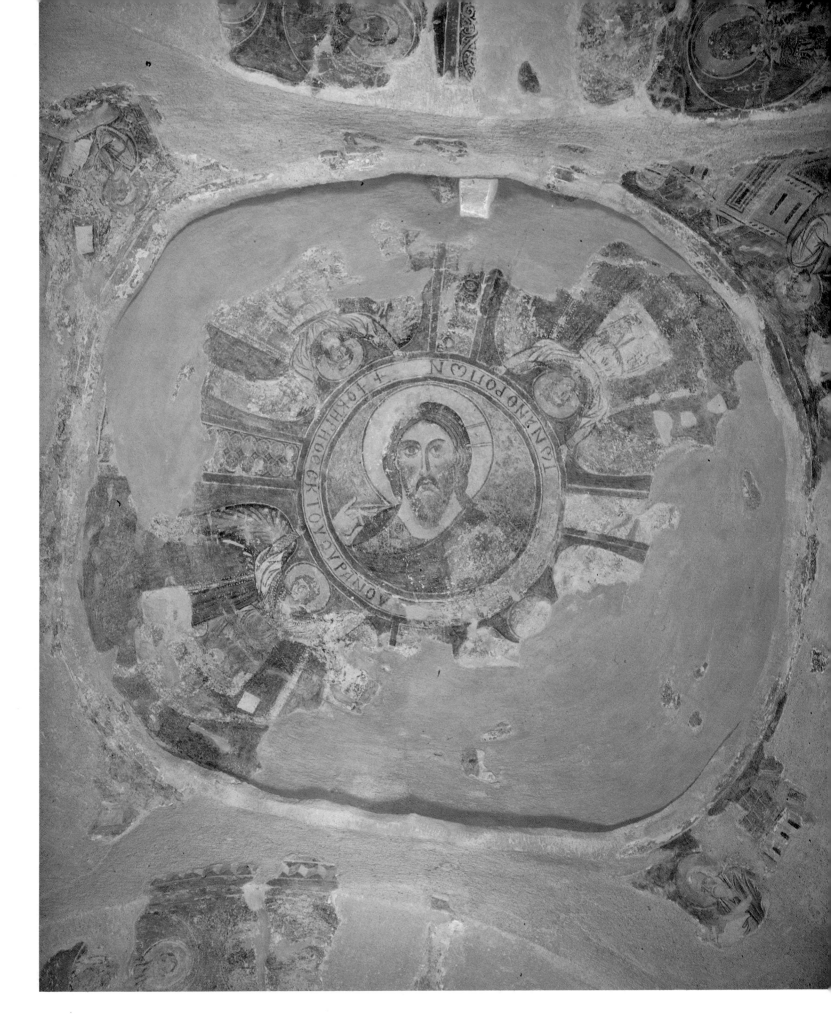

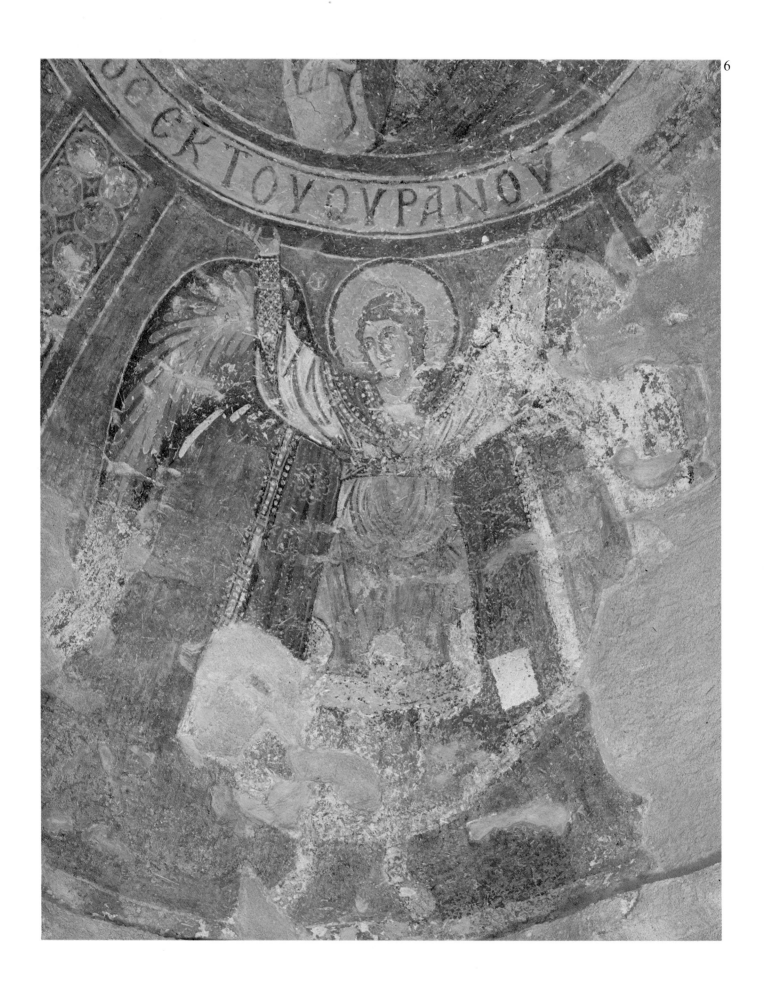

6. *Hagios Ioannis at Kerami. Archangel (detail of Fig. 5).*

7. *Hagios Ioannis at Kerami, NW pendentive. St. Luke the Evangelist.*

8. *Hagios Ioannis at Kerami, SW pendentive. St. Mark the Evangelist.*

9. *Hagios Ioannis at Kerami, W. arch. A saint and the Prophet Isaiah.*

10. *Hagios Ioannis at Kerami, S. arch. St. Cosmas the Poet and the Prophet Ezekiel.*

11. *Hagios Ioannis at Kerami, N. wall. The Descent into Hell (detail).*

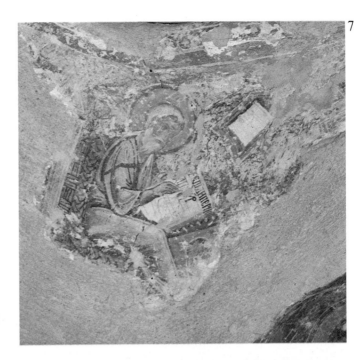

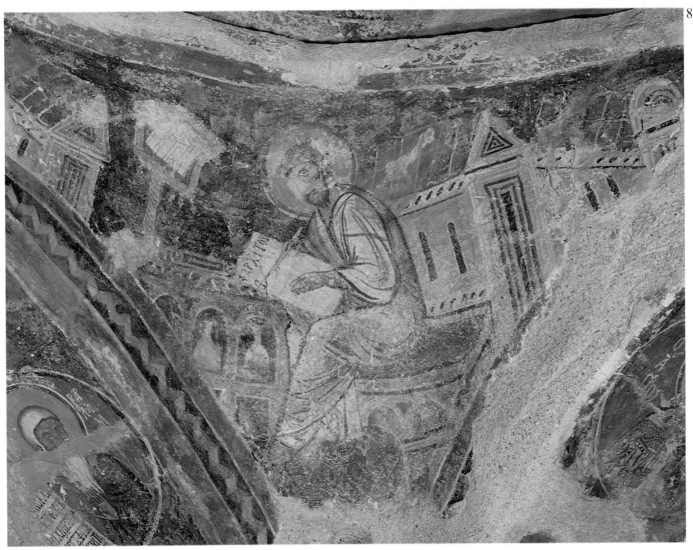

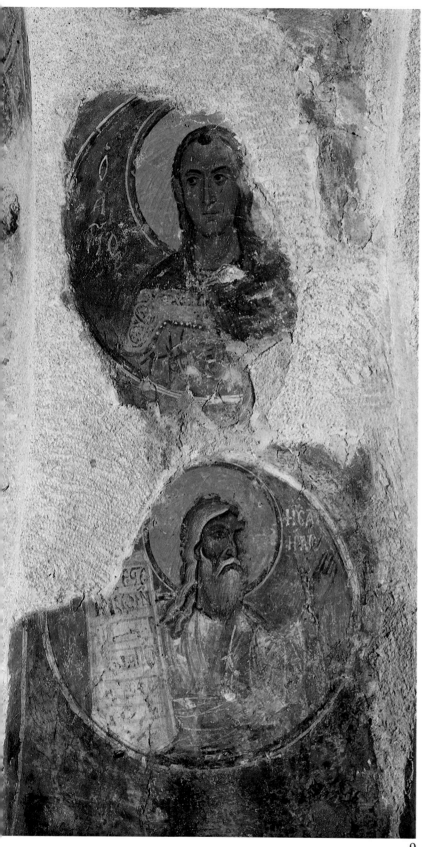

9

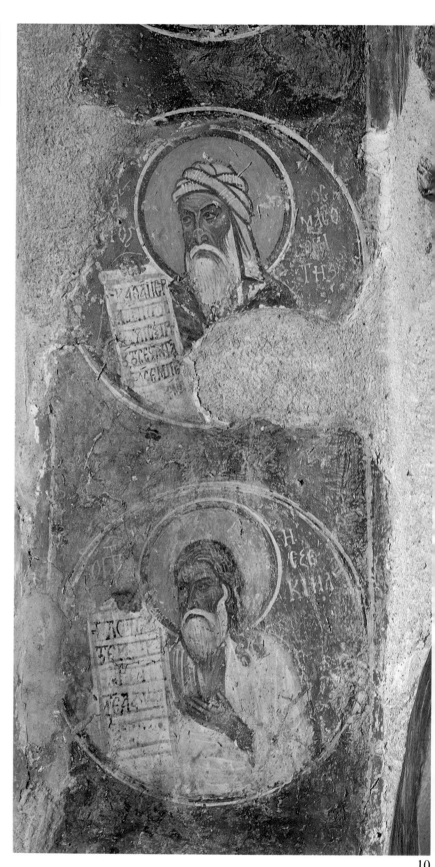

10

11

PANAGIA AT YALLOU

The all-white small single-naved church of Panagia at Yallou (Fig. 2, 3) is located in the almost deserted bushy area of E. Naxos, in the region of the village Filoti, not far from the coastal site of Agiasos. (The locality has perhaps taken its name from the ancient female daemon Yello — even in our days fairies are called *Yalloudes*).

Built of undressed stones, the church measures in the interior 7.32×2.79 m. (2.90 m. near the apse). The sanctuary is surmounted by a low dome, of conical shape on the exterior, with a cylindrical drum which had four small lights. Four arches, of which the two lateral ones are blind, support the dome (Fig. 2). The part of the church beyond the west arch is probably a later addition with a barrel-vaulted roof. There are low benches running along the two lateral sides. With the exception of the apse and the tympana of the blind arches, the interior of the church is covered with a coating of lime. No preservation works were carried out in the church, and only the crumbling wall painting of Christ on the S. tympanum was consolidated by N. Kailas, the former conservator of the Archaeological Service.

The notable dedicatory inscriptions accompanying the surviving wall paintings are carefully written and record the family names of inhabitants of Naxos in those times. In the apse, to the left of the Archangel Michael, we read:

Δέ(ησις)
Μιχ(α)
ήλ

("Invocation of Michael"), and higher (Fig. 2):

Ἔτους
͵ϚΨϞΖ΄
Ἰνδ(ικτιῶνος) Β΄

("In the year 6797, Indiction B΄"). The year 6797 from the creation of the world corresponds to A.D. 1288/89, when the Indiction cycle was actually the second one.

On either side of the Virgin Platytera the inscription records.

Δέ(ησις) τοῦ δού(λου) τοῦ (Θε)οῦ
Γεωργίου τοῦ Πεδιάσημ(ου) καί τῆς

συμ(βίου)
αὐτοῦ Μαρίας κ(αί) τῶν τέκνων αὐτῶν.

("Invocation of the servant of God George Pediasimos and his wife Maria and their children"), and below the representation, on the brick-coloured band (Fig. 3):

Δέ(ησις) Καλῆς τῆς Χηωνοῦ

("Invocation of Kale Chionou").

Next to the Sts. Mamas and Michael:

Δέ(ησις) Μ(ι)χαήλ
τοῦ Τ[;]ιακητα κ(αί) τῆς συμβίου Λεοντούς

("Invocation of Michael T(?)iaketas and his wife Leontou"), and below St. Demetrios:

Δέ(ησις)
Γεωρ
γίου τοῦ Κα
λαπόδι κ(αί) τῆς σ(υμ)
βίου αὐτοῦ Μαρίας

("Invocation of George Kalapodis and his wife Maria").

Lastly, to the right of the Virgin *Pausolype*:

Δέ(ησις)
Ἄννας
τῆς Κουτη
νοῦ κ(αί) τέ
κνου αὐτῆς
Ἐπιφάνιου

("Invocation of Anna Koutinou and her son Epiphanios").

On the half-dome of the sanctuary apse the Virgin Platytera is portrayed with a very long nose, holding with both hands a medallion containing a picture of Christ Emmanuel. The Archangel Michael, to the left, and the Forerunner, to the right, bow to the Virgin. St. Mamas, the unknown St. Michael of Miletus and St. Leontios the Younger are painted frontally on the curved wall of the apse. A band separates them from the hierarchs St. Polycarpos and St. Eleutherios. The holy figures painted on the tympana of the blind arches are possibly replacing the icons of a templon,

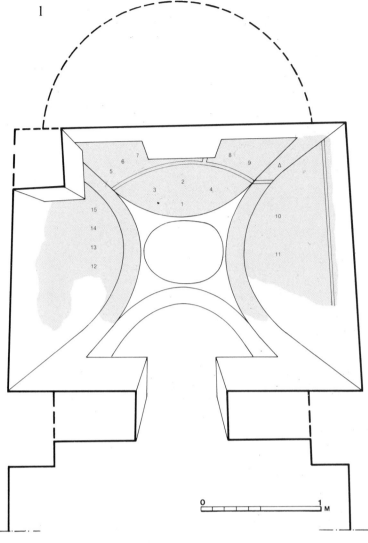

PANAGIA AT YALLOU

1. *The Virgin Platytera (Nikopoios).* 2. *Christ Emmanuel.* 3. *The Archangel Michael.* 4. *St. John the Baptist.* 5. *St. Mamas.* 6. *St. Michael of Miletus.* 7. *St. Leontios the Younger.* 8. *St. Polycarpos.* 9. *St. Eleutherios.* 10. *St. John the Theologian.* 11. *The Saviour.* 12. *St. Demetrios.* 13. *The Virgin Pausolype.* 14. *St. Kyriake.* 15. *St. Paraskeve.* Δ. *Decorative motif.*

1. Panagia at Yallou. Perspective plan.

2. Panagia at Yallou. Ground-plan.

3. Panagia at Yallou. NE view.

4. Panagia at Yallou, half-dome of the sanctuary apse. The Virgin Platytera.

5. Panagia at Yallou, S. tympanum. Christ.

6. Panagia at Yallou, N. tympanum. The Virgin Pausolype and saints.

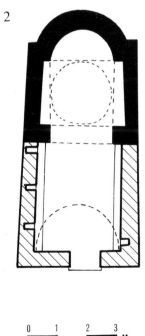

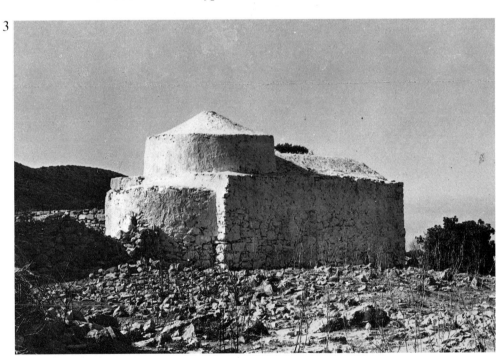

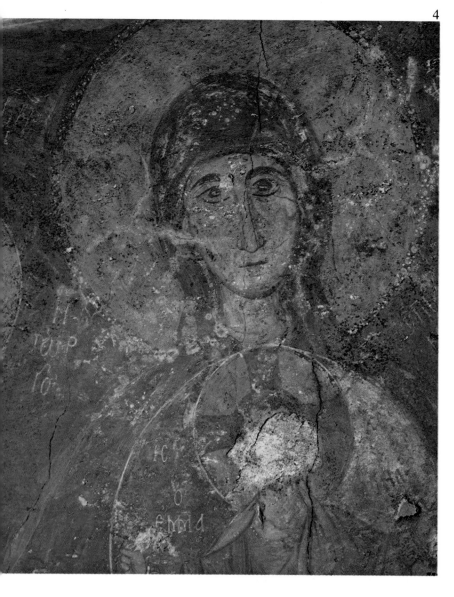

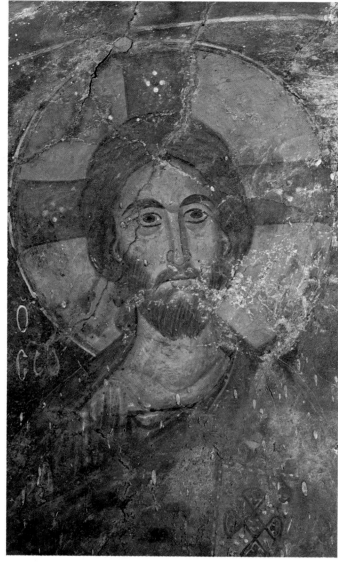

since the original church probably did not extend beyond the area surmounted by the dome. St. Demetrios wearing chain mail of a western type, the Virgin *Pausolype* and Child, and the Sts. Kyriake and Paraskeve (Fig. 6) are shown in frontal attitudes on the N. tympanum, and on the S. tympanum, St. John the Theologian, turned three-quarters to the left, and near him, frontally, Christ (Fig. 5). The few decorative motifs are confined to the intrados of the blind arches.

The wall paintings are quite damaged. Those that have survived, or more correctly those that are visible, depict single figures. Scenes from the Evangelical cycle or from the life of the Holy Mother of God are missing. The available space, of course, is very small. The archaism of the iconography is remarkable. The curved wall of the apse has other saints in addition to the frontally pictured hierarchs, whereas not many

years before, on the same island, the apse of the church of St. Nicholas at Sangri (1270) was painted with co-officiating hierarchs. The iconographic archaism and the representation of various holy figures other than those usually painted in the apse is not a unique instance in Naxos. The same occurs in the E. parecclesion of the church of Panagia Drosiani (13th century), where an angel in frontal attitude is depicted to the left and a soldier saint to the right (partly unpublished wall paintings), and later, in the church of St. Constantine at Vourvouria (1310), where we have the frontal figures of the Sts. Constantine and Helena in addition to the hierarchs.

The similarities in the style of the wall paintings lead to the conclusion that they were all done in 1288-89, together with the decoration of the half-dome of the apse. The Virgin Platytera is of the Nikopoios

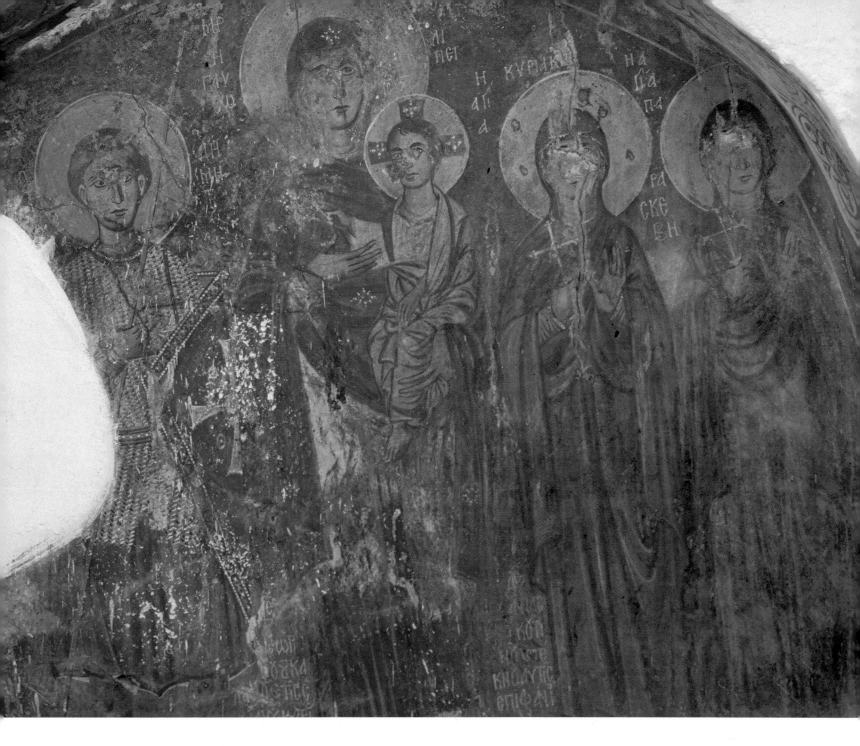

type, encountered since the 7th century in the N. conch of the Drosiani. This composition on the half-dome of the Panagia at Yallou, with the Archangel Michael and St. John the Baptist (Fig. 7), the principal representatives of the invisible and the visible world, constitutes a kind of Deesis.

It has been suggested that St. Leontios the Younger may be identified with the Abbot of the Monastery of the Theologos on the island of Patmos, who after an abbotship of twenty years became Patriarch of Jerusalem and was later exiled to Constantinople where he died at a very old age, probably in 1190. One cannot easily accept this identification, for here, in a non-monastic church, this saint is depicted

young and beardless (perhaps malebarbis?) wearing an ascetic's habit. The representation of St. Mamas, the patron saint of shepherds held in great reverence on the island, is not unrelated to the pastoral character of the region. The facial type of the full-length Christ with the forked beard (Fig. 5) resembles that of Christ on the half-dome of the apse in the church of St. George at Lathrinos, even though the paintings are of a different style and quality.

The figures of saints in the church of Panagia at Yallou are rather linear, two-dimensional, dry and fleshless. Lacking in expression but not devoid of nobility, they are distinguished for an occasional attention to minor details. The wall paintings are a provin-

cial work of good quality and the hagiographer, although influenced by great art, has retained traits of popular art. This is evident, for example, in the clumsy rendering and the disproportionate size of the neck and head of the Christ Child held by the Virgin *Pausolype,* and in the mediocre painting of the Archangel Michael which shows, however, a certain grace in the inclination of the head and in the flat-painted long and delicate face.

Nicos B. Drandakis

Bibliography

N.B. Drandakis, «Αἱ τοιχογραφίαι τοῦ ναοῦ τῆς Νάξου Παναγία "στῆς Γιαλλοῦς" (1288/89)», Ἐπετηρίς Ἑταιρείας Βυζαντινῶν Σπουδῶν, Vol. ΛΓ΄ (1964), p. 258-269.
Id., «Μεσαιωνικά Κυκλάδων», Ἀρχαιολογικόν Δελτίον, Vol. 20(1965), Β₂: Χρονικά, p. 547-548.
G. Demetrokallis, Συμβολαί εἰς τήν μελέτην τῶν βυζαντινῶν μνημείων τῆς Νάξου, Athens 1972, p. 23, 165-177.

7. Panagia at Yallou, sanctuary apse. St. John the Baptist (detail).

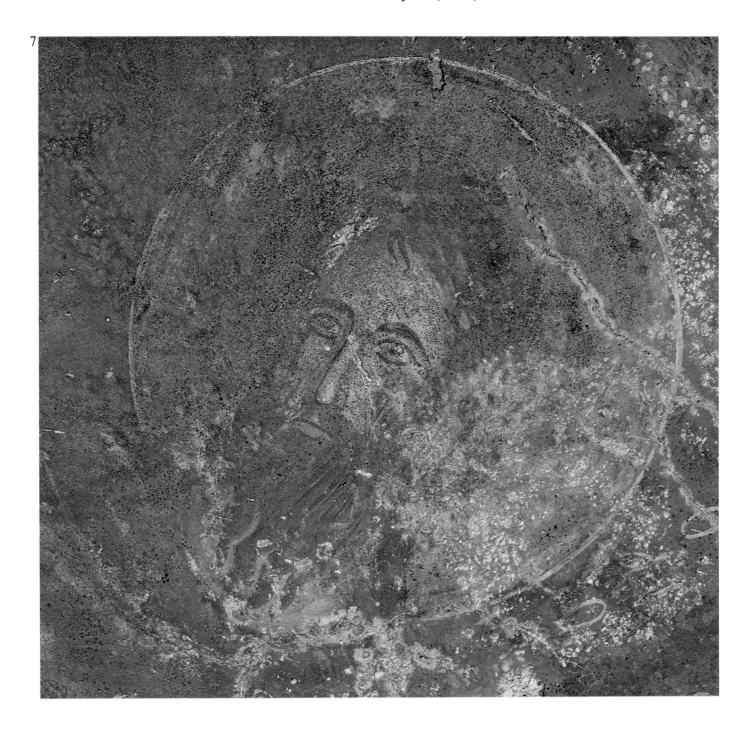